How to understand a painting

Decoding symbols in art

Françoise Barbe-Gall

F

FRANCES LINCOLN LIMITED

PUBLISHERS

INTRODUCTION

To understand symbols in painting, one must immediately rid oneself of a misconception: the idea that the apparent simplicity of an object means that it carries a simple meaning. The precise role of a symbol is to draw the mind from the material to the spiritual, to take it beyond the restrictions of the ordinary world in order to glimpse a deeper truth.

Religious painting, with its primary aim being to instruct, makes abundant use of forms and objects which aim to convey such abstract notions as love, fidelity, hope for eternal life, loyalty or betrayal. When attached as attributes to holy figures, symbols offered a convenient way of identifying them, or acted as a reminder of some important episode in their lives. These recurring motifs, which were familiar to many in the past, have mostly become mysterious to the audiences of today. Today's art-lover will have to learn to look out for the small things that can so easily seem like unimportant details, or simply decoration, there just to please the eye. But a flower, a reflection in a mirror or a bird in flight nearly always mean more than they first appear to.

This book is far from being a systematic study, and in no way claims to be a complete catalogue of the symbols used in art. It is no substitute for a dictionary of iconography, since it does not use the same methods nor does it aim to be comprehensive. It concentrates on a few main themes, its primary aim being to draw the reader's attention to their consistency and diversity throughout the history of painting. The reader should then be able to understand how each work makes use of the language of symbols in an original and more meaningful way. The works shown here were not chosen to simply illustrate a list of symbols, with the sole purpose of identifying them. On the contrary, each painting is approached and examined in its own context, as one might approach a person who behaves differently according to circumstances. Every image has its own colour and tone but the central meaning remains unchanged.

How to understand a painting

Decoding symbols in art

To Yoram
For Emmanuel, Eden and Raphaël

The message of a symbol is rarely obvious from the outset, but it gradually reveals itself as one draws closer, and meaning that had not been previously apparent, becomes clear. Of course one must always be aware that symbols can often be turned inside out like gloves, their double meaning displayed like the two sides of a coin: depending on the context, an object can represent one idea or its exact opposite.

The twenty most frequently occurring symbols have been grouped into two sections, one of images drawn from nature, the other from man-made objects. I must emphasize that, although these images often originate from other sources, such as Egypt, the Far East, or Judaism, they are all examined here from the perspective of western culture. Thus the book limits itself to a glimpse of those symbols which the Christian tradition, linked to its classical heritage, has brought to the history of painting.

Of course, many centuries have passed since painting was entirely religious. But it is nonetheless true that art continues to retain a memory of religion, if only to distance itself from that tradition. Echoes of symbolic meanings, depicted in non-conventional terms, are another way of validating such traditions. Examples of this would be Manet's cat lying at the feet of Olympia, or Magritte's comical candles. The poetic metaphor, the cunning allusion, sometimes the agonised question – these all add something to the original symbolic language. And it is this bundle of references which enables each new painting to present itself to the world as something fresh and original.

CONTENTS

Nature's repertoire

The eloquence of objects

NATURE'S REPERTOIRE

NATURE'S REPERTOIRE

Nature has been considered sacred in every civilization, perceived as a divine riddle, a challenge for mankind to decipher. Man, bewildered by the world around him, seeks to interpret the shapes he sees and to reassure himself by finding some coherence within them. Thus the world of antiquity was able to explain the cycle of the seasons, of day and night, through the endless adventures of their gods: every natural occurrence was a demonstration of the movements and plans of invisible spirits. Animals were both admired and feared, and themselves became actors in this mysterious performance through which one might interpret the will of an all-powerful creator.

The history of painting clearly makes use of the visual vocabulary that resulted from this, with all the variations that arise from the different cultures they spring from. Some universal symbols are immediately and intuitively understandable. Others demand a minimal amount of explanation. The sun, for example, appears as a constant presence throughout mythology, as the dispenser of life and death, capable both of warming and ripening the fruits of the earth and of scorching and destroying its crops. Christianity, by the same token, picks up and develops this image in its texts and paintings, providing its own particular vocabulary. The spectator, before referring to sources, should react to the images by trusting their own impressions or interpretations. It is true, of course, that you cannot simply guess that a crescent moon is connected to the Immaculate Conception of the Virgin Mary, or that a hovering dove always represents the Holy Ghost. Certain images only work in particular settings: some codes only apply in

certain places and at certain times, or refer to a particular story. Details of these can be found in the themes noted at the end of each section.

There is something else which counts for more: whether or not one can master the game of references, and whether or not one gets a little bit lost amongst all the legends, it is most important to understand how the painter, working on so many symbolic levels, has been able to meld them together into a natural whole. And finally, what is most exciting is the discovery of how close Ribera's bird, Cezanne's tree or Paul Klee's fish are to us – how familiar they are, and yet how they continue to suggest some other meaning that is beyond us.

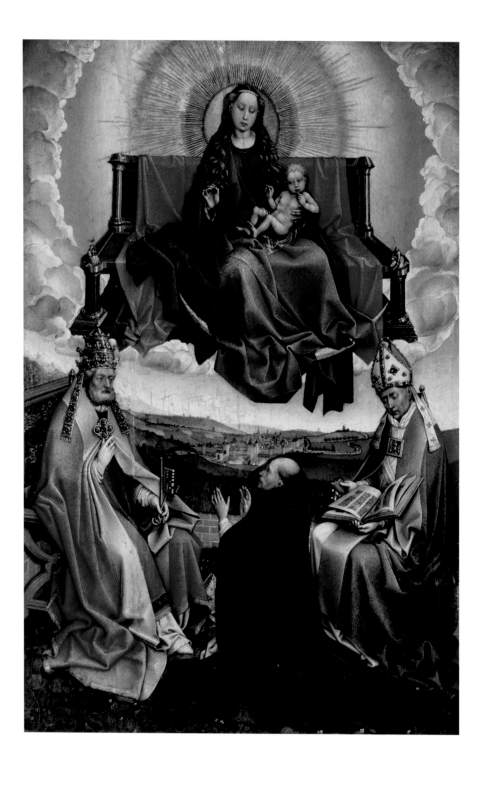

The sun and the moon

.
.
.

●

Virgin in Glory
with a Donor, Saint Peter and Saint Augustine

Robert Campin (Master of Flemalle) (1375-1444)
1435-40. Oil on wood, 48 x 311.6 cm. Musée Granet, Aix-en-Provence.

.
.
.

The man in black cannot speak. His hands are held out in amazement. How many other men have been granted the privilege of the sight that is now before his eyes: Heaven has come to him. The Virgin, enthroned in front of a circle of golden rays, with her child on her knees, bows down her head to look at him. Beneath her feet, a crescent moon rocks the sky.

Kneeling on the grass, the man turns towards Saint Peter, who, with the gesture of an orator, lifts his hand, which is weighed down by his robe. No doubt he is preparing to give him a blessing. His other hand, gloved in white, holds the two keys to Paradise: one which opens the gate and the other which locks it.

On the other side, Saint Augustine is immersed in the study of the Bible, holding in his hand what is, in its way, another kind of key: his heart, burning with divine love. The two long-dead saints frame the man in black, like a great doorway, mightier than that of a cathedral. Their crown and mitre tilted forwards, with a grave expression, they touch the clouds, as though bowing to the horizon. Through them, and through all that they know of divine mystery, a doorway to eternity appears. The divine vision places one man's life between brackets.

In Robert Campin's world Heaven could easily be associated with earthly details. Mary has the fresh complexion of a healthy young woman, proud of her rosy-cheeked but still skinny-legged baby. Her throne looks exactly like a church

bench, floating cheerfully in the sky. But the bench is made of porphyry, not wood, and this rare purple stone, immune to the ravages of time, silently represents the unchangeable glory of the hereafter. Heaven cannot be far away, nor the celestial Jerusalem, the object of so much hope. After all, did the Bible not promise its eternal splendour to the pure in spirit, did it not describe its walls of gold and precious stones, set in a city bathed in the purest light?

Outside the garden, beyond the little brick wall, there stretches a peaceful green landscape. Nature's beauty is enhanced by the movement of days and hours, as colour and shade are continually renewed. Soon the light will fade and disappear. On the bishops' heavy robes, the red begins to fade, the blue changes to purple. Soon all will be cloaked in darkness.

The light crosses the sky, becoming still around the Virgin, like a solid circle, so concentrated that it seems it may burn her. So this is what it comes to, the man in black seems to be thinking, this is what the halos of saints that you see in pictures are trying to say. Until now he had seen them only as a painterly device, a useful accessory to denote the grace of God. But here he sees a clear sign, a piece of evidence that transports him – the evidence of an unchanging light, a fire that does not destroy, the certainty of a divine presence. The man sees the eye of God in this dazzling circle of light. And he understands that Mary is at its centre.

Mary sits firmly on the crescent of the night, and the bottom of her heavenly blue robe spills over it. Sun and moon, dawn and dusk are together: the man in black accepts this, he is reassured that God can bring an end to the overwhelming weight of time. He is aware of his own inconstant nature, like the waxing and waning moon. He knows about the fragility of man's will, and how he can sometimes feel his soul dissolving with exhaustion in the evening. Often he too has had to recompose his shattered self.

The man has removed his hat, and placed his mitre beside him. The sunlight becomes softer, caresses the slender crescent moon and the man's bare head, releasing him from his fear and awe. He can raise his eyes at last.

.

.

.

.

.

.

.

.

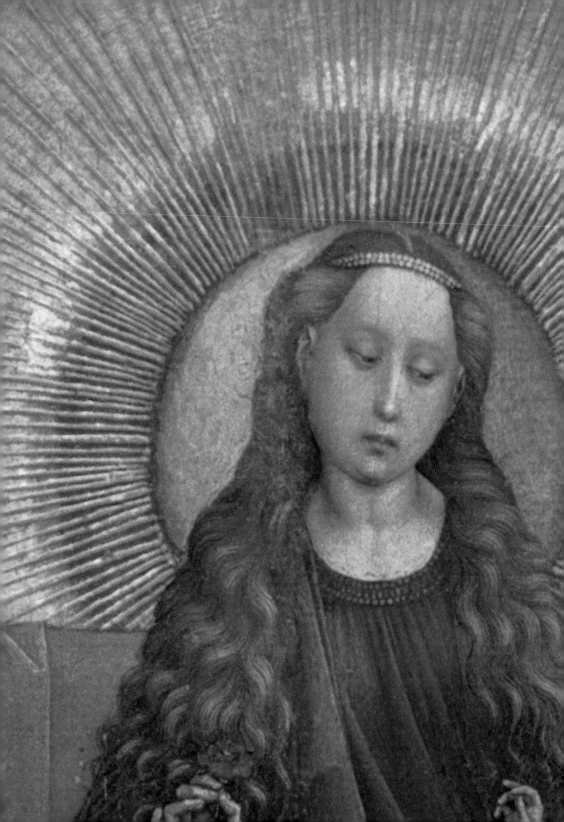

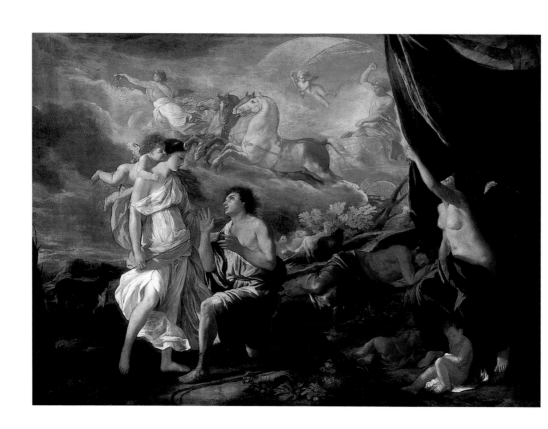

●●

Diana and Endymion

Nicolas Poussin (1594-1665)

c. 1630. Oil on canvas, 121 x 168 cm. Detroit Institute of Art, Detroit.

The curtain opens, and nightfall sets the world free. Men on earth are still sleeping when Apollo, in his chariot, sets his horses bounding up towards the sky. Earth prepares to greet the sun. This is the moment when Diana, the virgin goddess of the moon, disappears, withdrawing in the face of Aurora, the goddess of the dawn. But Diana lingers on – the beauty with the moon-shaped crown cannot bring herself to leave. A little cupid on her shoulder whispers something in her ear. He is urging her to stay. And so the chaste goddess stops in her tracks. She, who pitilessly unearths the smallest of her prey and targets with her rays those who dare to abuse the favours of the night, now gazes with infinite gentleness on the face of a simple shepherd. Diana, the untouchable, has allowed herself to fall in love.

She gently touches the shoulder of the young man who kneels at her feet. He gazes at her, not quite believing it; he lifts his hand, the outline of an impossible caress. The imperious soft light of the moon has taken possession of him. How could one ever long for the light of day?

The moment stretches into eternity. Is it possible that they could deny the advance of time, and prolong this night indefinitely, until the huntress's passion is sated and exhausted? The animals in the background stamp their feet – their shepherd is neglecting his duty. They can feel the rising warmth of the early morning. Diana's black dog is impatient too, awaiting the signal of departure. But the sun already illuminates the scene: Apollo, the god of light, will not wait. The goddess is only half leaving: even if she finally abandons Endymion, the shepherd will not notice her absence, as he will be plunged into an eternal sleep. His eyes will never see any light other than hers, and each night will be enchanted by her unchanging beauty.

Thus Poussin captures an impossible moment, when nature's immutable laws seem to go into reverse, and escape the inevitable passage of time. He paints one of those moments where everything seems to pause. For the ancients, the natural world was alive with stories and words, with hidden destinies and secret presences. The stories of mythology gave them names and faces, and the artist gives them their bodies and their reality, transforming their hidden world into a concrete existence. Diana and the shepherd are separated again at each uncertain dawn. And so, each morning, as the sun tries unsuccessfully to drive away the obstinate moon, the besotted goddess cannot tear herself away from the beauty that has captivated her.

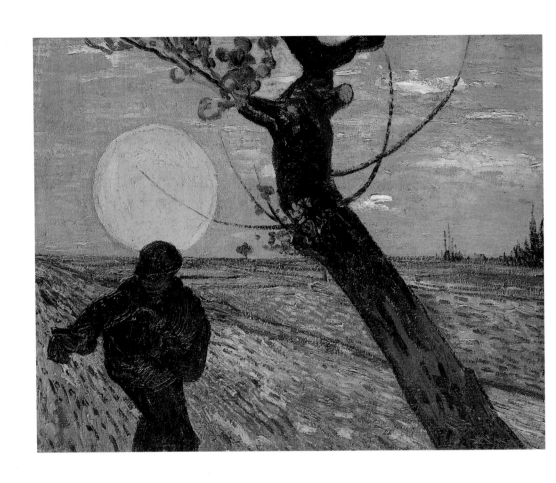

● ● ●

The Sower

Vincent Van Gogh (1853–90)

1888. Oil on canvas, 32 x 40 cm. Van Gogh Museum, Vincent Van Gogh Foundation, Amsterdam.

.

.

.

The sun rolls along the horizon. Behind the dark figure of the sower, the day appears to pause. The heavy yellow paint seems to slow down the advance of time. Nature falls into step with the rhythm of the man's actions. The heaviness of the earth halts his progress.

It is a simple landscape, a large triangle drawn out to allow space for the river. A sturdy tree trunk cuts through the picture, its curved and pointed branches bearing a few blossoms that extend over the frame. They are too high up for the man to consider looking at them. He probably does not even see the tree itself, which seems to have been transplanted straight from a Japanese print into the middle of his field. The painter may choose his references from wherever he likes, it makes no difference to the sower whether the tree bends towards him as he passes, or slices the picture in two. Indeed, he might find himself a little less lonely beside the bark which so resembles him. He is separated from the rest of his world. The house in the distance looks so small: he didn't realize he had gone so far. The sack on his shoulder is still heavy but he must go on.

Each brushstroke churns up the thick soil and the grains fall onto the wet paint. Exhaustion gradually leaves its imprint on the lumps of ochre and black. The sower is a part of the field he works in, they are made of the same material. The earth wipes out his features and comes off on his face, which is formed from a lump of clay. With his chin drawn in, his back bent, he is gathered within himself, sheltered by his cap. He is ageless, or perhaps has simply forgotten his age. His whole silhouette has been shaped by the centuries, and his hand, with its twisted fingers, knows no gesture other than sowing – it has become bowl-shaped. It looks as though it alone could work the whole painting – with one powerful gesture wipe away the earth and leave the canvas bare. The painter would not be surprised by this, and would like to hold this approaching hand in his. The sower does not stop.

The sky reflects the colour of the future crop. There is a sort of promise in the increasing intensity of the green on the other side of the tree. The sun waits for the man to doggedly reach the end of his working day. Van Gogh gives him no choice: the parable must not lie, he must not work in vain, the grain must not be wasted. The sky bows down before the faith of the artist who has read and re-read his Bible. The sun in all its glory sinks at the back of the painting. The sower bows his head, not realizing that the twilight has drawn a halo around him.

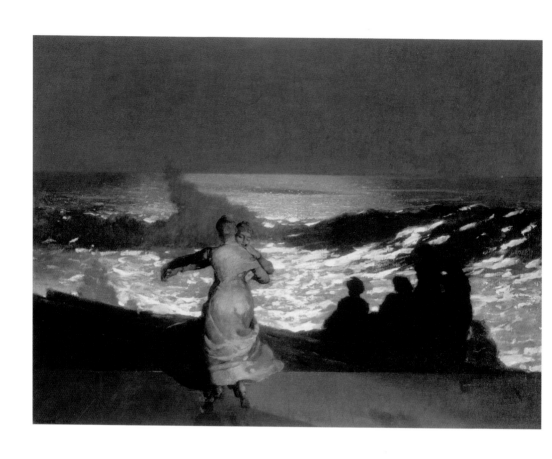

●●●●

Summer Night

Winslow Homer (1836–1910)
1890. Oil on canvas, 74.9 x 101 cm. Musée d'Orsay, Paris.

There is a warm breeze. An invisible moon lights up the coastline from afar, transforming the night. It is an intoxicating moment. The people sitting, lost in reverie, are no more than silhouettes. Are they men or women? On closer inspection it seems that they are all women. The picture captures the fleeting moment when women dream. Despite their neatly pinned-up hair and their high-necked dresses, these respectably dressed ladies seem to be transfixed and moved by a strange kind of energy. They are intoxicated by the moon, which controls tides and seasons, and produces this chilling luminosity.

It began as nothing more than an evening stroll – it was too bright a night to go home so early. And now they are alone. But where are their companions? The artist has created an imagined scene, but these are neither goddesses nor nymphs, nor ghosts or apparitions. They are simply women, neatly turned out in the fashions of the time. Where else, other than here in this painting, could they lose their heads in this way? Not for long, of course, just enough time for a few dance steps, one movement, followed by another. The heat of this extraordinary night brushes against their skin.

The artist's hand seems to caress the painting. The white splashes sparkle and disappear on the rocks. The terrace forms a sort of stage that flattens the edge of the canvas. Between the grey stretches of beach and sky, the silver light mingles with the foam.

The two women are set apart from the others, not happy, as on other days, to simply gaze at the astonishing beauty of the night – this time they completely surrender themselves to its seductive charm. Their dreams have come together. They could quietly dance away from the picture, on the tips of their toes. They could let themselves be carried away and the others would know nothing about it – maybe they are already out of their sight. They whirl and whirl, their dresses too light to slow them down.

The artist plays with light and shade, with silhouettes and large empty spaces. He keeps them under control – the figures can spin without leaving a trace, practising their own disappearance. The creamy density of the colour allows us to feel we can almost touch the night. The restraint of the greys and whites allows only silence. The music they hear comes from deep within themselves, made audible simply by this chance ray of moonlight. In the morning all will be forgotten. All that will remain is the faintest echo.

Day and night
●

According to the Book of Genesis 'God divided light from darkness' on the first day, and created the sun and the moon on the fourth, and then the stars. There is an essential difference between primordial uncreated light and what man can physically see thanks to the stars. 'God said, "Let there be lights in the vault of heaven to divide day from night, and let them indicate festivals, days and years. Let there be lights in the vault of heaven to shine on the earth." And so it was. God made the two great lights: the greater light to govern the day, the smaller light to govern the night, and the stars.' (Genesis, 1, 14-16)

The natural succession of day and night disappears in medieval crucifixion scenes in which both sun and moon are arranged on either side of the cross. Bringing them together like this is a relic of pagan imagery, as well as being an allusion to the darkness which fell at Christ's death, according to the Gospels. It also recalls the system of parallels drawn up by the elders of the Church between the Old and the New Testaments: thus for Saint Augustine (354-430) the one could only be explained by the other, just as the light of the moon could not exist without that of the sun.

The vital power of the sun
●

The sun, a source of light and heat, is above all a symbol of life itself in all civilizations. The strength of its rays makes it the perfect image of power and authority, and therefore equated to the greatness of God. In the first centuries of our era, Helios (the sun) was the most powerful of all the objects of worship in the Roman world. In the fourth century, the Christian Church assimilated this cult by fixing the date of the birth of Jesus at the winter solstice, on 25 December, the moment when the sun begins its rise towards spring. This *Sol Invictus* (invincible sun) represents victory over night, the triumph of life over death: it is the name sometimes given to Christ himself, as is the name *Sol Justitiae* (sun of justice); in this case the twelve apostles are compared to twelve rays of the sun. Therefore it is not surprising that the sun is one of the attributes of Truth, as described by Cesare Ripa (1550/1560-1622) in his *Iconologia* (1593) in which he draws up a standard list of symbolic figures: 'She holds the sun in her raised right hand . . . to demonstrate that truth is the friend of light. She is light itself, showing what is.' Gold, the unchangeable metal, representing both light and matter, was used in the Middle Ages to decorate the background of religious paintings, bringing together all of these themes, as well as symbolising divine perfection.

The gentle fertility of the moon
●

The moon, reflecting the light of the sun, emanates a softer light: it is therefore regarded as the symbol of reflected knowledge, adaptation and renewal. Lunar cycles connect it to the physiology of women, whose fertility it supposedly controls - this explains why the moon was the most common attribute of female divinities in antiquity. The planetary symbolism of the pagan world was adapted and incorporated by the early Christian thinkers in the first centuries after Christ; it survives with the connection established between the nourishing moon bathing the earth with its rays - the Greeks referred to dew as 'moon water' - and the Church, intermediary between Christ and his followers. In the Middle Ages, the Virgin Mary, after gradually becoming a part of the image of the Church, notably through the work of Saint Ambrose (339-397), was endowed with her own lunar symbolism in deference to her role as a mediator: on becoming the mother of Jesus, she, like the moon, directed the rays of divine grace (the sun) towards humanity.

Diana and Apollo

Diana, one of the twelve Olympian gods, twin sister of Apollo, with whom she shares the sky, represents the moon. Like the Greek goddess Artemis, she takes the form of a proud and chaste huntress with a formidable temper. Accompanied by a dog or a deer, she travels through the mountains armed with a shield which protects her from the arrows of Love. Her passion for the beautiful Endymion is an uncharacteristic episode in her story – originally it was that of the Roman goddess Selene, the sister of Helios, the sun: she fell in love with the shepherd, and came to visit him each night, as Zeus had frozen him in eternal youth. Diana, who had absorbed the image of Luna, a minor goddess without a legend of her own, borrowed Selene's story, as well as the crescent moon which adorns her head.

Like his sister, Apollo is regarded as a god of youth. Identified with the sun, the radiant Apollo crosses the sky each day driving a golden four horse chariot, each of his arrows is a ray of light. In ancient Greece he personified civilization and the spirit, and, reigning over the Muses with whom he lived on Mount Olympus, he both inspired and protected the arts.

The crescent moon

In the Bible's long poem of love, the Song of Songs, we can read the bridegroom's praise of the bride: 'Who is this arising like the dawn, fair as the moon, resplendent as the sun, terrible as an army with banners?' (Song of Songs, 6, 10). The Fathers of the Church interpreted the loved one as the figure of the Church and the Virgin Mary. The different elements of the text provide us with a full iconography of symbols pertaining to the Virgin Mary. The crescent moon, already a symbol of chastity in the ancient world, where it is one of the attributes of the goddess Diana, is now quite naturally associated with the image of the Virgin. It becomes one of the most consistent symbols of the Immaculate Conception, spelled out by the painter and theorist Francisco Pacheco (1564-1654) in 1649 in The Art of Painting, whose ideas were partly based on the Book of Revelation. 'Now a great sign appeared in heaven: a woman, adorned with the sun, standing on the moon, and with the twelve stars on her head for a crown.' (Revelation, 12, 1). The Christian victory over the Turks at the battle of Lepanto in 1571 has led to some confusion, whether intentional or not, between this crescent moon and the 'Turkish crescent' – the emblem of Islam – ground beneath the feet of the Church Triumphant.

The moon of dreams

The changing shape of the moon caused it to become one of the traditional symbols of inconstancy, its successive quarters suggesting varying and capricious moods. The early Church often contrasted it with the sun, the symbol of divine light, as incarnating its diabolical and impermanent opposite. Its transitory image, as it journeys towards fullness, suggests the passages of birth and death. The moon accompanies the wanderings of dreams, allowing suppressed instincts to flourish; it illuminates the depths of the unconscious and is connected to all kinds of beliefs and superstitions, in which its effects on human behaviour are seen as quasi-magical and always unsettling; hence the disparaging use of the word 'lunatic' to describe an unstable character. In that sense, moonlight was a particularly appropriate image in symbolist painting of end of the nineteenth century, which sought to represent images of the strange, the dreamlike and the irrational.

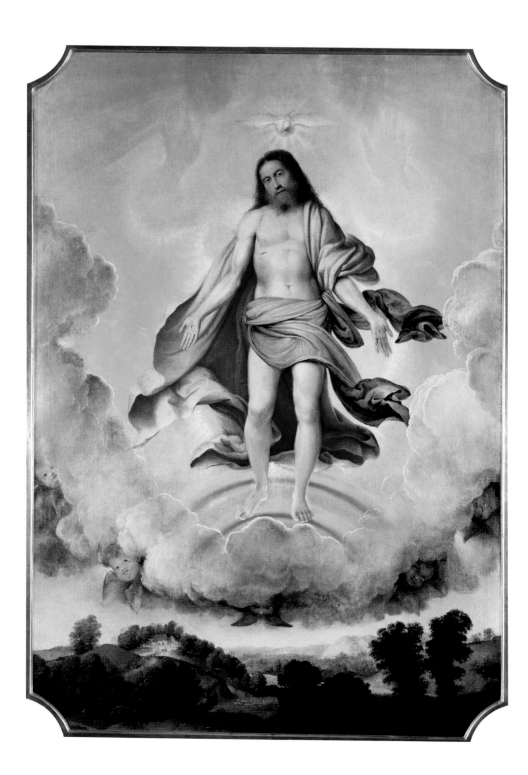

The cloud

.
.
.
.
.
.
.

●

The Trinity

Lorenzo Lotto (1480-1556)
c. 1517. Oil on canvas, 170 x 115 cm. Diocesan Museum, Bergamo.

.
.

.

Encased by clouds, Christ stands on a rainbow and gazes at us with a thoughtful expression. His agony and His death on the cross are long gone and the wounds hardly visible any more. The stigmata are thin scars of a past that no longer causes suffering. But every detail of the story must remain visible: the nails driven through hands and feet, the spear in His ribs and the spilled blood. He stands there, hands outstretched, continuing to walk, but not advancing. He is immobile in the centre of the painting, but still travelling on his way. That was the past, this is the present, and what has happened has enriched all eternity.

All around, the clouds form a rounded and symmetrical backdrop. Blue and pink cherubs with rounded cheeks emerge from the thick mist as though they have just been born. A few heavier clouds provide them with substance, hardly more dense than the vapours that float between heaven and earth.

Beneath the dove which symbolizes the Holy Ghost, there floats a large greyish shape, a suspended shadow of Jesus: It seems like a mirage, about to vanish into the immensity of the sky.

Christ, the incarnation of the Word, is by definition the visible image of the Creator. The artists of the Middle Ages often represented God the Father in the shape of Jesus. But Lotto avoids the subterfuge and the mirror image. He wants to suggest a divine presence, respecting the principle of its fundamental mystery and invisibility. This move away from iconographic conventions produces an image that is just an allusion. Thus the spectator comes close to the figure of the God the Father, but is only able to guess at it through the physical reality of the

Son, not as an identical figure, but as an inaccessible reality. Our view of it will always be an indirect one. In Lotto's glorious cloudscape, God takes a transitory human shape, placing himself in sight, but revealing nothing of his true nature.

Between the Father whose hands are raised as if in prayer, and the Son with his palms lowered, the artist has left an empty space where one might imagine a cross to be, tucked into a last gap in the sky: the clouds allow all sorts of possibilities, creating illusions on demand.

In the tiny landscape at the bottom of the painting, Lotto has scattered houses in the hollow of a small wood, and he has illuminated the hills, the grazing herds of sheep, and the distant valleys which disappear into a turquoise haze, with trees hiding the paths. The dimmed horizon dissolves into the mist which rises up, blurring the sides of the mountains. The peasants peering at the sky are perhaps wondering about the prospects for their crops. There is no knowing whether it holds any other kind of mystery for them, or if they experiencing the faintest spark of revelation. How could they guess what is hidden up in those clouds?

The precarious innocence of this earthly existence, which at first appears of minor importance, becomes precious. As the spectator draws closer to inspect these shades of detail they feel a kind of tenderness towards it, finding, as they inspect its grassy folds, that they forget, for a moment, the skies and the angels above.

The robes which tumble around the Christ figure reflect the duality of His nature: red like flesh and blood, blue like the heavens above. He is both substance and symbol, the object and the written word. The wind that blows around Him is stronger than any that blows on earth and does not affect the trees or the men. Nature remains ignorant of the fact that the gentle breeze that rustles in the tops of the trees comes from a breath more ancient than time, one which has provided her with everything, right down to the shadow of the smallest blade of grass. And so the painting superimposes two skies, distinguishing between the one we see, and the one we hope for. And Christ stands at the junction of the two worlds, in that nameless and invisible space in which the human gaze turns away from the beauty of the world, towards that nebulous frontier at which the spirit is detached from matter.

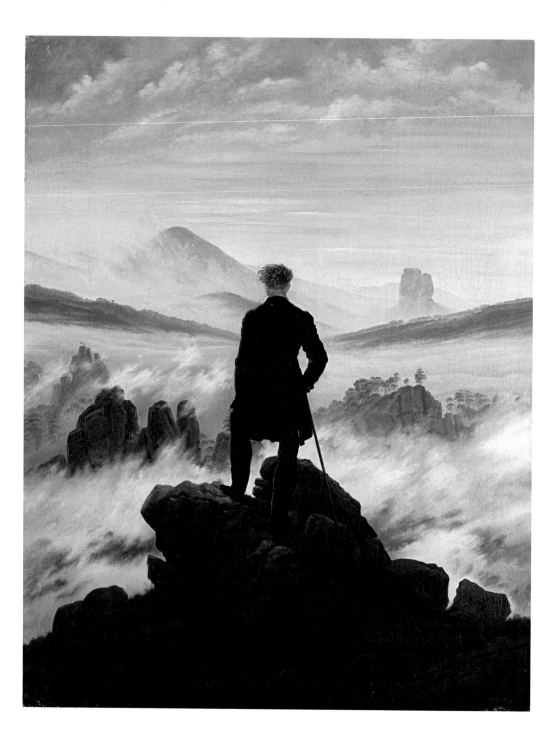

● ● ●

Wanderer Above the Sea of Fog

Caspar David Friedrich (1774-1840)

c. 1818. Oil on wood, 74.8 x 94.8 cm. Kunsthalle, Hamburg.

.

.

.

The man stands with his back to us at the summit of a rock. He is so high up that the landscape before him has disappeared beneath the clouds. He has arrived at a place which has nothing in common with any other destination, at a point where all the mountain peaks converge, the centre of everything.

With his long stick planted in the stone, he places his leg forward with all the elegance of a society gentleman. There is no real ostentation in his pose, but nonetheless one recognizes in it an echo of some great act of prowess, a sense of having achieved something. A big game hunter would strike the same pose, or a David who has just conquered Goliath, as sculpted by the masters of the Renaissance, perhaps with the bloody head of the giant lying at his feet. It's the pose of a hero, a biblical king, a leader of men. This rocky promontory offers him infinity. He is the figurehead on the bow of an invisible ship. And the spectator is invited to share with him the perfection of this unique moment, achieved after a long and perilous climb. Because, even though there may not be any other conquests, the man in his frock coat must at least have climbed this mountain to reach the great height that could offer him this vast panorama.

The image is seductive, but it borders on the absurd. What man dressed in this way would climb these heights? The artist has, admittedly, allowed a little disorder to enter the fray: a few stray hairs blowing in the wind. But these indicate nothing more than a certain romantic energy, the controlled enthusiasm of somebody who observes conventions – his hair may blow in the wind, but his steady hand is at the helm and order prevails.

The clouds that hide the earth simplify everything and conceal the deep precipices. All the details of the landscape have disappeared, and the world is a great distance away: he observes it from afar. He sees it, or imagines it, as a harmonious space which has been broken up by a few unfortunate accidents, the failings and shortcomings of history. The rocky outcrops which appear here and there remind us that below wars rage and obstacles rear up in the face of freedom and flourishing ideals.

Friederich's wanderer seems to be pondering what it is that separates him from complete fulfilment. But he has chosen a different outlook on life for himself, a proud solitude which sets him above the mediocrity of everyday life. Here he is wonderfully free, at the height of fulfilment, thanks to the power of a simple landscape bathed in clouds.

The cloud as a symbol of divine presence
●

In the Bible a cloud is the symbol of the proximity of God. It guides and protects the Hebrews during their walk through the desert. It is an ambivalent symbol as it can simultaneously display and conceal, confirming the presence of one whose voice can be heard but who cannot be seen. The moving shapes of clouds are a reminder that God can neither be held in one place nor controlled.

'And the Lord went before them, by day in the form of a pillar of cloud to show them the way, and by night in the form of a pillar of fire to give them light.' (Exodus, 13, 21)

'Then the angel of God, who marched at the front of the army of Israel, changed station and moved to the rear. The pillar of cloud changed station from the front to the rear of them, and remained there. It came between the camp of the Egyptians and the camp of Israel. The cloud was dark, and the night passed without the armies drawing any closer the whole night long.' (Exodus, 14, 19-20)

'And the Lord said to Moses, "I am coming to you in a dense cloud so that the people may hear when I speak to you and may trust you always".' (Exodus, 19, 9)

The cloud as revelation
●

Some passages of the Gospels and Revelation contain images of clouds as a kind of sublimation of space, increasing its light. Jesus is transfigured 'on a high mountain' in the presence of Peter, James and John, 'when suddenly a bright cloud covered them with shadow, and from the cloud there came a voice which said, "This is my Son, the Beloved; he enjoys my favour. Listen to him."' (Matthew, 17, 5)

Jesus's announcement of the end of the world takes up the same theme, which can also be found in the visionary descriptions of the Book of Revelation: 'then too all the people of the earth will beat their breasts; and they will see the Son of Man coming on the clouds of heaven with power and great glory.' (Matthew, 24, 30)

'Now in my vision I saw a white cloud and, sitting on it, one like a son of man' (Revelation, 14, 14)

The cloud as artifice
●

Representations of clouds in the paintings of the Middle Ages or the Renaissance are often completely unrealistic. This is because they are used more as theatrical devices than representations of nature, and their task is mainly to be a reminder of the reality of the rites and liturgy of the time. From the sixteenth century onwards painted clouds became less like solid theatrical backdrops and more realistic: from then on the supernatural qualities of the event depicted or the divinity of the figures would be represented by subtle nuances of the atmosphere. At the time of the Counter-Reformation, painting became more pedagogic, emphasizing the flashing visions, the miraculous intimacy between man and God, the saints and the angels, and to do this it increased its use of clouds: the image of the cloud, since it represented a kind of frontier between heaven and earth, could symbolize both the separation between two worlds and the link between them. Whether in the form of a simple fluffy crown or as a vast extent of light and dark, a cloud was the archetypal image of the mystical experience.

The Legend of Orion
●

According to Greek legend, Orion was a giant hunter of great beauty and prodigious strength, who had been blinded by King Oenopion, whose daughter he had lusted after. He had then taken Cedalion, one of the helpers of the god Hephaistos (Vulcan), to be his guide on his road to the east: an oracle had told him that the rising sun could cure him. When he regained his sight, Aurora, goddess of the dawn, fell in love with him and kidnapped him.

The circumstances of his death are ambiguous, but the most widely accepted story is that it was a punishment by the goddess Artemis (Diana) whom he had offended, and possibly attempted to rape. She had him stung by a scorpion, which was then rewarded by being transformed into a constellation. In Poussin's version, the giant who had 'three fathers, Jupiter, Apollo and Neptune, symbols of air, heat and sun and rain' was himself 'a kind of living cloud'. The painting can thus be interpreted as an allegory of the circulation of water in nature, beginning with the cloud arising close to Orion and then returning to earth in the form of rain after having touched the moon.

The rainbow as a symbol
●

Like the cloud, the rainbow has a similar role in both mythology and the Bible. Whilst a cloud indicates a divine presence both in the Judaeo-Christian sky and on Mount Olympus, the rainbow, in both those contexts, represents a bridge between sky and earth. After the Flood, God shows his forgiveness by making one appear: 'I set my bow in the clouds and it shall be a sign of the Covenant between me and the earth. When I gather the clouds over the earth and the bow appears in the clouds, I will recall the Covenant between myself and you and every living creature of every kind. And so the waters shall never again become a flood to destroy all things of flesh. When the bow is in the clouds I shall see it and call to mind the lasting Covenant between God and every living creature of every kind that is found on earth.' (Genesis, 9, 13-16). In mythology, Iris, the messenger of the gods, appears as a rainbow, dressed in light coloured veils. According to *The Dream of Philomath* written by Felibien in 1683, Painting, jealous of Poetry, who had been created by Apollo, declares that she is the daughter of Jupiter, and born to paint the whole world: the rainbow is her palette.

The romantic cloud
●

When Goethe (1749-1832) wrote in 1823: 'I am now going to study the atmosphere', he was demonstrating an interest in science, which would be shared by those interested in aesthetics throughout the nineteenth century. Clouds became a significant novelty in European landscape painting, both in artists' sketches, and, increasingly, in their finished works. Whilst their more or less shapeless mass had in the past been no more than a detail within a larger composition, they now played an increasingly prominent role. The English critic John Ruskin (1819-1900), a fervent admirer of William Turner (1775-1851) took the view in the middle of the century that painting at that time was 'in the service of clouds'. The cloud, a favoured image of the sublime, like the sea with which it was frequently associated – hence a sea of clouds – symbolizes both the infinity of nature and all the facets of heightened awareness.

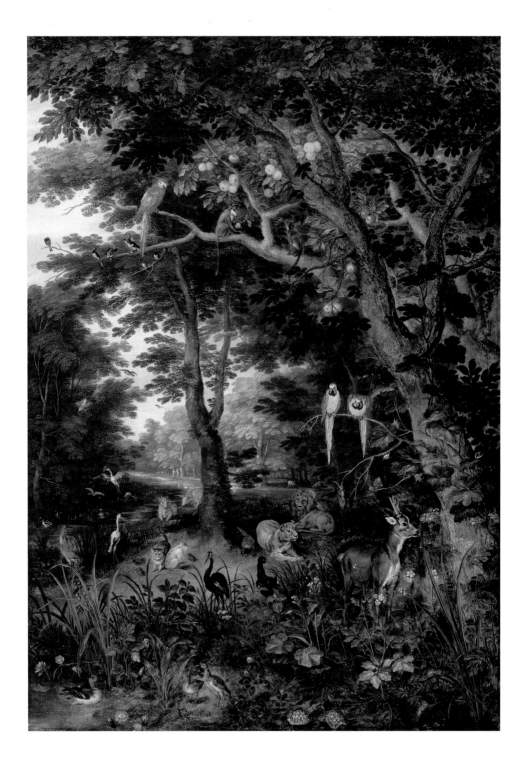

The tree

Paradise

Jan Brueghel the Younger (1601-78)
c. 1620. Oil on wood, 59 x 42 cm. Nationalgalerie, Berlin.

The trees have taken over the sky. Their foliage flows over the edge of the painting, which is unable to contain such profusion. It is filled with such density and generosity that one can become tangled up in the details and gladly get lost inside them. Perhaps there is no possible path through them, nothing to find: man is absent from the picture and geometry has not yet been invented. Nature simply proliferates with nothing to stand in the way of its vitality. Paradise is not yet subject to reason.

The animals do not yet know that they are wild. Weak and deceptive, lazy or bold – their roles have not yet been allocated. The world just exists without knowing why, without virtue, since there is no evil either. The only ones who seem to be on the outside are the parrots and the monkeys who gaze down from on high, although they are probably no better informed for all that.

With impeccable precision the artist has gathered everything he knows about this earth into his painting. He has borrowed here, there and everywhere, and placed opposites together: the lion and the gazelle; the duck and the cat; the birds and the tortoises; shade from the branches and full sunlight; the wet and the dry; the minute and the gigantic. The freshest green leaves grow alongside dark, almost black, foliage. All are equally innocent. He imagines a primeval landscape, a world that he has reassembled from the long-disintegrated one that we know. With the use of light between etched lines, such a subject shows the essential business of painting: examining, exploring, interrogating. The picture is a dream about completeness, and the restoration of lost integrity.

Through the artist's piercing gaze one is made aware of the glory of nature, which is rendered in the traditional Flemish style, with an eye for the smallest detail. The painting works through its documentary precision, and this accuracy is vital, as much for the sake of realism as out of respect for the sacred. It is crucial to be able to believe in a perfect harmony that is at the same time completely viable and life-like; one is transported to a new space, a place outside time, but in which every blade of grass is identifiable. One is simultaneously out of place and very much at home, buried in colour but able to breathe freely.

The packed spaces of the painting are reminiscent of the tapestries of the Middle Ages: they too saved you from the fear of emptiness, covering the cold stone walls, warming the eye and the body with realistic landscapes against which beautiful stories could peacefully unfold. In this tiny painting, just as on the great hangings, the world is a throbbing and vibrant place. Here and there a strident note breaks into the emerald silence: touches of red, yellow or blue on the parrots' feathers make the eye more alert; the multi-coloured birds enliven the painting.

A great tree, the branches of which form the parrots' perch, lends stability to the scene, acting as the curtain in a theatre, framing the performance. It lends dignity to nature's high spirits, and perhaps a certain mystery as well: over on the right another unknown world behind the scenes is hinted at. A bright forest in the distance draws the eye towards it. History has yet to begin, but the march forward will become inevitable. After passing the second, more slender tree in the centre, man will continue and proceed to travel beyond familiar terrain.

Trees of knowledge, trees of life, as they were called in the Bible, Breughel's trees of Paradise are examples of the power of the architecture of nature that would later be imitated in the pillars of temples. They give structure and shape to the crazy profusion of the Garden of Eden, and a landscape that did not contain that sort of rectitude would be in some way complicit with the chaos of its origins. Like monumental signposts, they are scattered throughout the as yet unformed earth, gently measuring out how much there is still to discover. Man, when he eventually appears, will see them as milestones for the journey that awaits him. He will also read the story written in their bark, and perhaps get a sense of infinity from the high branches as they brush against the clouds.

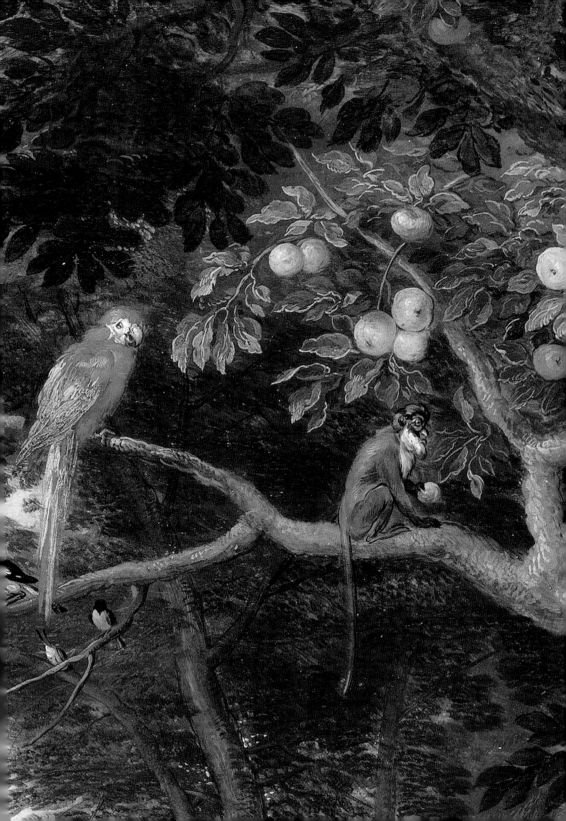

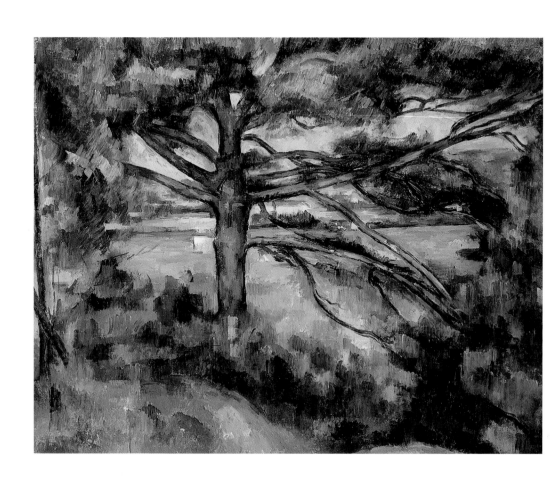

Great Pine near Aix

Paul Cézanne (1839-1906)
1890-95. Oil on canvas, 72 x 91 cm. Hermitage, Saint Petersburg.

The tree owns the canvas; it seems to be advancing towards the spectator, grabbing them. Everything in the vast landscape surrounding it is subordinate to the great pine tree. The painting is the place where this is recognized, the proof of an acknowledged sovereignty.

In past centuries a series of choices would lead an artist to reorganize the imperfections of nature in a carefully considered composition: the course of a river or the curve of a hill could be modified, heavy shadows or harsh deserts could be softened. This re-balancing made for an impossible world – it was a time of images in which reason never hesitated to override the uncertainties of everyday experience.

Cézanne does not make such categorical decisions, he waits, and hesitates: the world seems to tremble beneath his brush, the leaves hidden behind sliding green brushstrokes. Multitudes of different greens seem to cross over one another, and then melt together to produce the colour of a leaf – but which one? We feel that we should be able to see and identify each individual leaf, but the artist does not agree. His eye moves through the thickness of matter, taking no notice of received wisdom. He is determined to see things accurately, and so appearances dissolve, and definitions disappear, returning to the words and books from which they came.

The only thing that resists, and does not weaken before his stare, is this tree. The great pine stands before the red fields, dividing them like a cross. The strength of the trunk is reassuring to those who have felt the world falter – it is a certainty. The artist may have put his trust in it, but he has had trouble painting it all the same. Its obstinate contours, interrupted and reworked, demonstrate the difficulty he had in producing the silhouette. Nature, painted by Cézanne, is harsh and silent as though in the aftermath of a battle. A battle that, here at least, has been won by the tree.

Everything else, lacking in substance and energy, has gradually withdrawn: the bushes, the woods, the smallest branches have all become pointless distractions. The picture does not need them. Geometry has removed all narrative, and the tree is here at the start of the world.

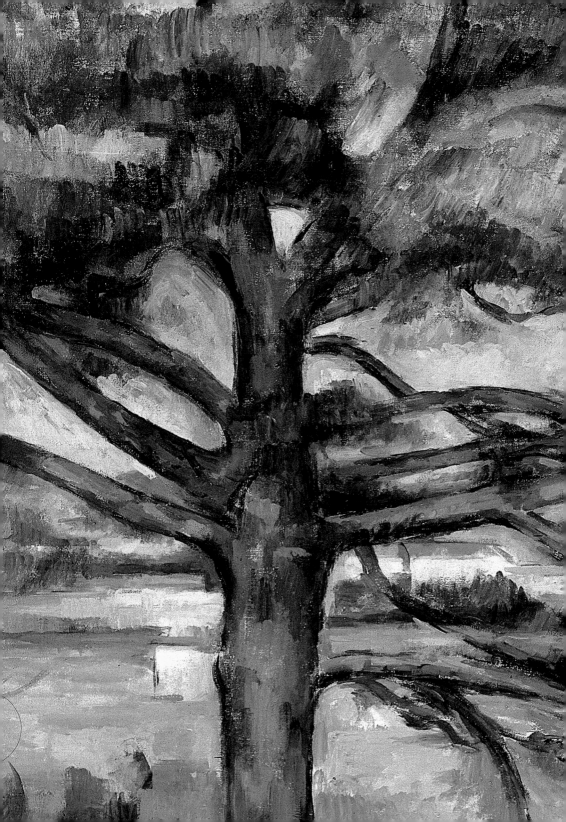

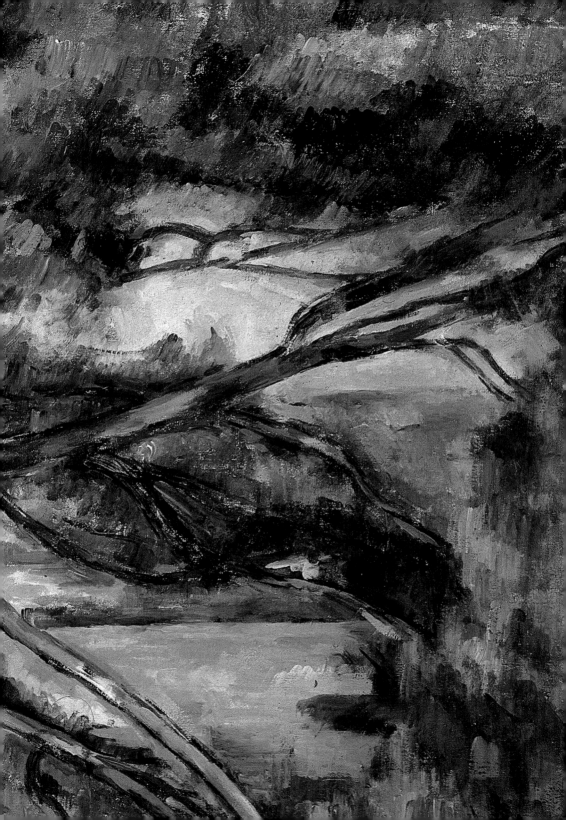

• • •

Untitled (Woodcutter)

Baselitz (Georg Kern) (1938)
1969. Charcoal and resin on canvas, 250 x 200 cm. The Art Institute, Chicago.

.

.

.

Bloodless bodies float horizontally across a tree trunk like the detached blades of a saw. Cut through the centre, into pieces, bodies in green overalls, the colour of moss and mildew.

One head but two bodies: possibly the same man in two parts. Here he is with arms, but no elbows, there with his two legs, or possibly just the trouser legs. The braces stand up by themselves, stiff in the empty space where the shoulders should be. No feet – the man's dissected story ends there. But there are footsteps visible close by: his or those of his executioner. Is there any difference between them?

He lost his life due to the simple action of the saw, to and fro, cutting through the thickness of the wood and eventually splitting the tree. Man is not at a level with the leaves or roots. The woodcutter did not need to know anything, he simply banged and chopped, hit and knocked down. But the tree, now reduced to a trunk, has taken his life. The stump is drying out, the leaves are rotting on the ground. There was no chance of any branches or the flowers they bore appearing in this painting.

The green has congealed, the clothes have gone back to nature. This is no longer a time for fairytales, and the charming magic which used to provide happy endings has stopped mid-story, forever paralysed. The woodcutter will not turn into a tree, but is condemned to eternal dissection.

What has happened allows for no possible future. The headless man's penis is erect but for no purpose. The other man, who is perhaps still capable of a thought or an idea, holds his to his ear, as though listening to the flow of his own blood, in the way children listen to the sound of the sea in a shell. His left hand covers the piercing, painful gap.

A young tree-trunk rears up in the background, its growth halted by the dead legs: it becomes a crutch for them. There is no horizon, no distance in this painting, just the end of the grey barren earth, a sort of nothingness.

.

.

.

The natural tree and the symbolic tree
●

In the story of the Creation, the Bible distinguishes between the nutritious trees, there to satisfy the needs of man, and the two trees of life and knowledge, which grow in the Garden of Eden: 'God said, "Let the earth produce vegetation: seed-bearing plants, and fruit trees bearing fruit with their seed inside, on the earth." And so it was. The earth produced vegetation: plants bearing seed in their several kinds, and trees bearing fruit with their seed inside in their several kinds.' (Genesis, 1, 11-12). 'The Lord God planted a garden in Eden which is in the east, and there he put the man he had fashioned. The Lord God caused to spring up from the soil every kind of tree, enticing to look at and good to eat, with the tree of life and the tree of the knowledge of good and evil in the middle of the garden.' (Genesis, 2, 8-9). As well as acting as the precise illustration of a religious subject, such as a representation of original sin, the tree in painting often represents the ambivalence between nature and symbolism. A simple landscape can therefore hold a deeper meaning that goes beyond the plain depiction of nature.

The tree and knowledge
●

The tree of knowledge of good and evil, of which Adam and Eve ate the fruit, is probably the most potent symbol of all duality and strife. It is interesting to note that, in Genesis, it is not given a precise location. We are not told where it stands inside the Garden of Eden. In this sense it already demonstrates the confusion and disarray of man once he is able to acquire knowledge: what he knows makes him conscious of what he does not know, and he is at once plunged into a world without guidelines. By its very structure the tree illustrates the idea of knowledge and the progression towards clarity of thought: 'The tree seems to think twice over, by gathering together the food in its thousand roots, and by giving it out through its branches - arborescence is a wonderful teaching method!' (Gaston Bachelard)

The tree as symbol of life
●

In almost every civilization the tree represents life force and seasonal renewal. It links three worlds - subterranean, terrestrial and aerial - and therefore demonstrates the fundamental unity of nature. Through the image of beginnings in its roots and the urge to ascend through its branches it symbolizes the presence of the living in this world. It can thus be a model of human perfection: both matter and spirit, coming from the ground, but reaching beyond itself towards celestial light. In the Bible the tree of life, in the centre of the Garden of Eden, is the axis on which the world turns. It represents the immortality of which man has deprived himself by disobeying his creator. 'Then the Lord God said, "See, the man has become like one of us with his knowledge of good and evil. He must not be allowed to stretch his hand out and pick from the tree of life also, and eat some and live for ever."' (Genesis, 3, 22). The tree of life, an inseparable part of the lost Paradise, can only reappear at the end of time, at the centre of celestial Jerusalem. 'On either side of the river were the trees of life, which bear twelve crops of fruit in a year, one in each month, and the leaves of which are the cure for the pagans.' (Revelation, 22, 2)

The tree as symbol of the cross
●

The tree and the cross are traditionally linked as symbols. Indeed one legend has it that the cross on which Jesus died was cut from a tree that had grown over the tomb of Adam. The archangel Michael had given Seth a piece of the wood 'from the tree through which Adam had sinned, telling him that his father would be cured when the wood bore fruit. The branch grew into a great tree that survived until the time of Solomon.' The Queen of Sheba came to visit him and prophesied that 'the saviour of the world would be hung on that wood.' The King, afraid, buried it on the spot where the pond would later be beside which Christ cured the crippled man. It was from this place that it was taken to make the cross. Hidden under the ground after the death of Jesus, this cross was eventually discovered in Jerusalem by Helena, the mother of the Emperor Constantine in the fourth century AD. This account from the *Golden Legend* thus connects the site of the crucifixion to that of Adam's death, creating a correspondence between original sin and the redemption by the cross. It explains why Christ was sometimes depicted crucified on a tree. In secular works of art, the shape of the tree is often that of a cross, if not as a direct reference to the Crucifixion, at least as an allusion to the suffering of man confronted by death and filled with the hope of transcending it.

The tree and the woodcutter
●

In a religious context, a man represented cutting down a tree or sawing wood will always be somehow or other connected with the story of the cross and the suffering of Christ. He will be a participant in the story of the Redemption, one of the anonymous players, like the Roman soldiers who carried out their duty in ignorance of the Salvation. But since the tree is seen as a supremely noble object, it is hardly surprising that the woodcutter should be regarded as a threat, linked to the forces of evil. From medieval times, right up until the nineteenth century, he was the object of suspicion if not downright fear: his life deep in the forest associated him with more or less fantastical creatures such as the 'wild man of the woods'. A threatening, unkempt and savage creature, this cruel 'enemy of trees' was seen as a magician with superhuman strength, who cut, mutilated and burned up the wood. Armed with his axe, he was perceived both as a butcher and an executioner.

The nobility of the tree
●

The tree almost always carries with it a message of immortality, whether in the Bible or in mythology. It is associated with many different qualities, according to type: the oak stands for royalty and nobility; the olive tree for peace, victory and abundance; the cypress for the after-life; the cedar for the incorruptibility of matter; the fig for advanced science; the vine for eternal life. The pine belongs to the same tradition. At the time when Cezanne was celebrating the proud posture of that beautiful tree, Nietzsche (1844-1900) too paid special tribute to it in *Thus Spake Zarathustra* (1892): 'Nothing, O Zarathustra more beautiful grows on earth than a haughty and strong will: that is its finest achievement. In all landscapes there is only one tree of that sort. I compare you to the pine, O Zarathustra, which, like yourself, grows: tall, silent, hard, lonely, the best, most supple wood, splendid and at the end extending its strong branches towards its own empire, questioning the winds and storms and everything that dwells in the heavens.'

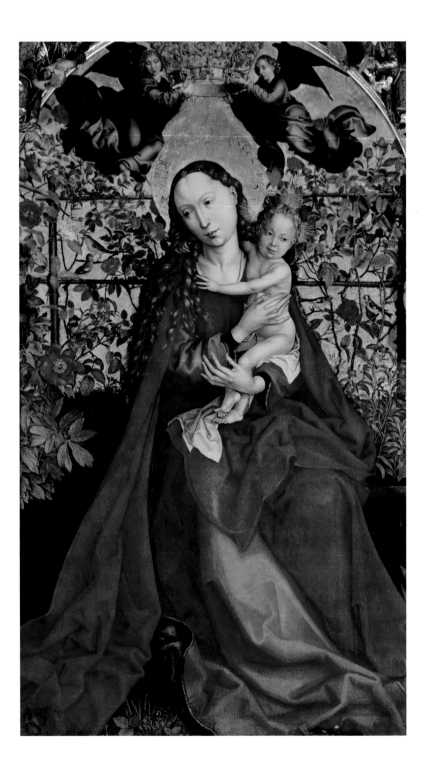

The flower

·
·
·
·
·
·

●

The Virgin of the Rose Bush

Martin Schongauer (1453-91)
1473. Tempera on wood, 201 x 115 cm. Church of Saint Martin, Colmar.

·
·

·

A pale rose has flowered. The Virgin Mary, draped in red, holds her child to her. The tiny angels who have come from far away pay homage to her with a precious crown that she seems to be unaware of. They hold it, suspended above her, as though she might not accept it. Heaven and eternity await her. But time is patient, and the roses have not yet faded. Each figure meditates within their own space, their mind elsewhere and their gaze distant. Mary is like a queen in her kingdom, enthroned in this gold-encrusted painting, but humble all the same – her palace is no more than a small garden. The branches of a rose bush creep up behind her halo and the folds of her robe trail on the ground amongst the tiny twigs. There are flowers concealed beneath the opacity of the skies.

Schongauer works like a goldsmith. His sharp strokes cut into the paint, creating the detailed forms. The two bodies seem almost weary. Mary wears a winter cloak, the fur lining revealed in a random fold, but the Child remains naked. She can neither wrap him in her cloak to warm him, nor protect him from what threatens him: the worshipper who gazes at the painting must recognize this, the infinitely vulnerable body of the Son of God. The Word has become flesh, flesh which can suffer from hunger and cold, unprotected against earthly suffering, as alive and fragile as the flowers which surround him.

The blue of the sky erupts into the painting in the shape of the flight of angels. They float gently, mimicking the clouds and the movement of the air. A pleasant breeze disrupts the stillness of the scene, and the whole painting seems to quiver at their passage. The Child may be listening to the song of the birds chirping in the hedge. We don't see these little birds at first: we have to almost listen for

them to distinguish their brown and pink plumage amongst the branches and the sharp thorns. The flowers are a kind of litany of the passage of time and the brevity of life: the first buds, the open petals, the beginnings of decay. Is that what Mary is seeing? The passing sweetness of scented air, beauty already condemned to die. The flowers tell the story of a life, from birth to death, always hurrying forward. And the birds are their witnesses.

Beside the red roses, a single pale flower, the colour of flesh: a delicate emblem for Mary. All in red herself, she too can meditate on human destiny. She has, for the moment, set aside the azure dress she normally wears, as though clothed by the sky itself. Peace is not possible outside this place inhabited by angels. The earth is fed by blood. The Child to whom she has given birth and holds in her arms is destined to be sacrificed. She knows this because it has always been written. She only needs to lower her eyes to see the proof of it, written on the smallest petal. The onlooker, too, will always be reminded of it, whenever they enters the most ordinary of gardens. Looking at the branches studded with thorns, they will remember that even the roses have lost their innocence and purity and that their beauty is no longer safe.

Gold glows around the Child. Jesus's blond curls shine like the sun. But it is a light that burns, forging the sharp points of a cross. The Passion of Christ is displayed all around him, and that future crown which will cut into his flesh.
The painting points towards the future. The white linen around the Child is already a shroud. The red roses are echoes of Mary's thoughts – she sees in them the bleeding body of her son, and her own heart which will always bleed, and the power of death, finally defeated. Her robe is that of a celestial empress, it is part of a power that cannot be shared. The worshipper who prays before this painting, in church, sees it flaming like a burning bush. The flowers are like the tongues of the flame, which nothing can extinguish.

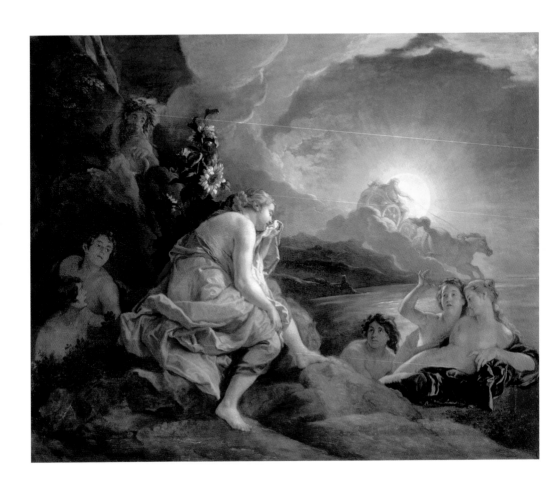

●●
Clytia Transformed into a Sunflower

Charles de La Fosse (1636-1716)
c. 1688. Oil on canvas, 131 x 159 cm. Grand Trianon, Versailles.

.
.
.

She has sunk into a deep sleep. Her body has become calm, and she is overcome by a torpor which numbs her pain. This day, now coming to an end, has deprived her of her lover: Apollo drives his chariot further and further away, gradually dissolving into the cool air. The setting sun is abandoning her. In the final rays she gives way to grief and gradually loses herself, her life ebbing away with the disappearance of the god that she adores. Her heart has been broken by the melancholy of the returning twilight.

The dwellers of woods and water gather around, moved by the sight of this mortal fatigue which is slowly killing her. These fauns and tritons can probably see what mere mortals cannot quite understand – they are accustomed to the strange twists and turns of destiny, and familiar with the unpredictability of the gods, as they watch for the always surprising results of their actions. After all they are participants in the secret world of Mount Olympus, as, day after day, it recreates the world all over again.

The voluptuous nymph can die – they know that the flowers that open around her will transform her despair into life force. The great yellow flowers will never again be separated from the sun to which they bow, transcending her great passion and transforming it into undying worship. There will remain perhaps a kind of exhaustion caused by the great suffering that has brought them to life, manifest in the heaviness of their blooms. But there will be no more tears, no revolt. Clytia's torment is over and when her heart stops beating it will suffer no more than a poem does when it ends.

Nature, too, will return to its previous state of calm. It will accept the oily sunflower grains, as golden as the distant sun itself, as a just tribute from the gods. Capricious and exhausting passion will give way to a harmonious alternation of day and night, and the plant will flower. The lowered heads of the sunflowers in the evening will be nothing more than a homage to the sovereignty of the sun.

The courtiers at Versailles had to take careful note of their privileges and duties, and this painting, like so many of those that decorate the palace of the sun king, is there to teach a serious lesson. In retelling an ancient legend it offers an elegant reflection and image of their own condition. They too, in the presence of absolute power, have acceded to all demands, forgetting their own selves, in order to be reborn later. They prefer blind obedience to the oblivion of being forgotten. And their own individual ambitions and failures melt away as they await the bestowal of some possible honour, in a moment that will never be forgotten.

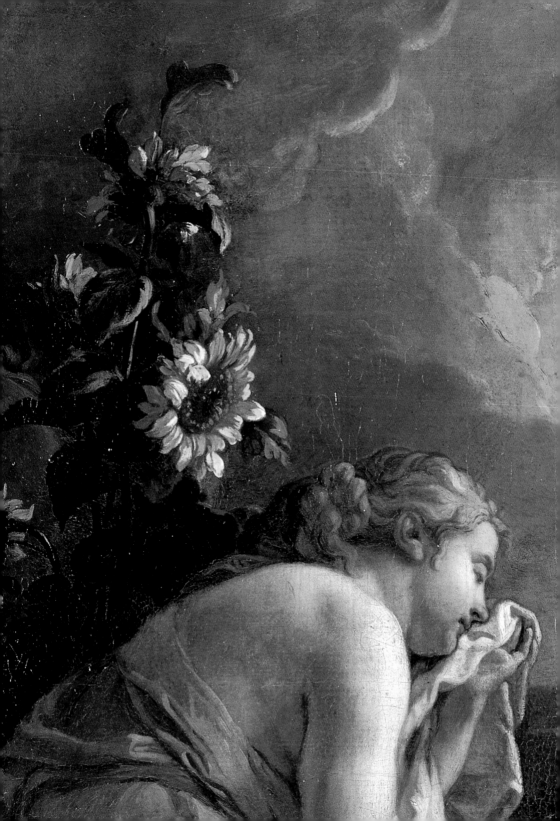

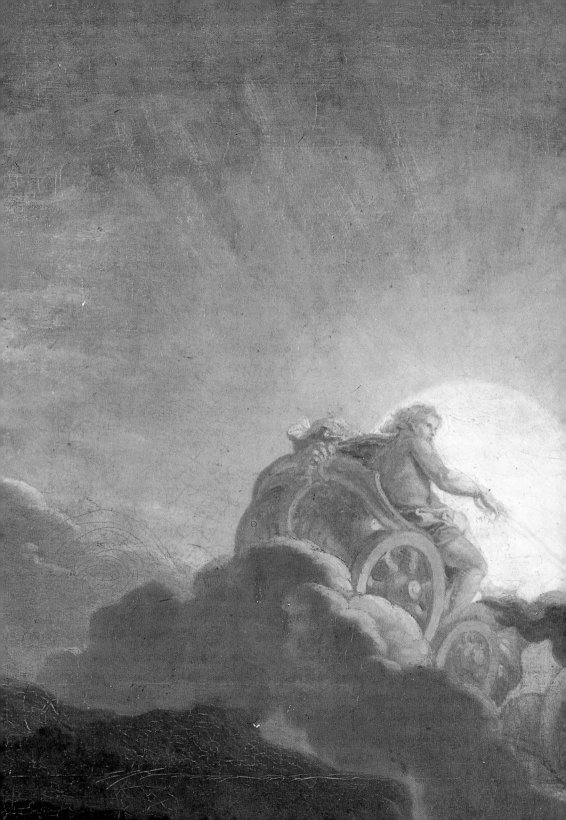

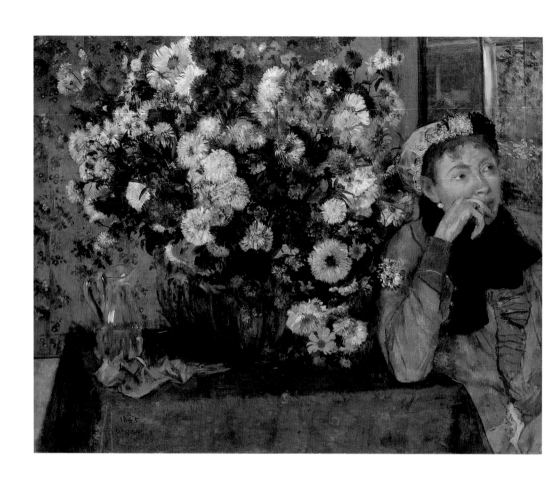

●●●

Woman Seated by a Vase of Flowers

Edgar Degas (1834-1917)

1865. Oil on canvas, 73.7 x 92.7 cm. Metropolitan Museum of Art, New York.

.

.

.

The multi-coloured bouquet takes up all the space on the small table. The flowers seem to multiply as one looks at them, some falling away untidily. Touches of paint splash colour around, disregarding the detail. The calm order of the house has been invaded by the vitality of nature.

This vitality has brought with it an atmosphere of freedom which subtly changes the dynamics of a banal moment in time. The pattern on the tablecloth is not specified, and the gloves, not yet put away, lying beside the vase, are merely indicated by a few lines of paint. The glass jug catches a ray of light but then quickly dissolves into the watery pattern of the wallpaper.

There is something off-centre about this arrangement: the model has been pushed to one side of the picture, enjoying less space than the bunch of flowers. The roles of woman and accessory have been reversed, and the shapes mingle and become muddled with one another. One could probably list the varieties of flowers, pick out the daisies and wallflowers, and distinguish between the dahlias and the galliardas, but in the end it is the energy of the whole bunch that holds the eye, the slightly disordered, unselfconscious spontaneity with which they spill out of the vase. Painted by Degas, flowers are just as relaxed as his human models.

The woman, leaning quite simply on the edge of the table, seems to have forgotten the presence of the artist. This is the moment he wanted to capture: her mind is elsewhere, and we are seeing a true side of her, one that is normally concealed. Not that there is anything sensational or reprehensible there – it is merely a short pause in the normal course of existence, a moment of absence. The painting has broken with convention and entered that tiny gap that has just opened up. Degas draws a few lines on an insubstantial panel of her coat, dressing her without conviction (she herself is not ready). But he has the decency to tie up her soft black scarf – it is still cold out there in the garden.

Having roughly pushed the flowers into the vase, the woman now gazes out beyond the painting, which makes no attempt to enclose her. The ephemeral nature of the flowers does not seem to inspire morbid thoughts. If that was what she wanted she could always go and contemplate one of the still lifes of past centuries. That is what museums are for. These flowers have nothing to show other than their own vitality, and no ambition beyond their present existence. Time is passing. Degas is not planning to linger, and neither is the woman. In a minute, she will pick up her gloves and start tidying, making herself look respectable.

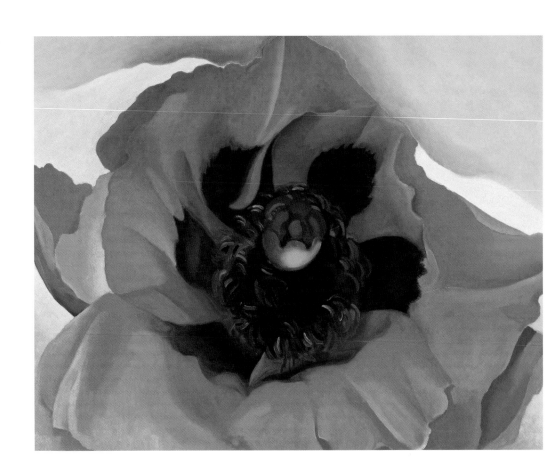

Poppy

Georgia O'Keeffe (1887–1986)

1927. Oil on canvas, 76.2 x 91.4 cm. Museum of Fine Arts, Saint Petersburg, USA.

The flower overpowers us. A motionless poppy, as smooth and flat as a photograph. A pure and absolute red, which leaves hardly any room for free space on the canvas. The petals flow over the edge. It is as though the artist had been so fascinated by the poppy that she had come too close, almost melting into it.

The spectator, unable to draw back, is deprived of the comfortable perspective of the still lifes of the past, those clever arrangements of flowers and artefacts intended to inspire thoughts on the unpredictable nature of life, whilst at the same time marvelling at its beauty.

The intense close up transforms what it displays. At first one is taken in by its botanical precision and objectivity, but, removed from its context, the flower's meaning and importance are transformed. The detail has taken over from the whole, insidiously, and one forgets that that is all it is, a detail. The examining eye, which would use a microscope if necessary, and carefully study each detail of its subject, is distracted here. It opens wide and is satisfied with something that can no longer really be seen. The spectator loses her critical sense: the flower, seen so close up, is no longer a flower, but a space, and a surprisingly large one, absorbing the gaze and letting it skim freely over its surface.

There is nothing accidental about O'Keeffe's painting. It is a cool statement of what is there, saturated with colour and sharp contrasts, with which she disguises a deeper truth. The flower seems bare of any secrets. There is nothing sentimental in the portrait of this poppy. And no lesson intended either – nothing poetic about the mortality of a flower once it has been picked. There is none of the poppy's famous butterfly-like charm and fragility here. Caught at the moment of full bloom, it does not move. Its future is not a concern. How could one believe in decay when faced with such steady intensity? O'Keeffe denies the transience of nature, and the splendour of the poppy removes any anxiety.

The flower opens up like a sexual organ: one is suddenly aware that painting had never in the past taken account of this natural truth, which upsets all the old conventions. Images of poppies in fields, bunches of wild flowers, had never upset anybody and had only awakened happy memories of walks in fields. Here the black heart of a single flower can suddenly shock the senses, and the spectator is suddenly frozen, surprised by the intimacy of the sensations it arouses in them. For a moment they become prey to the painting, and succumb, paralysed by the opiate trap.

The flower, death and hope
●

Flowers most commonly symbolize beauty and evanescence. They are represented in bunches that mingle every different species, in didactic still lifes, mostly painted from the seventeenth century onwards; these demonstrate the fragility of human life, whatever pleasures it might provide. One is reminded of the sombre words of Job: 'Man, born of woman, has a short life yet has his fill of sorrow. He blossoms and withers like a flower; fleeting as a shadow, transient.' (Job, 14, 1-2). Since life on earth is seen, from a Christian perspective, as simply a preparation for the hereafter, the brevity of flowering and its role in the cycle of nature can also represent a mere stage, a preliminary to eternal life. A flower would therefore be 'a hieroglyph of hope, and therefore since, when looking at a flower we hope for a crop of fruit, nobody can doubt that a flower announces good things to come'. (Piero Valeriano, *Hieroglyphica*, 1556)

The rose and thorns
●

The rose is the emblem of Venus, goddess of love and beauty, and was regarded with suspicion by the early Church, inclined as it was to totally reject all pagan culture and practices. One example of this would be animal sacrifices, during which both the priest and the victim were customarily adorned with crowns of roses. The antagonism between the pagan world and Christian teaching could be summed up by the radical contrast between the crown of roses and the crown of thorns: on the one hand the ancient idolatrous rituals, with their taste for luxury and gifts to the dead, and on the other the stark nakedness of Christ's Passion. Saint Benedict, the founder of monasticism in the sixth century, kept just one small rose bush outside his cell, to remind him that although the flowers charm the senses, the thorns mortify the flesh (when expelling Adam from Paradise God reminded him of this with these words: 'Accursed be the soil because of you. With suffering shall you get your food from it every day of your life. It shall yield you brambles and thistles and you shall eat wild plants.' Genesis 3, 17-18). The rose was gradually accepted for its ornamental value in the Muslim east, especially in Persia, and eventually in the West, where it became accepted as a tribute on the tombs of saints, along with other flowers. Eventually it was adopted by Christianity to the point of becoming a symbol of spiritual love in the twelfth century. The Roman de la Rose, written in the following century by Guillaume de Lorris and Jean de Meung would be a true allegory of mystical love.

The lily, tears and milk
●

According to the legend, Eve, expelled from Paradise and exhausted by grief and shame, let her tears flow to the ground, where they were transformed into lilies. Because of this, the flower appears in images of the Annunciation in which, announcing the Redemption, it symbolizes the opposite, the immaculate purity of the Virgin Mary. The lily, in the hand of an Italian angel, or in a vase in Flanders, can also represent the heavenly sound of the Annunciation because of its trumpet-shaped flower. Sometimes, where three flowers appear, it is a reminder of Mary's triple virginity, before, during and after the birth of Christ, as well the Trinity itself, the Father, the Son and the Holy Ghost.

Another story from ancient mythology relates how the appearance of the white flower, always of feminine origin, represents a link between heaven and earth: the goddess Juno was said to have let two drops of milk fall from her breast when she was feeding the infant Hercules, son of Jupiter. One became the Milky Way. The other, falling to the ground, became a lily.

The flower in *Metamorphoses*
●

In Ovid's *Metamorphosis* there are several stories in which the heroes die without actually disappearing forever, as they are reincarnated in the form of a flower or a tree. The sometimes violent deaths, the long hours of suffering, the terrible moments of despair, thus find a peaceful conclusion in the renewal of nature, which becomes a repository of the memory of past loves and glory. One of the myths tells of how Clytia, scorned by Apollo, god of the sun, starved herself and was transformed into a sunflower: 'For nine whole days she refused all food and drink; pure dew and her tears were enough in her starving condition. She never stirred from the spot. She only gazed on the face of the god in the sky and followed his course with her turning head. They say that her limbs caught fast in the ground, and a bloodless pallor changed her complexion in part to leaves of a yellowish green . . . firmly rooted but turns on its stem to its lover the Sun, still keeping faith in its new form.' (*Metamorphoses* IV, 262-65). The attraction between this flower and the sun caused it to become a representation of the star. Thus it came to symbolize light itself, as in Van Gogh's famous paintings. It also appears, much more often, as a symbol of royal power.

Wild and cut flowers
●

In one of his sermons (XLVII), Saint Bernard of Clairvaux (1090-1153) made a commentary on the Song of Songs ('I am the rose of Sharon, the lily of the valleys', Song of Songs, 2, 1) interpreting the different symbolic meaning of flowers according to where they are found. Cut and placed in a room, they need to be replaced often as they soon lose their perfume and their beauty: this is the image of conscience and good deeds which have to be renewed every day. The rose of Sharon represents martyrdom, as it dies and is reborn ceaselessly. The garden flower grows thanks to man who tends and preserves it, and therefore represents virginity. All these symbols are gathered together in the person of Christ, himself both garden and wild flower, the perfect martyr, and also, as a cut flower, a model of piety. Cut flowers, which were the only sort allowed to decorate solemn religious festivals after the sixteenth century, therefore represent sacrifice.

The bouquet
●

The mixed bouquet is a relatively recent introduction in the West, although it comes from a long tradition in China and Japan. Crowns and garlands had been made for centuries, following Roman customs. It was only after the fifteenth century that bouquets were introduced, necessitating the use of vases rather than baskets and bowls. They would be placed on the ground, as one can see in Flemish and Spanish depictions of the Annunciation. In later centuries they would be placed in more visible positions, on mantelpieces, sideboards, window sills or bookcases. By the seventeenth century, the bouquet - the word comes from *bosquet*, meaning 'little wood' - had become so fashionable that they became an important element in still lifes. By Degas' time the arrangement of a bouquet picked from the garden by the mistress of the house had become a bourgeois ritual, and the 'language of flowers' was such a feature in drawing rooms that many works on the subject appeared throughout the nineteenth century. A symbolic trace of this exists to this day: roses are a sign of passionate love; carnations are thought to bring bad luck (their dishevelled petals are reminders of nails, and therefore of the suffering of Christ); yellow flowers are to be avoided (the traitor Judas was dressed in yellow); and violets are thought to be 'shrinking' because they flower in the shade.

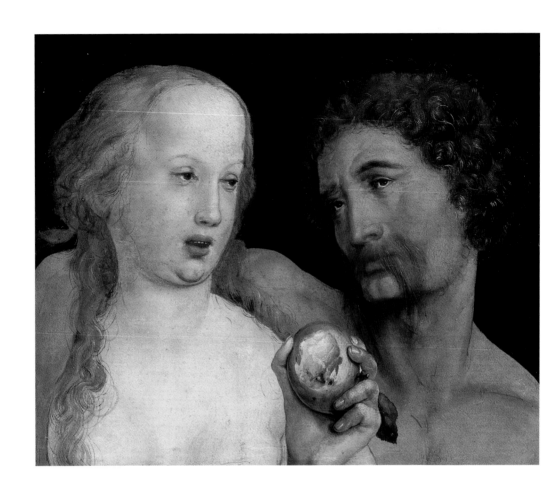

The fruit

Adam and Eve

Hans Holbein the Younger (1497-1543)

1517. Oil on wood, 30 x 35.5 cm. Offentliche Kunstammlung, Basel.

There is still a leaf attached to the twig. The apple has just been picked, and heartily bitten into, with no hesitation or reticence. There was boldness as well as greed, and never any doubt that this apple would be delicious.

And yet it brought no pleasure. The woman's mouth remains half open, her little teeth showing, and her face frozen, as though she doesn't yet know what to think. Perhaps this is the first time she has ever thought about anything. Only now is she discovering reason and intention, desire and satisfaction which cannot last.

It may be that Holbein is showing her saying something, inciting the man to taste the apple too. Or perhaps he has already tasted it, with her. It is not clear, and various possibilities are superimposed upon one another. The experience of time and space here is disconcerting: the painting veers from one side to another, forwards and backwards, leaving the spectator in a precarious and confused state of mind – just like the protagonists themselves. They are now forced to separate the past from the future that they face, and inhabit the small and unknown space in which they find themselves, the present moment. In this painting, designed like a pair of scales, the apple holds the balance.

The man looks out from the painting, his eyes raised, his chin lowered, his shoulders leaning to the right, his face to the left. His whole being is in disarray; the journey that lies ahead of him is tearing him apart. The rest of the story will soon unfold: the expulsion from Paradise and the loneliness of disobedient man. But in truth it is already here, in this impossible conversation they are having.

They are separated forever by this thing between them: the transgression, the tasted fruit.

The shape of the universe has been overturned by just one bite. Everything now revolves around that missing piece of fruit. The last mouthful has left a raw wound. The fruit, neither whole nor completely devoured, is tainted, caught between its previous perfection, which we can only guess at, and its eventual disappearance, which we can predict. The artist stops history in its tracks, blocking its development. Time began with this original sin, but the painting remains frozen in the moment, the irreparable act; it cannot move forward. If the fruit had been depicted whole and intact, one might have hoped for some reprieve, although damnation would never really have been deferred. But Holbein treats the subject with complete pragmatism, by depicting this moment of confusion rather than the original innocence or the hope of salvation. He chooses the terrible moment at which everything changes, before anyone has had a chance to see the whole picture or measure the consequences.

The fruit in question is neither desirable nor particularly appetizing. It is just another piece of fruit, and that is all that is needed: the type is more important than its individual qualities. Neither does the painting attempt to provide any personal detail about the two people. It simply observes them. Both the apple and the figures follow convention: the voluptuous woman with her pale skin, the bearded man with brown skin and dark hair. The format of the painting, however, is more unusual: of the original painting of mortal sin, only the upper part remains, and the scene is reduced merely to two torsos, like portraits. And so, thanks to the vagaries of time, the story of original sin has become reduced to a domestic drama.

Hardly has the apple been eaten than the gestures become heavy. The hoped-for happiness had all been in the anticipation. The pleasure had been in the planning, and now it is followed by a great emptiness. Eve barely recognizes her own hand – it seems strange, too dark for her, too light to be Adam's. The colour is now blurred, like her mind.

Knowledge will forever continue to choke man who has sinned. The mark will remain on his body, the story in the Bible will always prevent him from forgetting. His bad conscience will choke him, although he will still be able to breathe – it is, after all, only an Adam's apple.

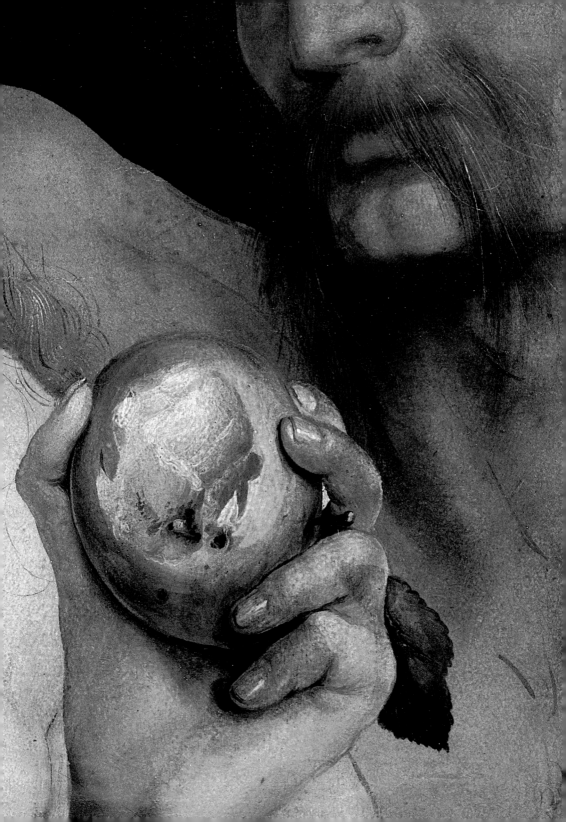

●●

A Dessert

Jan Davidsz de Heem (1606–83)
1640. Oil on canvas, 149 x 203 cm. Louvre, Paris.

One absent-minded gesture and the whole thing would collapse. An idle finger on the edge of a silver dish, an accidental tug on the white tablecloth, a piece of fruit dislodged in the great tilting bowl – nobody dares to move. Perhaps we should skip the dessert.

But the picture does seem to contain everything needed to please the senses. Sight to start with, which embraces the opulence of the scene, the variety of colour, the subtlety of tone, the complexity of the arrangement. Smell, a combination of ripe fruit and the fresh breeze coming in from behind the large theatrical curtain. Touch as well, as it distinguishes between the smooth and the rough, damp and dry, warm and cool, the hard flesh of a green fruit, resistant to the touch, and the brittle crust of the already stale loaf. And finally taste – the tender pie, the sharp cherries, a slightly sour grape. Maybe a mouthful of bread, or a sip of wine? Or perhaps a large glass of cool water. A lute rests against the table, like a resting musician.

Although you might suppose that you were invited to this feast, you are suddenly aware of a drawback: the meal has already begun, and may in fact already be over, before you have had a chance to join in. This luxurious disorder does not betray any haste or hesitation in the preparation. It is too carefully arranged to be accidental. The pie has grown cold on the casually draped tablecloth. The glass has already been used, but one can hope that there is more there in the mother of pearl decanter to quench the thirst. A few translucent cherries form a crown around another glass, which ignores them. Even drunkenness passes. One piece of lemon peel stretches out, another curls like a snake, like a child playing at Paradise lost while singing a playground song. The blue ribbon of a watch hangs off the edge of the table. The only music here is its faint ticking.

The huge globe, hidden in the shadows, and a few books piled up high, remind us that the same story is told in other lands, beyond these pale seas. And that it will continue to be told long after the end of sight and appetite. Beneath the large curtain the play goes on, it has not reached its conclusion. Life is offered as a horn of plenty, still magnificent but full of potential disappointment.

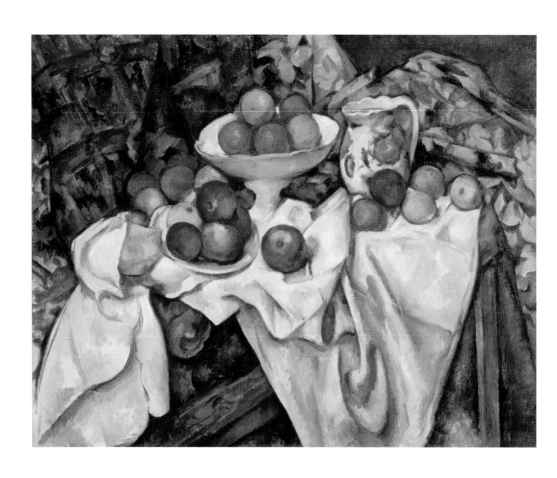

● ● ●

Apples and Oranges

Paul Cézanne (1839-1906)

c. 1899. Oil on canvas, 74 x 93 cm. Musée d'Orsay, Paris.

.

.

.

The tablecloth seems to be trying to hold back the fruit, which is about to roll into its folds. The tapestry in the background and the embroidered cloth on the side also seem to be restraining all these objects that would usually go off in every direction. The jug appears to be unsteady on its base. The fruit bowl leans as though unsure of its shape and the blue-rimmed plate is tipped over by the weight of the apples.

The objects slide, and are about to escape. In earlier still lifes, those sumptuous stage settings, the potential collapse of the arrangement of objects symbolized the fragility of all life. Here, the greatest danger that threatens the fruit bowl is not that it would shatter to the ground, but that it would become shapeless and unrecognizable. The painting does not offer it a guarantee of permanence – the apples maintain their beautiful roundness at the price of constant movement. The artist has allowed himself a margin of error and softened their outline, choosing a middle way between what could be, what actually is, and what it is really possible to see. Is it really necessary, under the pretext of precision, to enclose the spark of light inside a hard line, fixing forever the shape and colour of a fruit that is not yet ripe?

The artist needs the passage of time to change things, and he makes it his ally. The shapes are just a succession of appearances. The objects, like people, exist through the attention they get – one second of indifference and the plate seems to melt away. One needs to concentrate on it in order for it to keep its shape, but the eye is drawn away by some sudden spark of light. The painting records all of this: the blank spaces, the stumbling movements, the passing seasons which help the colours to mature.

The tablecloth, having been handled, turned, put away and crumpled, seems to have forgotten what sort of material it is made of and what shape, if any, it is supposed to be. The wear and tear of time has transformed it into a different kind of object, a solid block of light which folds beneath the objects and prevents them from dispersing. Increasingly, it resembles the canvas itself on which Cézanne is working.

The oranges float in the fruit bowl with the lightness of balloons. The yellow and red apples wipe their surplus colour onto the white cloth. The painter wipes his paintbrush – there is no hurry, and there is still one green fruit.

The nameless fruit of sin
●

The Bible tells of how Eve and then Adam ate the fruit of the Tree of Knowledge despite God's interdiction, which led to them being expelled from Paradise (Genesis 3). But nowhere in the text does it specify exactly what sort of fruit it was. Christian culture has generally taken it to be an apple, but Jewish tradition suggests four symbolic possibilities, each representing a different form of temptation: the grape, signifying the drunkenness of power; wheat, signifying the power that comes from knowledge (bread replaces milk when the child reaches the age of reason); the fig, because Adam and Eve, after the expulsion 'realized that they were naked. So they sewed fig-leaves together to make themselves loin-cloths' (Genesis, 3, 7) and they would likely have chosen the closest tree, therefore the tree of knowledge, to cover themselves; the citron, which is entirely edible, as the tree itself would have to be, and whose shape rabbis compared to that of the human heart. With great wisdom, commentators left the question open, saving any particular species from the shame of having in some way participated in original sin.

The choice of the apple
●

The Latin word *malum*, meaning 'evil', also means 'apple'. It was therefore easy, after the Bible was translated into Latin, to confuse the two meanings. This so-called mistake might also have been a deliberate choice, in order to give a concrete form to an imaginary fruit, and to supply artists with a simple image. *Malum* can also mean quince, pomegranate, peach, orange or lemon, all of which sometimes appear in the paintings. But the apple also had the advantage of establishing some continuity with ancient mythology, and continuing in its role as the 'fruit of discord': the shepherd Paris gives a golden apple to Venus, declaring her the most beautiful of goddesses; she had promised him the love of Helen in return. This choice was to have fateful consequences when Paris stole Helen from her husband Menelaus and started the Trojan War. Another legend also tells that when Hera married Zeus, the Earth gave him the golden apples, which grew in the gardens of the gods, guarded by the Hesperides, the nymphs of the evening, helped by a dragon.

The grape, wine and blood
●

The grape, the fruit of the autumn, is a general symbol of fertility because of its multiple fruit. It is a symbol of drunkenness too, but also of the wisdom of the mature man who harvests the fruit of his toil. Above all, it is the attribute of Dionysus or Bacchus, the god of the vine and of mystical ecstasy, a god who is born twice, is murdered by the Titans and comes back to life. His passage from death to resurrection, similar to that of Christ, is paralleled by the transformation of the fruit into wine. The grape thus plays an initiatory role, since the pips, hidden inside the sugary flesh, can also signify the bitterness buried at the heart of pleasure. In Christian-inspired images, the grape is an allusion to the Passion and the sacrament of the Eucharist in which wine becomes the blood of the sacrificed Christ: 'This is my blood' (Mark, 14, 24). The conjunction of black and white grapes play on the symbolism of colour, recalling the blood and the water that sprang from the ribs of Jesus when he was pierced by the spear on the cross.

Fruit and the taste of the present

Fruit, of whatever kind, appeals to our sense of touch, sight and smell, as well as taste. It is less obtrusive than a full meal, and puts fewer constraints on the viewer. Fruit is part of the decor, whether in a bowl or a basket, always available to be looked at before it is eaten. This dual role is exploited to a great extent in the still lifes of the seventeenth century, in which the multiplicity of fruit represented symbolize a wonderful abundance, whilst at the same time a sense of unease and anxiety is introduced with the odd sign of decay and rotting. These signs of mortality, which put the emphasis on the vanity of the human condition, at the same time place the viewer in an impossible position: they cannot grasp and enjoy all that is put before them. So with the fruits of life, we have to make a choice, and resign ourselves to missing certain things. If we do not do this, we will lose everything, without having been able to enjoy the present.

Cézanne's apples

The theme of the apple, which runs through all of Cézanne's still lifes, is more than just a prop or technical exercise – it is also an echo of his childhood. As a young boy, Cézanne had defended a school friend who was being bullied by the other boys, and had, as a result, been beaten up himself. 'The next day', the artist later wrote, 'he brought me a big basket of apples. "Here are Cézanne's apples," he said to me, with a mocking wink, "they've come from a long way away . . .".'. The schoolboy was none other than Emile Zola, who became a close friend of the artist. But Zola's 1886 novel, *L'Oeuvre*, a contemptuous portrait of a failed painter in whom Cézanne recognized himself, brought an end to the friendship that had been sealed by a basket of apples. More than just a youthful memory, the apple represents the painter's relationship with the outside world, as well as his desire for knowledge. For him painting was a way of questioning reality, the permanence of temptation and impossible longing, and the fateful decisions that have to be taken, sometimes with terrible consequences.

The peel as a symbol

In a seventeenth century still life there is very often a peeled fruit, usually a lemon, whose peel forms the shape of a fine spiral. One can read this as a progression towards truth, a demonstration of the difference between appearances and reality, an unmasking of things. According to the Kabbalah, in Judaic esoteric tradition from the twelfth century onwards, heavenly abundance is shown in fruit by the lack of peel and pips. Far from Eden, sinful humanity is deprived of this perfection with fruit that has been hardened by Sin. Peeling them in order to taste them thus symbolizes the purification that is necessary in order to achieve eternal life. Paul Claudel (1868–1955) saw in the slow spiral of peel in Dutch still lifes 'the uncoiled spring of time'. The skill needed to peel the fruit in such an elegant way gave the image a quasi-magical quality; several superstitions attached themselves to the process, such as reading in the number of coils the amount of children who would be born, or how many years would pass until marriage.

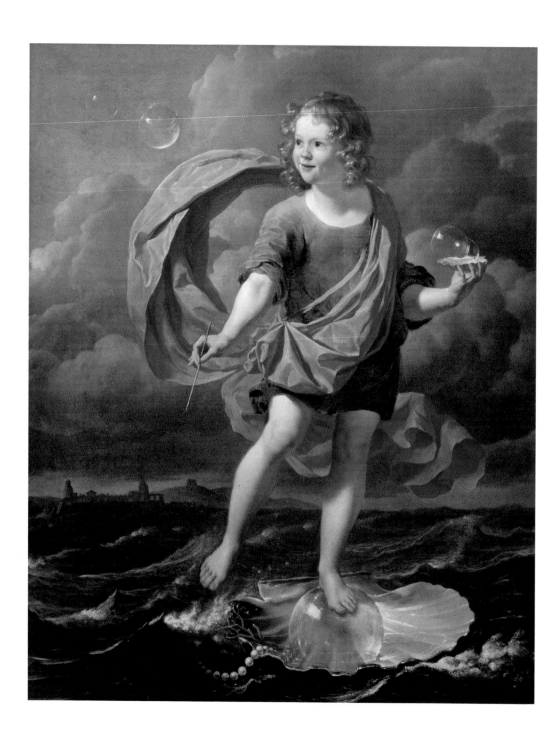

The shell

Allegory

Karel Dujardin (1622-78)
1663. Oil on canvas, 116 x 96.5 cm. Statens Museum for Kunst, Copenhagen.

The laughing child watches the bubbles fly away. He balances on the largest one, a fragile sphere that could burst at any minute. He drifts gracefully, like a tightrope walker, oblivious of danger – he knows that the large shell is keeping him afloat for the moment.

A branch of coral, perched on the edge, will bring him luck, so they say. Even as night falls the glow from the pearls reminds him that light can emerge and glimmer in the darkest night. It is a sort of miniature tree, a reminder of the tree of life and of paradise lost, bleeding like the redeeming Passion of Christ – small drops of blood sink down to the depths. All through his journey these precious ornaments will be his passport and protect him from evil encounters, demonic beings and the danger of shipwreck.

Between sky and sea, in an unstable harmony, the wind whips up the waves and plays with the bubbles – all they know of the world is their own transparent perfection, followed by a sudden, pain-free disappearance. The ephemeral life that is there will vanish without trace. The bubbles have no memory. Nobody expects anything from them other than a passing reflection of light. They will disappear as though they had never existed, and then return. Time kills them so quickly that it cannot affect them. A bubble sinks down on the edge of the shell, settling into it, smoothing the surface, adjusting itself. Everything is so rough on the outside and so smooth within. The folds and spirals of the shell reflect the movement of matter required for its creation. These minute convulsions have gradually died down and it has taken form. The shell has become a monument.

Thanks to the shell the child can continue on his dangerous journey, sailing between the storm and sunshine, unaware of danger. It is not clear whether he is innocent or uncaring, nonchalant or certain of his destiny. Dark waves gather at the bottom of the painting and the horizon is heavy with threatening clouds. His pink mantle floats like a veil. If he was suddenly swallowed up by the darkness he would perish without having had the time to give it any thought, blowing a last bubble through his straw. Perhaps he is not a child, but merely the image of eternal childhood, where death does not exist. Perhaps he is an actor, who has mastered his role so effectively that he can be certain of the effect he is having on his audience. The transparent globe beneath his feet is just an untrustworthy prop filled with air.

Nothing has been decided, the spectator need not despair. This minuet with death is simply unsettling to watch. It inspires thoughts in us unwary travellers on the instability of our position in the world, encourages us to expect the best and the worst, to be carried away like a bursting bubble or to cling at all cost to the shell, fighting to the end against the currents. To either sink like a stone or save one's soul. The traveller can choose his own route and prepare for his arrival in a safe haven, beyond the mortal world.

Karel Dujardin's painting conveys a serious message but with a gentle tone, making a pretty picture out of a sermon. The young sailor with the golden hair sailing into the wind, who looks like a cross between a cupid and a young Jesus, is not duped by the emptiness of the bubbles: he renews the image of Christ as fisher of men, walking on water. Absorbed by the infinity reflected in the fragile bubbles, he triumphs over the laws of nature, and, with a heavenly smile, prepares to face the storm.

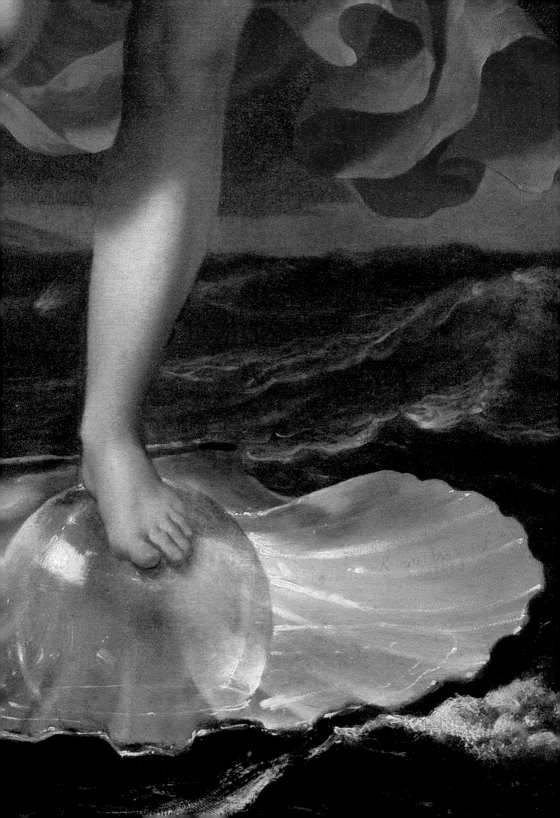

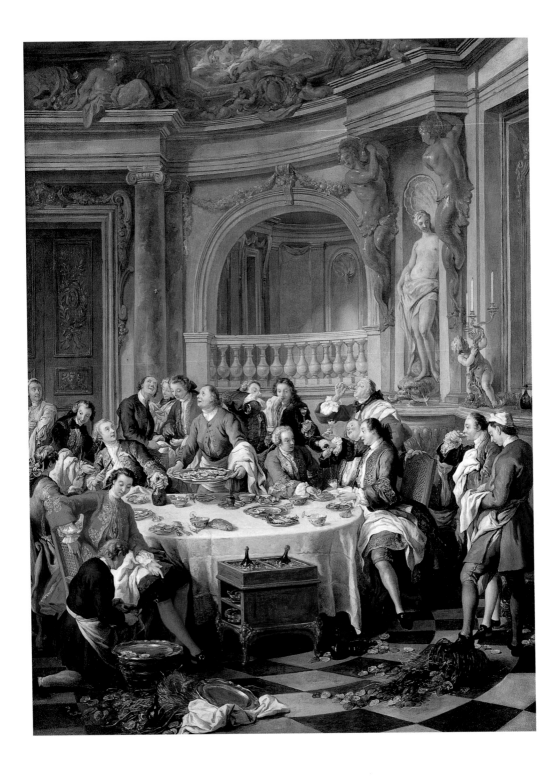

●●

A Dinner of Oysters

Jean-François de Troy (1679-1752)
1735. Oil on canvas, 180 x 126 cm. Musée Condé, Chantilly.

.

.

.

A table full of people, sparkling with colour and wit, where revelry is as important as food. We don't know how the hunt went, but the ride will certainly have sharpened the keen appetites of the guests.

The languid figure of Venus presides over the festivities in the dining room where the King is entertaining his young Lords. The goddess, from the height of her niche, with a shell above her head, looks down on a little cupid tangled up with a rococo candelabra. His young companions climb around on the cornices which caryatids pretend to support. An oval painting above reflects the scene, depicting the revels of the flighty gods, but it is so high up that its message can be ignored. The scene is set.

The silver plates do the rounds and are emptied. Oyster shells pile up all over the floor, as they did in the good old days when the gods, who loved refinement and luxury, would feast together. Versailles has nothing on Mount Olympus and Jean-François de Troy pays a passing tribute to the old masters who celebrated its beauty. The translucent flesh of the oysters melt on the tongues, and its salty freshness simultaneously quenches and causes thirst – one leads to the other. The servants bring forth more and more. The goddess of love, who, like the oysters, emerged from an abundant sea, has marked them with her seal. The pleasures of the table are only a prelude.

The gaiety spreads and spills onto the black and white tiles around the room. One could well imagine that there might be glimpses of lace peeping out from beneath layers of silk, but there is not a single skirt in sight and no pretty faces lurking in the background. For the moment these agreeable gentlemen are happy with their own company, enjoying the mouth-watering oysters. They never tire of them. And the gods of the past, those poor deprived immortal beings, didn't know then about the sparkling wine which tickles the throat and makes the drinker feel as light as the wine itself. They are becoming light-headed, all their senses relaxed. As a subtle finale a champagne cork has just popped, and in the hands of Louis XV's artist it will never fall to earth.

.

.

.

.

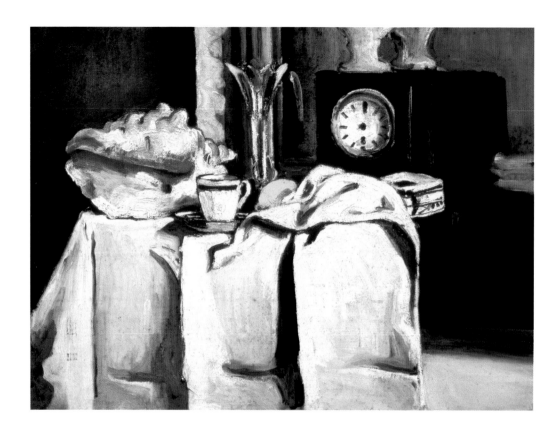

●●●
The Black Clock

Paul Cézanne (1839–1906)
c. 1870. Oil on canvas, 55.2 x 74.3 cm. Private collection.

.

.

.

A large shell takes up most of the mantelpiece. The clock, with its blank face, prevents the passing of time. Life has been frozen at an unspecified moment, perhaps after coffee, or possibly a little earlier. In front of the mirror are a small slender vase, a lemon that bolts the picture together with a splash of yellow, and further along, a small box. The paint is thick and heavy, weighing the objects down in a sort of torpor. The atmosphere is not conducive to conversation. The folds of the tablecloth are filled with dark paint, a great deal of black, like the black of the square clock which dominates the painting. A mute clock with indestructible authority.

The whole composition is evenly balanced between black and white. This is a life which contains no surprises. Light, dark, good, evil, innocence, mourning, it is all there. The material hangs like stone, deadening any stray impulse. Everything is geometrically arranged, except for the shell, which the artist has chosen to play the opposite role. Its complicated curves have escaped the rigidity of the rest of the painting. Its vibrant red contrasts with the other colours, with the lemon as its only ally, an acidic flash. Excess has no part to play here.

And then there is the question of the opening on the side of the shell, like lips in a strange kind of smile. It suggests some different kind of life, a very different kind of subject. Unless it was an object of scientific study? But this is neither the time nor the place for that. It is a disturbing presence in this drawing room, a stranger to the good manners implied by these flat surfaces and regular shapes. This shell, so full of life, opening itself like a naked woman, seems so young beside the black clock. The artist is contemplating his own lust, and no doubt remembering the still lifes of the past, in which skulls, hourglasses and flowers were assembled to drum in their message about the pitiless brevity of life, and the futility of pleasure.

Cézanne silences the murmurings of the confessional. The severe clock has ceased chiming the hours, deprived of its hands; and the shell can't measure time. Perhaps you should put your ear against it to hear how the heart beats even on monotonous days filled with everyday tasks. You could let yourself be carried away by the sound of a noisy sea, anywhere in the world, if only you could set sail, and travel far away, tossed on the waves, far from these rigid walls.

.

The shell as a symbol of regeneration

●

The shell, emerging as it does from the bottom of the sea, symbolizes above all life-bringing water. It not only suggests the idea of universal birth, but it does so in an indestructible form, remaining unchanged long after the disappearance of the animal that it sheltered. It is therefore both the image of life beginning and the proof of its permanence, through a process of continual renewal. This is why it has been associated since prehistoric times with funeral rites: its presence as an offering indicating the hope of an afterlife. In Christian imagery, often derived from the iconography of antiquity, it suggests both the sacrament of baptism and the resurrection of Christ: on the one hand a spiritual 'birth' through the purifying water, on the other a victory over mortality. And so, just as Saint John the Baptist is often represented baptising Christ with a shell, pouring water from it, so an empty shell is a reminder of the empty tomb of the resurrected Christ at Easter. This explains the presence of shell-shaped holy water stoops in churches.

The shell of Saint James

●

In the Middle Ages it was the custom to bring back relics from the holy places you had visited on pilgrimage. A bit of earth or dust, a piece of cloth that had been in contact with the tomb of a saint, wax from a candle or a few drops of oil – all these could be precious and venerated souvenirs. The great boom in pilgrimages after the eleventh century led to the production of metal insignia which varied according to place. In Compostella, where people went to visit the tomb of Saint James, who died in 44 AD, a natural object was chosen in the twelfth century: a shell with rounded ridges, which had to be bought in the immediate vicinity of the cathedral, and whose sale was strictly controlled, with a threat of excommunication if it took place outside the city. These tiny shells would be taken home, fixed onto a bag, coat or hat, and preserved with great reverence, often buried with the bodies of the pilgrims when they died. By the end of the century fishermen were unable to keep up with demand, and shells were manufactured from lead, tin or jet. The custom soon spread beyond Spain and the scallop shell, soon became the symbol of all pilgrimages.

A symbol of marriage and love

●

According to most common forms of the legend, Venus, born of sea-foam and wind, arrived in Cyprus on a shell which deposited her on the shore. More ancient sources relate how, like a living pearl, the goddess of beauty was born from the shell itself. The shape of the shell, reminiscent of a female sexual organ, reappears in all cultures as the emblem of love and marriage. Snails and oysters, said to be aphrodisiacs and to encourage fertility, belong to the same network of connections, appearing in many paintings, both sacred and profane, to convey a moralizing message. As for the pearl, many early Christian writers saw in it 'the image of the undescribable light of the Lord'.

●●●

The Goldfish

Paul Klee (1879–1940)
1925. Oil on cardboard, 49.6 x 69.2 cm. Kunsthalle, Hamburg.

The fish has come from a distant time, a little frail now, clothed in clumsy scales, which look as though he has knitted them himself, dropping several stitches.

He hangs there peacefully, not letting himself by carried away by a too-strong current whilst others swim around him in all directions, like a prince at the centre of his court. He allows himself be gazed upon, like a kind of vision.

The artist has scratched undulating waves and gentle little aquatic plants into this ceremonial sea. The golden fish swims beyond the legends. He skims through the deep blue waters, where night threatens but does not quite fall. It is a pure ultramarine blue, as precious as the holy skies of medieval paintings, and as absolute as a wordless dream.

The painting is the place where you re-encounter half-forgotten stories. Their remains are carefully preserved, all the rest disappears. There is no need to recall the details of the story, or the ending, still less the moral. The golden fish of ancient fables was the thing that granted the wishes of the poor man who had caught it, on condition he then let it go. But the artist, as impoverished as he might be, demands nothing: this picture is no trap. All he needs is the space for a work to appear. He has allowed the image to approach and rise to the surface of his consciousness. The artist has worked, studied, corrected and often destroyed his own work, always hoping for the unexpected. Sometimes it happens – an image imposes itself on him. He had looked out for it, but it arrived unannounced. Everything was prepared but he was caught unawares. His paintbrush discovered what lay deep within him, beneath the sand, buried beneath a heavy shipwreck. His own hand, which has drawn so many lines, and loved so many colours, has suddenly felt something swimming close by, staying a while, and leaving its mark: a golden fish that previously did not exist has suddenly shown itself.

The artist has witnessed a small miracle, the birth of a painting. An achievement. He can now contemplate something that was invisible a moment earlier, that he has somehow tamed. He seems to be almost holding his breath, so as not to create any ripples in this still water, and especially not to frighten the little pink and purple fish with glasses which carefully demarcate the corners of the picture, like guards. The beautiful fish has some of the stillness and grace of early icons. Maybe he hasn't yet learned to swim.

The Image of Christ

In the first centuries of its existence, when the Christian community was suffering from Roman persecution, believers were forced, for the sake of security, to use coded symbols. The figure of Christ was then symbolized by a fish, Ikhtus in Greek, the word corresponding to an acrostic of *Iesous Khristos Theou Uios Soter* which means 'Jesus Christ Son of God Saviour'. The choice of the fish could also be based on the biblical account of the baptism of Jesus in the Jordan: the theme of water as the sacred bringer of life leads to that of the fish, rising up to the surface from the depths of the sea, like the soul which finds a new life thanks to the Grace of the Sacrament. In the third century, Saint Cyprian wrote: 'It is in water that we are reborn, in the image of Christ, our master, the fish.' (*Letters* LXIII, 8). The Ikhtus-Christ is also a transposition of the image of the dolphin - replacing it by the second century - which had been considered, throughout antiquity, as the king of sea creatures, a reformed pirate, now saviour of ship-wrecked sailors. By the end of the second century, Clement of Alexandria listed it amongst the figures that Christians could use for their seals. Its use completely disappeared after the fifth century.

A symbol of purity

The book of Genesis tells of how God, angered by the wickedness of men, decided to wipe them out by sending floodwaters for forty days. He spared one just man, Noah, whom he had ordered to build an ark in which to shelter his family and a pair of every species of animal. And so, 'The waters rose fifteen cubits higher, submerging the mountains. And so all things of flesh perished that moved on the earth, birds, cattle, wild beasts, everything that swarms on the earth, and every man. Everything with the breath of life in its nostrils died, everything on dry land.' (Genesis, 7, 20–22). Such a punishment obviously could not affect fish, whose purity in Jewish tradition was thus rewarded: 'Only the fish survived as they had not sinned like other animals'.

The fish and the figure of the Christian

Running water, the image of God in the Old Testament, is full of life. Water sprang from the side of the Temple, as described by the prophet Ezekiel: 'Wherever the river flows, all living creatures teeming in it will live. Fish will be very plentiful, for wherever the water goes it brings health, and life teems wherever the river flows. There will be fishermen on its banks. Fishing nets will be spread from En-gedi to En-eglaim. The fish will be as varied and as plentiful as the fish of the Great Sea.' (Ezekiel, 47, 9–10). This image of the people of God born of the Covenant is echoed in the words of Christ who said to his four first disciples: 'I will make you fishers of men' (Matthew, 4, 19; Mark, 1, 17; Luke, 5, 10). One of the fathers of the Church, Tertullius, called Christians 'pisciculi', little fish.

The fish and the Eucharist

●

The fish appears at several moments in the Gospels, when Jesus is feeding his disciples. This is why it is often represented as a reminder of the Eucharist, the sacrament by which Christ offers his own flesh and blood to those who believe in him. Here are some of the most significant episodes in which this symbolism appears:

. The feeding of the five thousand, with the multiplication of the five loaves and the two fish (Matthew, 14, Mark, 6, Luke, 9, John, 6) or seven loaves and a few fish (Mark, 8 and Matthew, 15)

. The story of the miraculous catch after the Resurrection (John, 21)

. The appearance of the resurrected Christ before his disciples: 'Look at my hands and my feet; yes, it is I indeed. Touch me and see for yourselves; a ghost has no flesh and bones as you can see I have. And as he said this he showed them his hands and his feet. Their joy was so great that they still could not believe it, and they stood there dumbfounded; so he said to them "Have you anything here to eat?" And they offered him a piece of grilled fish, which he took and ate before their eyes.' (Luke, 24, 39-43)

The food of penitence

●

According to Cesare Ripa in *Iconologia* (1593), the woman representing the allegory of Penitence must hold a fish in one of her hands, since penitence must be accompanied by fasting. In a great many compositions in which fish appear, either on their own or with other foods, it is taken as a symbol of days of abstinence or fasting rather than feasting. This sign of frugality is supposed to encourage detachment from earthly possessions and the pursuit of spiritual perfection.

The still lifes of the seventeenth and eighteenth centuries play up the contrast between these types of food, either within the same picture, or in works conceived to hang alongside each other. This adds a pretext for a contrast in shapes, colours and textures.

The fish and happiness

●

The goldfish originated in the Far East, where it represented happiness and good luck, and became known in Europe by the seventeenth century. A character called Goldenfisch appears in many stories and legends. With a few variations, he is a benevolent figure, endowed with magic powers, which he generously uses to satisfy men's desires. However their insatiable and ungrateful natures lead to them losing everything – the fish sends them back to their original state of poverty when they start to demand not just more possessions or higher status, but a different power altogether, one that could usurp the place of God. This fish in the fable, who makes wishes come true, is a symbol of the inexhaustible goodness of God. It can be found both in Chinese and popular western folklore. Two of the most well known versions appear in the nineteenth century, one by Alexander Pushkin, the other from the brothers Grimm.

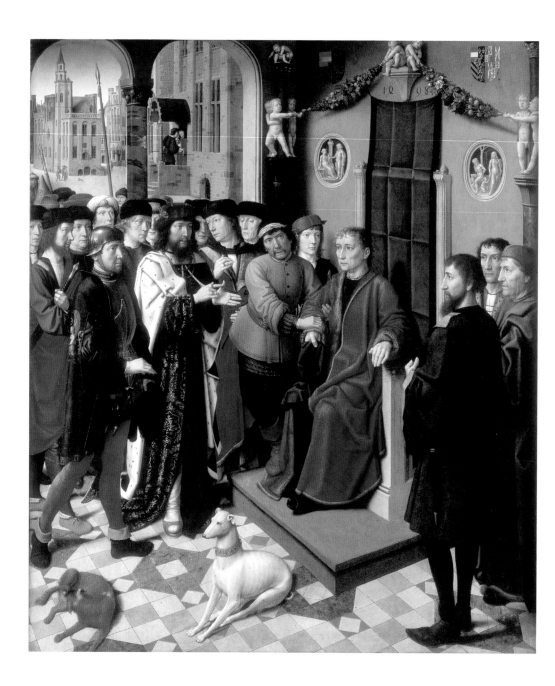

The dog and the cat

.
.
.
.
.
.

●

The Judgement of Cambyses

Gérard David (1460-1523)
1498. Left hand panel of diptych, oil on wood, 182.3 x 159.4 cm.
Groeninge Museum, Bruges.

.

.

They have come to arrest the judge. The good citizens listen to the King, who is dressed in brocade and ermine, as he counts the charges on his fingers. The town is reflected in the shining helmet of an advancing guard. The dogs remain unmoved.

The judge knows what he is accused of: he sees himself again, on the step of his fine mansion, accepting payment in exchange for passing an unjust sentence. In retrospect that purse of coins doesn't seem so heavy. He can't even remember much about the case, it was quite a while ago. This scene, which gives only a small space to the moment of betrayal, makes the profit seem even more derisory. He can remember that moment, behind the arcade; it is as though he is witnessing somebody else's life, some other Judas once again betraying Christ for a few pieces of gold. A secret meeting, a few words, a vile promise. He should have known that he would be caught, if not by his own remorse, at least by justice. He should have thought about the meaning of these porphyry columns that surround him, he should have found the strength within himself as firm as the marble, and as pure as the veins of blood red that flow through it.

There, now it has happened. The faces around him remain expressionless, nobody is here to settle a personal score. The King is acting according to the unshakable imperatives of the law. There may be some amongst them, old friends or acquaintances, who feel a little compassion. They have removed their hats, and stand bare-headed, like him, before the others. It is a mark of

sympathy, they feel they still owe him some sign of respect. The corrupt judge, once his headdress has been removed, will no longer be a person. Soon his scarlet robe will also be removed, and then his skin, while he is still alive.

In the Bruges courtroom, those reaching a verdict can look up at this bright-coloured painting. It is a pleasing work of art which paints a flattering portrait of the town and its inhabitants, a good clean composition. One can almost touch the cloth and the fur. But the painting's message is incontrovertible: judges are only the emissaries of divine justice, and if they lose their way and abuse their power, the punishment is terrible.

The dogs, like the men, are divided between purity and vice. The white dog beside the King waits for his master; his head is fine and straight and he wears a jewelled collar. He is an idealized figure, drawn more from heraldry than nature, with his indifference to the drama unfolding around him. The animal lies serenely at the centre of the painting, the incarnation of fidelity and vigilance, with the inner peace of one who, in his traditional way, obeys righteous laws.

The other dog, of a lesser breed, with red fur, plays the part of the villain, or at least the sinner. He raises his hind leg, no doubt searching for a flea. It is not very elegant, and the fact that he is infested condemns him. You cannot see his nose or his eyes. He is anonymous, and has no collar; nobody is proud of him, he is too old to be trained, and is only good for the occasional kick.

One dog is rare, immaculately clean, and the object of envy. The other is ordinary, riddled with parasites, like a person scratching away at his wretched longings. These dogs speak to those who do not know this story with its tribulations. They are the voice of the street, of everyday life. Everybody has known a dog just like the little untrainable mongrel, and everybody might have dreamt of the other one, too beautiful to be real.

There are some pretty decorations above the judge's throne: little cherubs from antiquity having a terrible struggle to hold up heavy garlands of fruit and foliage. Underneath, sculpted medallions tell other stories which have also ended badly, such as the flaying of the satyr Marsyas, who claimed to be as good a musician as the god Apollo. The judge was much mistaken in ignoring such serious lessons. Perhaps he just took them for simple Italian ornaments, too difficult to see to worry about. Now he knows, but it is too late. And down there before him that blasted dog is still scratching itself.

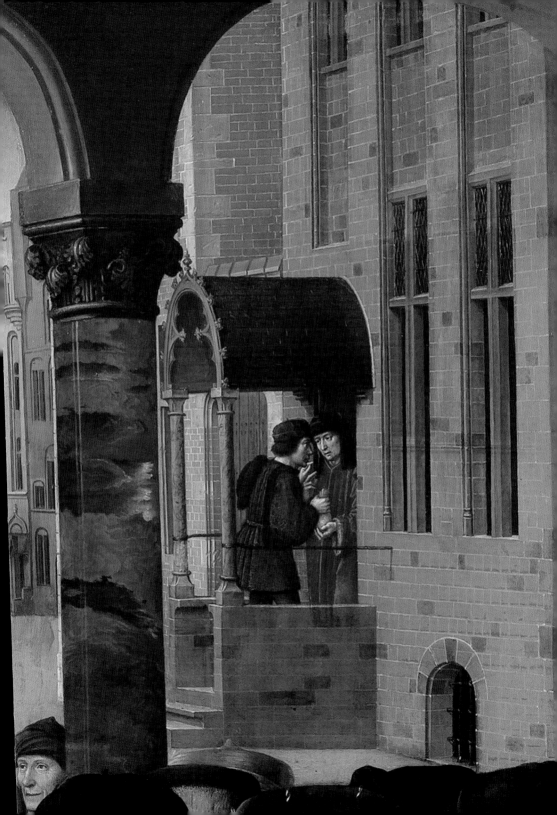

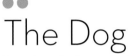

The Dog

Francisco de Goya y Lucientes (1746–1828)
1820–23. Oil on plaster, 134 x 80 cm. Prado Museum, Madrid.

It is too late. He won't escape. The painting is so high that one can hardly see the dog. There is nothing to be done against the moving sands, one just melts into them. The paint sometimes seems exhausted; giving in to the will of the sand, like a bog, it sucks down everything one would rather not see, or what one would rather never have seen.

The colours have faded, become too liquid to attach themselves to anything. They no longer speak. Light comes up from the depths, but is immediately tainted. The dog is exhausted.

Goya has come up against a wall. His touches of paint melt and disappear into empty space. He is working with the almost-invisible. By hanging on to what remains, he is attempting, up to the very end, to seize anything that still wants to live. The image is a kind of reprieve. In this crumbling matter, traces of wear and tear tell us nothing about what has happened, nor what can be learnt from it. This is not the end of a story, there is no event here. The work exists in a void.

Nothing can be heard. The dog's breath, perhaps, can penetrate the surface of the painting. He is lost without even having reached the edge of the picture. One can only see a few streaks in the recurring greys and ochres, perhaps fingerprints, or the marks of a slipping paw, it's all the same thing.

He is sinking down into a place that the spectator has no access to. Consciousness goes down too, with the body, able only to envisage its own disappearance.

It is almost a landscape, or at least the beginnings of a horizon. With his ears pricked up the dog is conserving his strength. On the other side, the line seems to climb up to the hills. The time has not yet come. In the scratches on the plaster he sees what nobody else can understand. The grey unending day closes in around him, creating shadows and presences.

The dog looks up, at something or someone. He is waiting and this patience is killing him. The twists and turns of a hunt have landed him in this nameless mass which is swallowing him up. The pursuit of the longed-for prey is now just a distant dream. It escaped a long time ago, he never really had the chance to come close to it. The artist wonders how it all happened so quickly, how one could suddenly be so alone.

The dog has not moved. The colour on the paintbrush is as weightless as ash.

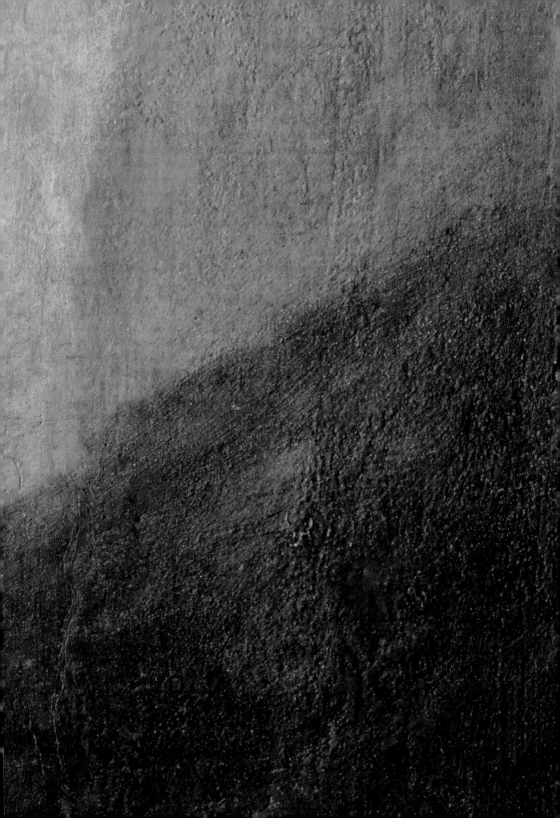

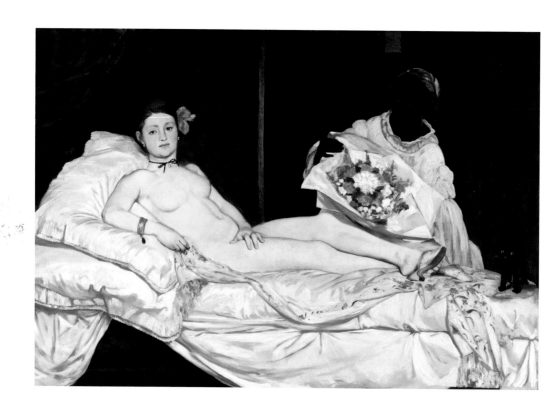

Olympia

Edouard Manet (1832-83)

1863. Oil on canvas, 130.5 x 190 cm. Musée d'Orsay, Paris.

She looks at the spectator. Her indifference tells us that she's seen plenty of them before. A servant brings a bunch of flowers; she's not interested. The young woman lying back on the big pillows will not give herself to anyone or anything. You come to her, and that is all.

The flowers that have been sent are of no more interest to her than those embroidered on the shawl she lies on. Manet paints them in much the same way, with a free and light touch. A few casual splashes of blue and red glow in the midst of the whites, rich and rustling, softened by yellow or embellished with gold.

Olympia is worse than naked, with those few jewels, the black ribbon around her neck, and the blue-edged slipper hanging precariously on her foot: she is simultaneously dressed and undressed, exhibiting a consciousness of herself designed to shock the bourgeois, smugly wrapped up in their high-brow principles. Ancient mythology had been so much more appropriate for Sunday visits to painters' studios, with the safe pleasures of respectable nudity: marble and mother-of-pearl flesh, modestly exposed, and above all a literary tradition descending from antiquity. All those surprised nymphs were so delightful to look at – their confusion excused their lack of clothing. But Manet is not in the business of providing a manual of good manners.

Beside this creature who refuses to avert her eyes for the sake of propriety, even the little cat stretching itself cannot claim to be innocent. A little sleeping cat might have been better than this immoral creature whose blackness melts into that of the curtain. Its arched body and eyes shining in the darkness produce a disquieting effect. Neither he nor the young lady could ever be acceptable companions. She is the epitome of impudence, lying so visibly in the bright light. He, although hardly noticeable, is not to be admired for his discretion. Rather, he simply confirms his centuries-old reputation for craftiness.

Olympia's cat arches his back with the same nervous energy that inhabits the supple body of the young woman. He is wary of whoever is approaching. The servant awaits her orders. She presents the bouquet, holding back the paper to display the flowers. But the visitor already knows that he has lost his privileges. He is the one being observed here, being gauged and sniffed at. The present was too banal. Olympia does not blink. The cat won't be disturbed after all.

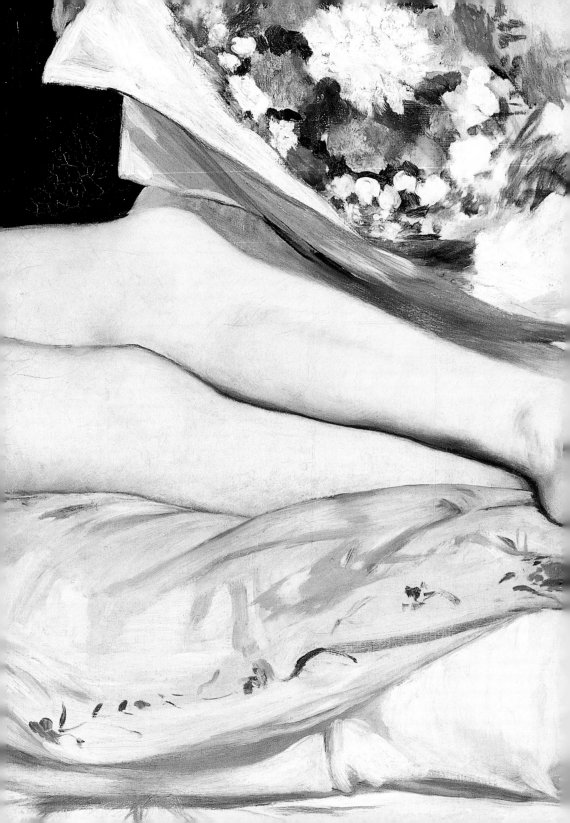

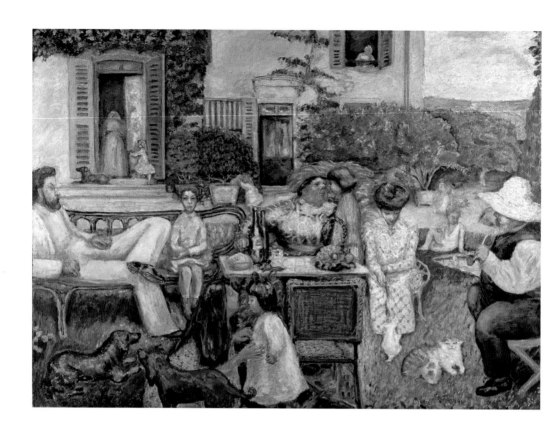

● ● ● ●

A Bourgeois Afternoon (or The Terrasse Family)

Pierre Bonnard (1867–1947)

1900. Oil on canvas, 139 x 212 cm. Musée d'Orsay, Paris.

Out in the garden, life goes by in slow motion. The backdrop of the solid house sets the scene. Each is in their place. They whisper in the ears of inquisitive children. The eldest sits nicely on the bench, as if for a portrait. The dogs fuss and yap. The cat narrows her eyes; she looks as though she is smiling.

Bonnard watches them living, making sure nothing and nobody is missing. He allocates roles according to character, stylizing the poses, submitting nature to the neat equilibrium of a striking scene. The artist is the winner in the game of happy families. The peaceful models connect with one another like patterns in a tapestry: full face, in profile, sitting, standing, young and old, frail and robust, turning to the left and the right, outside and indoors, the father, the mother, the grandmother, the grandfather, the dogs and the cats.

The artist, working with melody and counterpoint, leaves nothing to chance. Everything is equally important: there are no lesser roles or extras, whether with two or four legs. Each is offered the versatility of his brush, with soft and gentle shapes blossoming in the afternoon sun. The harmony of the painting seems to gently absorb the atmosphere, like an old-fashioned blotter.

Everything here is a complementary component of the whole, of carefully measured freedom and silent control. The strict lines of the facade, the relaxed curves of the bench, the discreetly playful patterning of the rush chairs, even the suggestion of untidiness on the table which holds together the centre of the tableau. Bonnard balances the tones and the silhouettes, creating a plotless choreography. The canvas moves from one to the other, contracting and dilating with a calm rhythm, as though breathing; it moves through all shades of authority and indulgence, of discipline and laissez-faire. The men act as frames to the scene. The women watch over the children. Over there, a dog lies on the doorstep guarding the entrance to the house. A cat plays with a ribbon. The different elements alternate and interlock. In this half-coloured world, life goes on, alternating vigour and drowsiness.

The dog and the cat: a necessary enmity
●

The traditional enmity between cats and dogs was less prevalent in the past. It does not appear before the thirteenth century, when, by order of the Pope, the new order of the Dominicans embarked on their ferocious battle against heresy. A Latin play on words on the name of their founder Saint Dominic (1170-1221) gave them the name *Domini Canes* or 'dogs of God', charged with guarding the purity of the Christian doctrine. This explains the presence in some religious paintings of black and white dogs, their colour referring to the order's habit. Cats, who were said to catch mice as fast as the Devil caught souls, were vilified at the same time, damned by the nature of their prey, since mice were said to be born of the excrement of Satan. The idea of the cat as the idol of heretics then began to spread, reinforced by the idea of the lecherous habits they were thought to indulge in, like cats. The good dog / evil cat pairing probably arose in this context, and became an efficient image for the preoccupations of the Church.

Fido, or the good dog
●

In his *Natural History* Pliny the Elder (AD 23–79) considers the dog, along with the horse, as the animal who is most faithful to man. This quality of loyalty prevailed over all the others in the Middle Ages, which saw the dog as the very symbol of fidelity: they were sculpted on tombs, lying at the feet of the dead, conveying their virtues into the afterlife. In portraits of women or couples, dogs often represent the attachment between spouses. One might on the other hand wonder whether the little dogs which sleep at the feet of a reclining Venus in Renaissance works represent the serenity of a clear conscience, or the momentary relaxation of its vigilance. As for portraits of children, which began to proliferate after the sixteenth century, the presence of dogs indicates the rigour of the education or training that is intended. Dogs are both friends, good servants, and a model of obedience. All these notions are contained in the traditional dog's name Fido, from the Latin fidere, to trust, something the ancient Egyptians had already conceived of at the deepest level, imagining Anubis, who guided souls to the afterlife, in the form of a god with the head of a dog.

The dog as symbols of wickedness
●

Dogs can, in many situations, be symbols of low instincts: at the end of the sixteenth century, Cesare Ripa's iconological list designated them as attributes of Envy, personified by a thin and ugly old woman. The Bible also gives dogs a fundamentally negative role, both in the Old and New Testaments: one of the Proverbs of Solomon quotes them as examples of persistence in error: 'As a dog returns to its vomit, so a fool reverts to his folly.' (Proverbs, 26, 11). And Christ warns his disciples: 'Do not give dogs what is holy; and do not throw your pearls in front of pigs, or they may trample them and then turn on you and tear you to pieces.' (Matthew, 7, 6). Dogs are often connected with the sow who 'when it has been washed, wallows in the mud' (Peter, 2, 22) or the pig, an animal reviled in the Jewish world, and their reputation consequently tarnished. Artists often depict a dog beside Judas at the moment during the Last Supper when Christ tells the disciples that he is about to be betrayed.

The cat and the devil
●

Worshipped in Ancient Egypt, not
mentioned in the Bible, the cat has
suffered from a negative image in
the West since the beginning of the
Middle Ages, despite its usefulness
at catching rodents in the home.
People were afraid of its skill and
suppleness; the uncatchable
creature was reproached for its
craftiness, its hypocrisy, its
propensity for quarrels, and its
voluptuous poses: all attributes
generally assigned to women. The
cat's purported inability to reason is
placed in parallel with the
indomitable nature of women, as
described in the *Roman de la Rose*
by Jean de Meung: 'As the cat
naturally knows the science of
catching mice, and cannot be
deflected from it, as it is entirely
turned in that direction, so with
women, so foolish are they in their
natural judgement.' And so the cat in
medieval imagination is charged with
all the sins of the vain and lascivious
woman: the one arching his back at
Olympia's feet in Manet's painting is
no exception; for the audience of
the time, its long symbolic past
would have been enough to display
the lady's lack of virtue, her
abandonment to her all-powerful
carnal desires. And its black fur only
confirms the malign nature of the
poor beast by connecting it to the
traditional garb of the devil.

The poet's cat
●

Baudelaire (1821–67), a friend and
contemporary of Manet's, wrote
several poems dedicated to cats. He
celebrates their sensuality which is all
the more striking for its splendid
ambivalence, which reappears in the
image of Olympia, painted a few
years later.
The Cat (1857)
Come, my fine cat, against my loving
 heart;
 Sheathe your sharp claws, and settle.
 And let my eyes into your pupils dart
 Where agate sparks with metal.
Now while my fingertips caress at leisure
 Your head and wiry curves,
 And that my hand's elated with the
 pleasure
 Of your electric nerves,
I think about my woman — how her
 glances
 Like yours, dear beast, deep-down
 And cold, can cut and wound one as
 with lances;
Then, too, she has that vagrant
 And subtle air of danger that makes
 fragrant
 Her body, lithe and brown.

The dog and the cat:
balanced rhythms
●

Bonnard painted dogs and cats
throughout his life, either on their
own or as part of larger
compositions, frequently placing
them within a similar image. If
there is no particular symbolism in
his use of animals, a peaceful
domestic intimacy is suggested by
the presence of these familiar
animals, which reinforces the very
interiorized image of the home.
The way each one behaves sets
the rhythm of the composition: the
particular qualities of body
language conveyed by cat or dog
in a sense form the narrative of the
picture. They reverberate within
the painting, which rather than
relating an anecdote, is
constructed more like a piece of
music, harmonizing all the
similarities and contrasts of their
movements. Bonnard observed
animals very closely, describing
them in his notebooks, as though
they were so many different
tonalities: 'The cat's moments of
daydream, the dog's sleep
between spasms of excitement.'

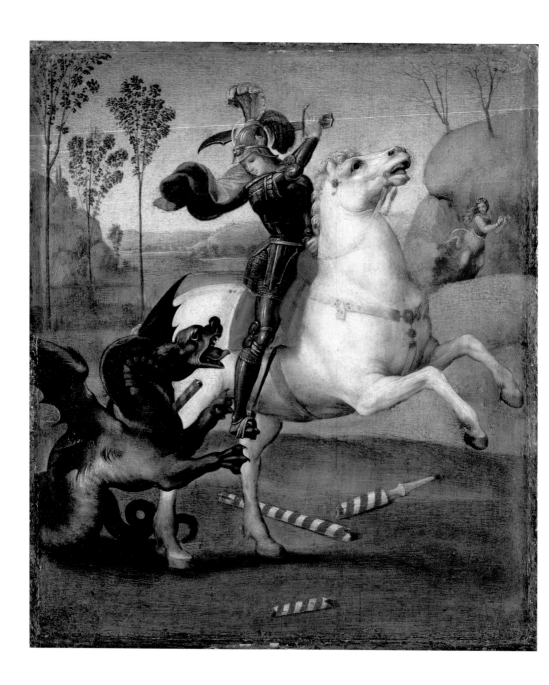

The horse

.
.
.
.
.
.
.
●

Saint George and the Dragon

Raphael (Raffaello Sanzio) (1483–1520)
1504–5. Oil on wood, 30.7 x 26.8 cm. Louvre, Paris.

.
.

.

The gallant knight prepares to strike. He has broken his lance several times, and one of the pieces remains embedded in the dragon's chest. The white horse forms an insuperable barrier between the monster and the fleeing princess.

The scene would be familiar even if one didn't know the names of the protagonists: a bold hero, a damsel in distress, a battle against a terrifying monster. Here, the tiny halo that can be glimpsed beneath the hero's feathers reveals the holy story beneath the epic tale which includes every fable in mythology. Saint George fights against the forces of evil incarnated in this hybrid mud-coloured being. The terrified beauty is none other than the Christian soul tormented by a pursuing demon.

The painting shows us a merciless battle, with no prospect of immediate victory in sight as far as one can tell. The dragon appears weakened, and looking up at the saint without daring to rear up completely, he growls and roars. The lance which has pierced him has not killed him, and his retreat is only temporary. However the evil beast will soon be tamed and the princess, reassured, will be able to return and place her belt around his neck. But the Devil on his leash will not remain still and will try to break his shackles again. Victories and defeats will continue in succession, and history will continue to advance and then retrace its steps, to settle its fate and then change direction, as tortuous as the body of the dragon.

Even though one is well aware of all this future uncertainty, there are no doubts about the outcome of this particular bout. It is the horse, as much as – if

not more than – the angel-faced hero, who will guarantee its glorious outcome. He is the very incarnation of the light that will defeat the machinations of the Devil. No doubt all the saint's virtue and courage will repel them, but his steed represents something that goes beyond all human endeavour. His central position in the painting and the radiance of his coat signal to us that he is the true representative of Virtue.

Beside the horse's powerful neck, even the mountains appear insubstantial, the trees young and frail beneath a blank sky. The horse, against this tranquil landscape, seems to embody the vital forces of nature; he is the dynamic heart of the painting. The saint is looking over his shoulder and protecting his back, whilst the horse, his head raised towards the sky, anticipates the ending and seems to announce that the hereafter is the only possible goal for this formidable venture.

The animal's importance in no way diminishes that of the saint – they represent two facets of the same principle. One is acting, the other is being. The timelessness of the divine essence represented by the horse corresponds to the spiritual battle being fought by the soldier.

The antagonism between good and evil is emphasized by the resemblances between the horse and dragon: Raphael naturally conceives Saint George and the dragon as the protagonists of the legend, but in reality, the true confrontation is between horse and beast rather than man and beast. Hence the rigorous parallels between the two which dominate the whole composition, determining their posture and the tilt of their heads: the dragon, terrestrial though he is, insists on miming the horse's posture. He falls into step with him, opens his mouth and rears up. He is a caricature of something he cannot grasp, projecting himself like a distorted reflection of the heavenly animal.

The fact is, the Devil has never forgotten his original purpose. All he is doing is re-enacting an unchanging scenario, like a gambler who always bets on the same number, counting on the law of probability for his number to come up eventually. The demon was once such a beautiful archangel and God entrusted him with light: his name was Lucifer. But the pride that came with his mission made him forget that he was a mere servant. He took himself for master, and seized hold of the divine light, which suited him so well that he thought he himself had created it. Lucifer was punished for his sin and hurled down into Hell. The fallen archangel became master of the underworld. Here he returns to the charge, sinuous and embroiled in contradictions, with fins that masquerade as wings, this time more servile than openly menacing.

The horse does not look at him. He is on a journey and will not by waylaid.

Horsemen on the Beach

Paul Gauguin (1848–1903)
1902. Oil on canvas, 66 x 76 cm. Folkwang Museum, Essen.

They ride towards the sea. They leave no trace on the pink grass. They sink slightly into the pigment, and then diminish and disappear completely into the blue shadows. One can glimpse a spit of land a few steps further ahead, and then nothing but the water, the advancing waves, and very soon the grey sky.

The horsemen are riding bare-back, barefoot and hardly dressed. There are two men, and near them a young boy. Young women enter the picture, bright shapes hooded in yellow and red. There are three purple trees standing there, as if to provide a meeting place. There is a mound, perhaps the beginning of a hill, on the left of the painting. The bright grass, tinted with yellow, turns to a warm orange.

Gauguin has come a long way to observe this story as it begins. A few young people sometimes gather at the edge of the island. Couples will perhaps be formed, but not just yet, that's not what this is about. The painting is not interested in them, it just records the direction taken, the convergence of the paths, their separate natures.

The three horses with their backs to us are still a part of this earth. It does not matter that the artist might have observed them on his walks, and even stylized their shapes, remembering other images. They nonetheless represent a lived reality, a real experience. The other two, riding along the beach with their high profiles and clipped necks, date from a long time ago: their gallop began on the friezes of the Parthenon, whose stone colour they still retain. Gauguin engineers a meeting between the two worlds, where he no longer finds any contradiction. The two groups of riders reflect his own journey which has linked the West with this tropical adventure.

No matter how far he travels, and what horizons he reaches, his work continues to refer to memories of the past: all the forms of that classical culture that he had admired, loved and hated, that he had finally abandoned for other skies, are still there before him, present until the end. Two marble horses, bearers of all the nobility of antiquity, have re-entered his consciousness, ignoring his about-turns and rebellions. And in the distance, the foam of the waves ripples like a horse's mane.

● ● ●

Improvisation III

Wassily Kandinsky (1866-1944)
1909. Oil on canvas, 94 x 130 cm. Pompidou Centre, Paris.

The landscape seems to vibrate under the pressure of the different colours. The black contours compress the shapes without quite containing them. Long strokes of paint cross the painting, capturing the exact moment before the jump. The horse has reached this precise point and is about to leap.

The rider and his mount are carried along over the obstacle by the flux of matter. Other figures, who stand immobile on the left of the picture, seem deep in conversation. The moment of thought before departure, the retreat before the forward spring. Kandinsky intends to show both the vitality of movement and its rising force. Colours are exchanged: the heavy fortress-like building glows like the sun, and the trees and bushes absorb the blue of the sky. The green horse, like the leaves themselves, is a vibrant expression of the dynamism of nature. Everything in this image is focused on movement, starting with the paintbrush itself, and followed by that of the body and the spirit.

This painting marks an end to the tradition of equestrian figures; it inaugurates another kind of conquest. There is no longer any question of celebrating the glory of great soldiers, or of showing examples in the virtues of the great heroes. Here we are admiring an extraordinary leap forward. The nameless figure is shaped somewhere between an angel and a horseman. His great pink cape forms wings and he seems to be clothed in a cloud. No ride has ever been so important. With the improvising skill that results from long experience of discipline and mastery of technique, the painter is able to loosen the reins. He throws the charger into a gallop; what is left behind is dying of old age, all the minutiae of ancient imagery, the descriptive anecdotes of past stage settings, all are now fleeting shadows, soon to disappear. Princesses will now sleep forever, no longer in fear of worn out dragons.

On the other side of the bridge, the painting will shed the past and the visible shapes which held back its flight, and move into abstraction. The old forms will fall away like a moulting skin, and the horse will finally melt into the infinite blue of the spirit.

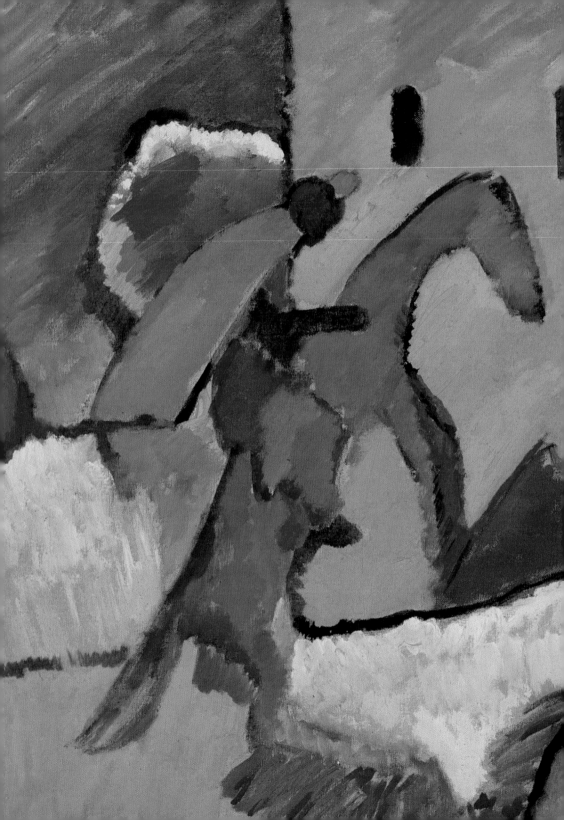

The role of the white horse

Most heavenly horses are born of the wind, whose speed they share, and they accompany the sun on its journey through the sky. Harnessed to Apollo's chariot, like the senses tethered to nobility of spirit, their coats are immaculately white to demonstrate their solar nature. In their post-mythological incarnation, white horses are the chosen steed of saints, heroes and spiritual conquerors. Anybody who struggles against evil benefits from the supernatural power of the animal that symbolizes virtue. Shown alone, a white horse can even represent the figure of Christ as is the case in a twelfth century fresco at Notre-Dame de Montmorillon, in which he appears with a cross-shaped halo. Picasso's white horses in his bull-fighting paintings, and in particular the one who suffers in the monumental *Guernica* (1937), express the same concept. They are images of goodness, love and innocence confronted with the cruelty of a world that has tortured or sacrificed them.

'The White Horse' as a traditional name for an inn dates from the legend of the Hippocrene spring – from the Greek 'horse's spring' – which appeared after a kick from Pegasus's hoof. This theme reappears in the stories of the druids. It is a reminder of the mythical origin of springs, close to which, sensibly, such resting houses were built.

The myth of Pegasus

The myth of Pegasus, a luminous creature born out of evil forces, is one of those that most clearly illustrates the highly sacred value of the horse. After Perseus has decapitated Medusa, the Gorgon, with her crown of squirming snakes, a winged white horse rises up from the hideous corpse. He flies to Olympus and puts himself at the service of Zeus, the king of the gods. The stories of his exact origin vary: some say he was born of Poseidon and the Gorgon, others that it was the earth soaked in the blood of Medusa which gave him life. In either case, the horse is the exact opposite of the dark world from which he has emerged. His radiant power contains the knowledge of the darkness. He was nourished by it, and has absorbed and overcome it. Thus he symbolizes victory over evil, not through battle, but through the knowledge he has gained from his own origins. He has grown out of serpents, as if from roots, and up towards the regions of light, a manifestation of the sublimation of instinct.

The horse and the world of the dead

It has been proven that horses were sacrificed in such prehistoric sites as Solutre, where the bones of thousands of animals were found. Equally, in antiquity, it was customary to put horses to death to accompany their masters to the afterworld. More than just a lavish gift, they were also the surest guarantee of his journey into the next world. This was the theme of the scene in the *Iliad* when Achilles oversees the funeral of Patrocles: 'Four proud horses did he then cast upon the pyre, groaning the while he did so' (*Iliad* XXIII). This role as the guide of souls, which horses share with dogs and cats, is an important element in the composition of equestrian monuments and paintings inspired by them. In both the classical world and that of the Renaissance, from the statue of the emperor Marcus Aurelius on the Capitol in Rome to Titian's portrait of Charles V in the Prado, the presence of the horse signifies that the man can travel without danger, and perhaps without fear, as far as the next world.

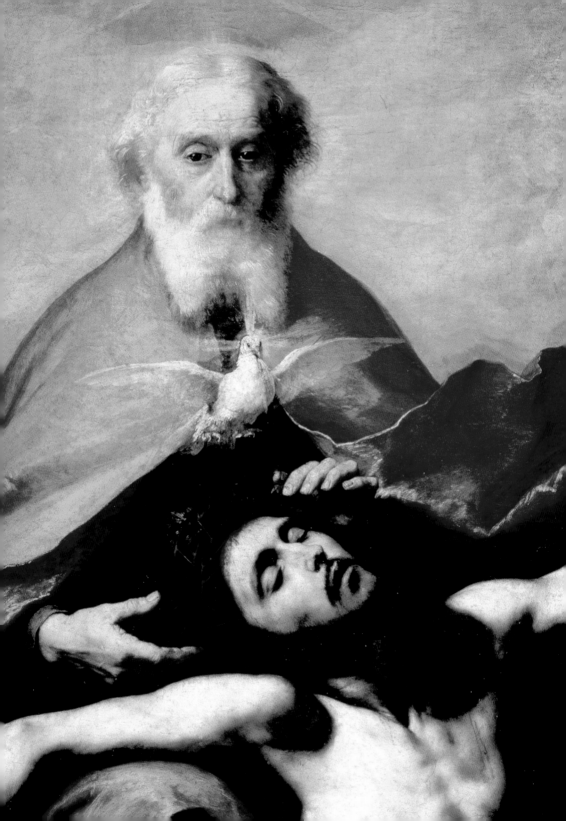

●●

The Magpie

Claude Monet (1840-1926)
1869. Oil on canvas, 89 x 130 cm. Musée d'Orsay, Paris.

.

.

.

A little black patch in a white landscape, a minute presence which nonetheless gives the painting its title: the magpie reigns over this scene.

On the face of it she is no more than a small detail in the dazzling scene that blinds the viewer's eyes. The brightness of the snow is what first catches the eye, drawing it far away towards the fields, to the bright stretches of continuous light. The foreground is bare: if you lower your eyes the only landmark you see is the artist's signature. Above the large milky-grey roof the branches of the trees are laden with frost. The hedge acts as a horizon.

The white only appears simple. It is in fact full of reflections of the nature that surrounds it, brushing the surface and adding translucent reflections of blue, pink, yellow, mauve and grey. All these shades have accumulated in what at first appeared to be a complete absence of colour. Monet confuses the eye with a falsely monochromatic image, an illustration of light itself. In painting the snowy countryside, he has reflected the colours that float in the air; instead of adding to the brightness, they reveal it as a prism composing and decomposing itself with random exuberance. The magpie's black and white plumage punctuates these perpetually moving colours.

Snow is a perfect tool for the artist, concealing as it does contour, texture and individual detail. By showing an attenuated version of nature it allows the freedom to paint a simplified version of reality. The physical reality of things has to give way to the uniformity of the paint, and allow its edges to soften. The spectator who imagines themselves wading through the snow might well be overtaken by a kind of winter lethargy. But the magpie, perched on top of the gate, prevents this just in time. Like every magpie in every garden, it chatters and sings relentlessly, a useful counterpoint, emphasizing and breaking the prevailing silence. The bird is like an apostrophe in the picture, and as clear and strident as a musical note on a score.

.

.

.

.

.

.

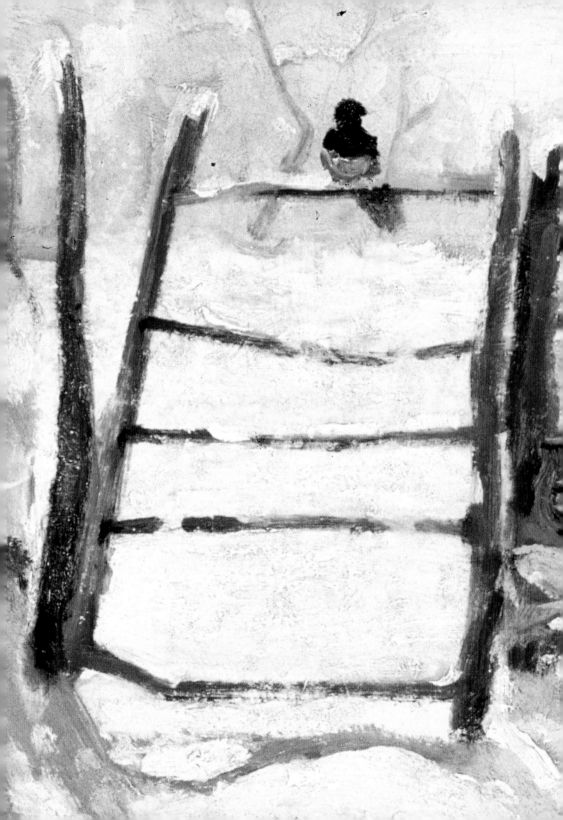

●●●

Flying Off

Georges Braque (1882-1963)

1956-61. Oil and sand on canvas stretched on a panel, 114 x 170.5 cm.
Pompidou Centre, Paris.

.

.

.

The bird flies straight to the target. The stony surface doesn't slow down its flight. Its neck grows longer, stretched like a blade. One does not know what it is aiming at, nor what it is suffering. It travels through a rough opaque substance like an old wall. Harsh but accessible, its texture simple enough to accept the danger slicing through it.

Braque paints space and what it reveals: a profile cut out in the distance invalidates the emptiness. Its interrupted motion, a part of the mass, penetrates the surface, denying the fatal danger of gravity. This bird only knows its own lightness.

As pure as a blackboard, the bird overcomes the inertia of the world and is ready for anything. It discovers its own existence as it progresses, changing as it goes along. It is not held back by any of the sort of details that might have trapped it in the confines of any particular story. The picture seizes just one of those unquantifiable appearances, a solitary landmark in the midst of all the transformations that are still to come: it will be a pale silhouette against future eclipses, sudden and soft perhaps, like the large block of black edged with grey which appears before him.

The artist has left a geometrical imprint around the contour of the wings, a line which has now become a part of the bird that he was creating. The bird has become distorted, changed from its original appearance, in its craving for a new space. The artist, holding the familiar tool in his hands, carried on digging into his palette and choosing his colours. What he touched became a bird, on a horizon he did not need to create.

The bird multiplies itself into infinity. A smaller grey bird, right against him, follows his flight. Another one, as white as a blank canvas, inhabits its own little frame. The work alternates between light and dark, between blue and black, creating a balanced image full of barren echoes. The grains of sand embedded in the thick paint of the sky mingle with the colour and one by one unhurriedly measure the present moment.

.

.

The bird, the soul and the Holy Ghost
●

The bird is the symbol of the air in which it flies, the infinity of space and the freedom of being in a place where you will meet no obstacles. As both a terrestrial and aerial creature, it represents a link between matter and spirit, flesh and the soul. More precisely Plato likens the flight of a bird to the soul: 'The wing is the corporeal element which is most akin to the divine, and which by nature tends to soar aloft and carry that which gravitates downwards into the upper region, which is the habitation of the gods. The divine is beauty, wisdom, goodness, and the like; and by these the wing of the soul is nourished, and grows apace; but when fed upon evil and foulness and the opposite of good, wastes and falls away.'(*Phaedrus* 246). The four Gospels relate the episode during the baptism of Jesus when 'the heavens opened' (Matthew, 3, 16). John also declared, 'I saw the Spirit coming down on him from heaven like a dove and resting on him. I did not know him myself, but he who sent me to baptize with water had said to me, "The man on whom you see the Spirit come down and rest is the one who is going to baptize with the Holy Spirit". Yes, I have seen and I am the witness that he is the Chosen One of God.' (John, 1, 32-34). From the sixth century onwards, the dove features in images of the Annunciation, the baptism of Christ, the Pentecost and the Trinity.

The bird as image of faith in providence
●

The bird that is carefree of the future is frequently used in Biblical texts as an exemplary image of faith in God: 'That is why I am telling you not to worry about your life and what you are to eat, nor about your body and how you are to clothe it. Surely life means more than food, and the body more than clothing! Look at the birds in the sky. They do not sow or reap or gather into barns; yet your heavenly Father feeds them. Are you not worth much more than they are? Can any of you, for all his worrying, add one single cubit to his span of life?' (Matthew, 6, 25-27) In the thirteenth century, Saint Francis of Assisi took up this theme, and saw animals as models for the mendicant order that he founded, the Franciscans: 'The little brothers, like the birds in the sky, must possess nothing, but trust only in the Providence of God.'

The dove as symbol of gentleness and love
●

The dove was one of Venus's companions, symbolizing the gentle bonds of marriage; it shared some of the goddess's characteristics, such as gentleness and beauty. It retained these qualities in Biblical texts, as in the Song of Songs, where the loved one is exalted: 'How beautiful you are, my love, how beautiful you are! Your eyes, behind your veil, are doves' (Song of Songs, 4, 1). The plumage of the dove is seen as a sign of purity, the opposite of the blackness of the crow, who represents the impenitent sinner. It appears again as a symbol of innocence in the words of Christ: 'Remember, I am sending you out like sheep among wolves; so be cunning as serpents and yet as harmless as doves.' (Matthew, 10, 16)

The dove of peace
●

Picasso's famous lithograph of a dove was chosen by Louis Aragon to be the emblem of the World Congress for Peace in 1949. Although not religious, the image (possibly a pigeon in reality) returns to a theme from the Old Testament. It was the sight of a dove that informed Noah that the Flood was over and divine anger had been appeased. The bird, the 'dove of peace' acts as a messenger of reconciliation between heaven and earth. 'At the end of forty days, Noah opened the porthole he had made in the ark and he sent out the raven. This went off, and flew back and forth until the waters dried up from the earth. Then he sent out the dove, to see whether the waters were receding from the surface of the earth. The dove, finding nowhere to perch, returned to him in the ark, for there was water over the whole surface of the earth; putting out his hand he took hold of it and brought it back into the ark with him. After waiting seven more days, again he sent out the dove from the ark. In the evening the dove came back and there it was with a new olive-branch in its beak. So Noah realized that the waters were receding from the earth.' (Genesis, 8, 6–11)

The magpie as symbol of gossip
●

In one of the legends of ancient mythology, the Pierides, nine young girls from Thracia defied the nine Muses by claiming to sing better than them. As a punishment they were changed into magpies whose chattering song is painful to the ear. In Ovid's *Metamorphoses*, one of the Muses, Uranie, tells their story to Athena: 'There were nine of them, roosting up in the branches, all bemoaning their fates; they were magpies, wonderful mimics. The Muse replied to the puzzled goddess, "Those creatures up there have recently joined the mass of birds after losing a contest" . . . Puffed in the pride of their numbers, this rabble of ignorant sisters travelled through all the towns of Haemonia and all of Achaea here to Parnassus and then presented the following challenge: "Cease to deceive the uncultured mob with your empty attractions. If you believe in your musical gifts, Heliconian Muses, you'll surely agree to compete with us."' (*Metamorphoses* V, 296–309). For the same reason the magpie is sometimes shown in holy scenes, where it represents the antithesis of the Word of God.

The sacred role of birds
●

Birds appear as attributes of particular saints, such as Saint John the Evangelist, who has an owl with him as an image of his spiritual elevation. Or they can play a part in a particular story, like the little birds who listened to the preaching of Saint Francis of Assisi, thereby confirming the universality of his language. There is a long list of species associated with particular moral qualities, according to their colour or behaviour, as well as many beliefs and legends associated with birds. They most often act as intermediaries, rather in the manner of angels: a dove inspires Saint Gregory the Great and chooses Saint Joseph as future husband of the Virgin Mary by landing on his stick; a crow brings bread to Elias and Saint Paul the Hermit. According to Saint Augustine, the croaking of this black bird – which can sound a little like cras, meaning 'tomorrow' in Latin – signifies its refusal to mend its ways by always procrastinating, hence its solid black colour. Or, perhaps, one can see in that some kind of promise or hope for the future. The pelican, reputed to feed its young with its own flesh, represents paternal love and sacrifice, and more specifically, Christ himself. A little goldfinch, the playmate of the infant Jesus, foreshadows the death on the cross with its red breast. And the peacock, whose flesh was thought to be incorruptible in antiquity, wears the omnipresent eye of God on his feathers.

THE ELOQUENCE

OF

OBJECTS

THE ELOQUENCE OF OBJECTS

'A comparison is often the beginning of a symbol' wrote Gaston Bachelard. And man-made objects, whatever they are used for, are often subject to the wanderings of the imagination, which leads down unexpected paths. Most of the time the trigger is a simple association of ideas: the ladder on which you stand, a wobbling pair of scales or a closed curtain will suddenly reveal a significant moral correlation. You find yourself contemplating a desire for elevation, or begin to feel the need to weigh up pros and cons, brought about by contact with everyday objects, whose connections become part of the symbolism of everyday life.

However, it is sometimes difficult to distinguish between an object placed in a painting for its symbolic value, and one that just happens to be there, with no ulterior purpose. Some objects, such as the cross, always and to this day carry a particular meaning, and will therefore continue to hold the attention of the viewer. Others will have long since melted back into the normality of ordinary life. The Church, with its powerful use of imagery, regarded the tangible world as a kind of dictionary, a network of meanings devised by the highest authorities. In the Middle Ages, the smallest thing mentioned in the Bible became clothed and illuminated by the divine Word: no window, no mirror could appear in a painting except in relation to its first mention in the holy text. One might suppose that this symbolic vitality would die down and that objects would no longer be seen in this single perspective. But the process continues through the very ambivalence of things: Gerard Dou's shopgirl, shown in the full banality of her everyday life, is suddenly caught up in a daydream in which the smallest

detail plays its part. The disappearance of symbols and her sudden awakening are the true subjects of the painting. An object's strength often springs from displacement, when they are found where they are least expected, in a place where their normal function cannot justify their presence. This is found as much in contemporary works which have no narrative as in ancient stage settings: Sutherland's majestic scales, Kiefer's solitary book, immediately become solid and powerful emblems.

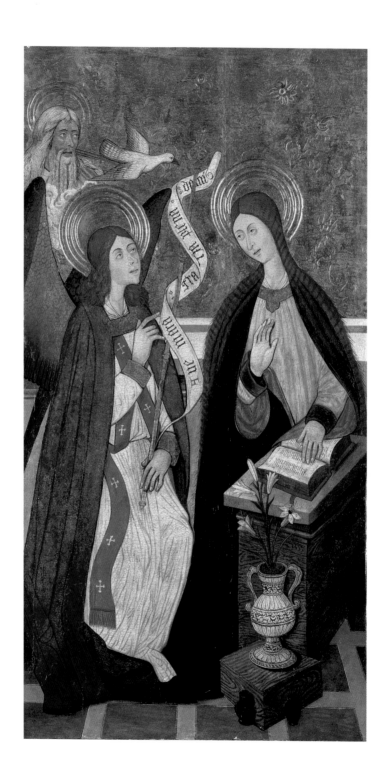

The book

The Annunciation

Pedro Espalargucs (fifteenth century)
Fifteenth century. Oil on wood, 142 x 80 cm. Musée Goya, Castres.

The visitor has interrupted her train of thought. The Virgin, with a surprised expression, tilts her head to hear this unexpected angel who has suddenly appeared, without her noticing his approach. The breath of God has entered the house with the wings of the dove. She keeps her hand on her book, so as not to lose her place.

Space is limited. There is only room for what is essential. Every detail has its role in the story because everything that exists is there to reveal the Word of God in action: the artist's luminous composition is like a text in which each word must be clearly written.

God remains in the background, on high, like a father watching the lives of his descendants, measuring the progress of each one. The son has yet to be born. The dove above the angel points its beak towards the centre of the painting bathed in gold. Everything is ready.

Mary listens to the angel, who resembles her but whom she cannot see. He is speaking to her and she understands his language – it has always been a part of her. Are they not like brother and sister, with identical faces? She, with the long loose hair of a young girl, he, with his great coat over his shoulders, like a traveller who has just arrived and will not be lingering. He won't even have time to fold his wings. Angels only exist through the power of their message.

The Christian world eliminated the pagan gods, but often retained their accessories: the stick in the angel's hand is that of Hermes, the messenger god of

the Greeks. His wand, previously entwined with snakes, now carries the text of the angelic greeting. The archangel Gabriel speaks in Latin: 'Ave Maria gratia plena' (Hail Mary full of grace). His words are written on the phylactera as he pronounces them, twining around this golden stick, which has now gone from being a simple shepherd's crook to a royal sceptre. The subject here is the birth of a poor child amongst poor people. And also the birth of a king.

The Word must also be visible to us all. The scroll is raised up between the angel and the Virgin, in the very space where it is being spoken and heard.

The painting shows us what cannot be seen, or what could not be seen until then: Mary appears to be reading the words she is hearing. She is thus positioned between two texts, two versions of the Word: the Bible, the book of ancient law, which we cannot decipher because God made himself heard but never showed himself; and the scroll whose words we can read, because it is announcing the Incarnation. At the bottom of the painting, the white of the flowers recalls the chastity of the Virgin and the purity of the child to come.

The whole scene is based on a mixture of familiarity and the unknown. The revelation does not surprise Mary or the person looking at the painting, because it had all been predicted, written in the book in front of the Virgin, more as a sign than an object. She would not have been able to read all those words, but she is their recipient and she will continue to store them. Thus the event that has taken place is connected to the past. It does not change the story that awaits her in this book that lies open, like her own life.

With her right hand raised in response to the angelic greeting, Mary keeps the other flat on the Bible, and serenely submits to the will of God. Her whole body conveys this; she seems to be swearing an oath at this moment. Having reached the exact point in history where the scripture will become flesh in her own body, she quite naturally turns towards the very words that announced that this would happen. She cannot forget the words of the prophets: she must not lose a page of the Book, she must not turn away from what was taught long ago. The announcement that has just been made is simply the first sentence of the next chapter.

● ●
The Lecture

Henri Fantin-Latour (1836–1904)
1877. Oil on canvas, 97 x 130 cm. Musée des Beaux-Arts, Lyon.

A dark-haired young woman, leaning on the edge of a table, is absorbed in her book. She holds it in a detached way, as though she already knows what she is reading about. Her posture does not exactly suggest indifference, more a subtle withdrawal: the tilt of her head suggests that she has already been through this text and is now evaluating its importance. There is no suggestion of the surprise or awakening of curiosity that might accompany the discovery of new book, with perhaps an almost imperceptible tremor of excitement. In any case, without knowing its contents, one can see that the volume, lying wide open, has been worn out by being read over and over again, but perhaps never finished. Unless the book has simply been damaged by too much handling, taken from some family library. It is not necessarily particularly old, just a small bound volume, soon worn out.

It seems as though the other young woman is listening: she is reading out loud. Perhaps there are comments, and exchange of opinion. Or perhaps she is simply waiting for the end of the chapter, already thinking of something else with that determined profile, focused on some plan that is occupying her mind. The hard-backed chairs are not conducive to daydreaming. The afternoon drags on, boredom looms. But still the dark red reflections on the fabric of her dress do not sink into blackness, and her slightly dishevelled blond hair softens the austerity of her dress. Beside her the splash of red introduces an unexpected note of energy and movement, breaking into the lethargy of the afternoon.

No gesture or movement is possible here. The space in the painting is limited, as Fantin-Latour has constructed the decor as a kind of impasse: a solid wall and a shut door, and on the table a Turkish carpet that muffles all sound, and a few roses gradually dying. But they are only half way through the book. Words have accumulated throughout these pages, inspiring thoughts which, without warning, take shape at the end of a paragraph, or even between the lines. All that is needed is one phrase, one phrase that might awaken, hold together or break away this secret imperious voice that will not be hushed. And a whole life might change.

The Book

Anselm Kiefer (1945)
1979–85. Mixed materials on canvas in two sections, 330 x 555 cm.
Hirschhorn Museum and Sculpture Garden, Smithsonian Institute, Washington, D.C.

.

.

.

The earth will not swallow up this book. It will bury the dead and the traces of lost paths, rain, snow and dust will fall upon it, it will reach the skies with its whirlpools of mud, almost wiping out the horizon that is pushed right to the top of the picture. But it will not swallow the book.

It has landed on the earth, as heavy as a stone. A stubborn ruin that one could avoid but not fail to notice. It is like a keystone.

Footsteps disappear into the mud, their resistance tested. The lines which criss-cross the painting are like roads and railways, with tracks forking and crossing one another. The solitary book weighs heavily at the meeting of paths.

The only element taken from ancient paintings here is the scene of the empty battlefield – one of those mornings after an inglorious skirmish when survivors come out to pick over the debris. There are no corpses left. Perhaps their names are in the book, the smallest squeezed between the lines. They fill up the emptiness of the open book, in which nothing can be deciphered. Perhaps the words disappeared with the cries that nobody heard, somewhere beneath the dried-out grass. The thick paint, splashed with red in places, seems to weigh down and re-shape them. This huge canvas, as big as a wall, will never be big enough to tell the whole story.

The book had to remain there to preserve what the earth had forgotten, and the earth had to stretch beyond it to embody what was written, to show the cruelty of the world and all its wounds, the repeated migrations which left their marks on the rocks themselves; the miserable epics and fires that never died out. The canvas throws it all together in disorder, as though there was no time to choose, everything had to be preserved. The burned book turns to stone in the ashes; there are remnants of the dead lingering in the mud. Grey shadows in the distance seem to search for a shore. The book obstinately survives, floating above the turmoil.

.

.

.

.

.

Text and image
●

Although the second of the Ten Commandments expressly forbids the making of graven images, the Christian Church in the Middle Ages made all possible use of painting, mainly for didactic purposes. The direct justification for this was found in the incarnation of Christ: God, invisible throughout the Old Testament, became visible in the form of his son, and so painting does nothing more than reiterate this ultimate expression of the image par excellence. However, the book, a frequently used motif in the religious iconography of the Middle Ages, is a reminder that the Revelation came primarily in and through words. It sends us back to the expression of the Word of God, or at least to that of something transcendental; by emphasizing the unchangeable nature of the text, in the midst of the changing appearances of the world, we are assured of its pre-eminent and seminal position. And so the artist, who knows how to illustrate, reproduce and recreate, makes a space for the book, which, no matter what kind it is, functions as an illustration, sometimes nostalgic, of the absolute power of a thought: it is simultaneously the starting point, the ideal, and the end of all creation.

The Book and other books
●

From the Middle Ages until the sixteenth century, the books that were depicted in paintings were generally there as symbols of the teaching of Christianity and of fidelity to Christ. The book is an essential attribute of Christ in glory or Christ all-powerful. It also appears in depictions of the evangelists writing, an image from antiquity, in which the book most often characterized the figure of the author. This is why it is associated equally with the Fathers of the Church, theologians and saints, as it celebrates their works and their erudition. Examples of these are Saint Gregory the Great, Saint Thomas Aquinas, and Saint Jerome, who translated the Greek Bible into Latin. During the Renaissance, the book was valued as a general symbol of wisdom – the wisdom of prophets and oracles – but also as the personification of the figures of grammar and rhetoric, or the Muses of history or poetry. The book was connected in different degrees, too, with Truth, Fame, Eloquence and Melancholy, as its symbolism became more secular with the passage of time. After the Bible, the Gospels and books of prayer came scientific treatises and account books, with finally, in nineteenth century, depictions of novels. The attribute of the exemplary figure became simply that of the ordinary reader.

The Annunciation and the Virgin Mary's Book
●

From the end of the Middle Ages onward, scenes representing the Annunciation always included a book. It was placed beside the Virgin Mary, sometimes on her knees or in her hands, and it was an allusion to the incarnation of the Word into flesh: what was written was becoming flesh at that very moment. The symbolic connection between the Book and the Virgin – both rendering visible the Word of God – also underlines the theme of the accomplishment of the law through the workings of Grace. It is also a reminder of a particular passage from the Old Testament which, from the Christian perspective, was regarded as a prophecy of the birth of Christ: 'The Lord himself, therefore, will give you a sign. It is this: the maiden is with child and will soon give birth to a son whom she will call Immanuel. On curds and honey will he feed until he knows how to refuse evil and choose good.' (Isaiah, 7, 14–15)

The shape of books: the scroll and the codex
●

Most of the books depicted in ancient paintings are in codex form, arranged in pages as they are today. However, in antiquity we see tablets of wax or rolls of papyrus and later of parchment, as sometimes depicted in representations of the prophets. The distinction between these two forms comes not only from their different historical setting, but also from two distinct forms of religious teaching: paganism and Judaism are attached to the scroll form, whereas the codex is representative of the birth and development of Christianity. The codex, which was familiar to the Romans, could contain longer texts and it was easier to find particular passages for study. This partly explains its role in the spreading of the Christian message, intended for as many readers as possible. In the early centuries of the Church's existence, the scroll-book was intended for a relatively small readership, whereas the codex was normally reserved for scholarly or technical tracts, or personal journals and notes. This popular medium made it the most effective way of propagating the Gospels, followed by texts of every kind during later antiquity, both in the East and in the West. The book which appears in the images of the Annunciation, although anachronistic as an object, works as the symbol of the transition to the new faith.

Flying words: the phylactera
●

Phylactera are the scrolls, with or without inscriptions, which one sees floating in the air in religious paintings. Larger or smaller, in more or less motion according to period and style of painting, they are, first and foremost, a way of identifying the figures, as sometimes the attributes – or lack of attributes – as well as their generalized physical features, are insufficient for their identification by the faithful. These inscribed banners, derived from the shape of the scroll, are even more useful in 'spoken' scenes, in which they play the part now seen in the speech-bubbles of today's comic strips. This is why phylactera are mostly held by angels, although they can appear beside apostles, prophets or saints: their words are clearly inscribed, becoming in a sense audible for the spectator. All this is to say that, unlike the scroll or the book, the phylactera is not an object that plays a part in the scene, it is merely a technical support, standing in for speech. After the Renaissance, it would gradually disappear from paintings, as their content had become so familiar that the faithful no longer needed 'sub-titles', but also because they were no longer compatible with the illusionist effect that painters were aiming for.

Reading in the nineteenth century
●

The theme of reading became more and more frequent in painting from the end of the eighteenth century, and by the end of the nineteenth was a recognizable part of the general iconographic repertory of artists. There was at that time a kind of golden age of books: by the 1890s literacy in the West had reached 90 per cent, equally divided between men and women, who formed a particularly enthusiastic new public, mainly consuming cookery books and magazines. The novel too became hugely popular in middle class households, opening up as it did new intellectual and imaginary spaces for women, unthinkable until then. Numerous artists tackled the subject of the woman reading, sometimes absorbed, sometimes in a dream, serious and thoughtful, or prey to tumultuous and unprecedented feelings; these were, of course, much disapproved of by those upstanding citizens who feared for the effects on these women's virtue.

The cross

·
·
·
·
·
·

●

The Vision of Saint Eustace

Pisanello (Antonio Pisano) (c. 1395–c. 1455)
Mid-fifteenth century. Tempera on wood, 54 x 66 cm. National Gallery, London.

·
·

His horse has just stopped. Eustace does not know how he has found himself at the heart of this forest, which seems to be closing in around him. Suddenly the darkness that was enveloping him lights up: he hears a voice, words being spoken. The person speaking is there, crucified, between the antlers of a stag. The horseman stares, bewildered.

The shadows are so deep that he cannot be sure of what he is seeing. Hesitantly, he forms a salute with his hand. He had been galloping happily with his pack of dogs in pursuit of the animal, and now he finds himself lost amongst the trees, facing this extraordinary picture: the stag that he was hunting is now coming towards him. History has changed direction and meaning, and his life is about to be transformed as well. There is no other path to follow; when he sets off again, he will have to carve out a new path, one that nobody could have foretold. Everything Eustace does from now on will be new.

And yet all around him, everything seems the same. Each leaf is still on each branch, down to the last twig. The birds are flying as usual, and other stags are drinking in the background, behind the rocks. Pisanello reproduces the details of the scene with meticulous accuracy, and with all the precision of portrait painter. He leaves nothing out: Eustace is in the midst of his own familiar world, a world that he knows and understands. The horse's luxurious harness was chosen by him, these are his own dogs accompanying him, he is riding in the forest that he has always known. How is it then that this whole world should suddenly be turned upside down? In the past this forest had always been a source

of wonderful abundance for the hardened huntsman. Wherever he looked, in every direction, there had been a profusion of game. These leafy surroundings had never disappointed him. There was such a huge choice that he had always ended the day exhausted and satisfied. In front of him a hound pursues a hare, as though nothing had changed. But the other dogs have picked up the scent of something new, and find themselves completely disorientated.

The artist does not imagine that the hunter could be afraid. It is more that he is overcome by a deep respect: the animal coming towards him is doing him the greatest of honours, no hunter could deny that. As extraordinary as it is, the vision seems to have something almost inevitable about it: Christ is appearing to him in the very place he has travelled through so often.

Pisanello is not so much telling us the story of a miracle as setting up the order of things. He is not trying to create a spectacular effect, more a sense of arrival: the painting has little to do with any logic, the figures are juxtaposed with no particular concern for proportions or verisimilitude – just as long as every space is filled. The conversion of the hunter is depicted quite simply, and completely truthfully, as a simple change of direction. His story, which seems to simply travel from left to right, like a written text, is interrupted by the appearance of the stag: the crucifix halts the march of history. The narrative stops.

The earth has opened up between the astonished rider and the stag. The gap clearly indicates that two kinds of truth are confronting one another, and Eustace's wanderings already belong in the past. If he crosses this dividing line, he will shed his past life like a heavy and over-decorated coat. The pack of hounds will not follow him.

The light attaches itself to all the living things. It was daytime and hardly anything could be seen. Now night is falling and Eustace can see clearly for the first time.

In the midst of this crowded scene, the artist has depicted the cross with geometrical accuracy, as though he has suddenly decided to build roads or embankments in the middle of the woods. To Eustace, accustomed as he is to so many wild gallops, the cross seems to offer the devastating simplicity of a crossroads.

●●

Cardinal Albert of Brandenbourg Before Christ on the Cross

Lucas Cranach the Elder (1472-1553)

c. 1520-30. Oil on wood, 158 x 112 cm. Alte Pinakoteke, Munich.

.

.

.

The cardinal's knees are hurting. Absorbed in prayer, he purses his lips, without seeing Christ who is suffering a great deal more than him up there on the cross. No doubt his thoughts are on the faraway Calvary, but his gaze seems untroubled: there is no glimpse of thunder in his eyes, not a hair out of place, despite the wild sky and rising wind. The reality of the Passion of Christ quite naturally disappears into the past, no matter how pious he is; it has become no more than an image.

Christ lowers his head as though observing this man at the foot of the cross. But He belongs to another time, and His agony takes place in infinity, in a space that is now beyond reach; He looks frail seen from so far away. Ragged clouds trail below, rising with the dust. Golgotha is the whole world, a hill as round and smooth as a skull. Soot coloured waves roll in the sky and you can hear them rumbling.

At the turning point between two realities, the figure of the praying cardinal divides the landscape in two, rising up from the clear sky to touch the storm, between the green countryside and the dry rock. He is neither an actor nor even a witness to the sacred event and he can only devoutly recall the memory of it. He has had it painted, he has imagined it, and he sees himself right next to the figure to whom he owes his faith, or nearly: he knows perfectly well that he will never truly be able to come close to the horror of the cross, to the mystery of this death which, in fact, isn't a death.

Beside the birch tree he has carefully spread out his garment; every fold of the heavy material emphasizes the dignity of its wearer. Above him the veil blows around the tormented body of Jesus, crying out his pain to the world as it flaps in the wind. Does Albert of Brandenburg shiver or quake? His beretta has slipped a little on the cushion which protects him from the hard earth. He joins his hands, close to the feet of the dying man, which have been nailed together.

The cardinal, wrapped up and well protected against the cold by his woollen cloak, ponders deeply at the sight of the wooden cross soaked in blood. The bright red blood, as red as it was at the beginning, now flows towards him, and transforms his thick coat into a large scarlet pool.

● ● ●

Interior (or Mystery)

Edouard Vuillard (1868-1940)
1896-97. Oil on board, 35.8 x 38.1 cm. Private collection.

Night has fallen in this empty room, and nobody has thought of coming in to light the oil lamp, even less the chandelier that has almost disappeared in the dusk. All the objects seem to have been swallowed up by the heaviness of the atmosphere. The painting smells of dust and suppressed thoughts. The brown and ochre shades seem to be slipping into black, and one can hardly see the floor. Footsteps echo too loudly in this sinister silence.

Surrounded by darkness the spectator becomes cautious; faced with indistinct shapes jostling each other in the crammed space, we hesitate before venturing in, conscious of the danger that might result from the slightest bump: one clumsy or ill-judged movement, the slightest jolt, an ornament harmlessly tipped over – the sound would resonate like some eternal guilt. The noise would be worse than the breakage. In such a confined and claustrophobic world it takes very little to experience the violence of the outside world.

A ray of sun enters, striking where it can, spreading an incongruous light. The lamp, which illuminates nothing, begins to glow next to the window, more precious than it has ever been before. One is reminded of the delicate pattern on the curtain, which one had long ceased to notice. A door swings open, suddenly visible.

Lost at the edge of the ceiling, a halo lingers on one of the crossbars, which, until this moment had been identical to all the others. Now everything seems to tip up: the random right angled lines appear to take on a meaning. The erratic shapes formed by light and shade join together to form a sign, a capital letter shaped like a gallows, a cross – incomplete but nonetheless apparent. There was no warning of such an apparition, and perhaps it is no more than a worrying game played by the mind. But still the twilight invades the room, telling its own version of the past, introducing scraps of memory into these familiar surroundings. The walls, impregnated with history, begin to tell their story, and the artist, with his eyes half-shut, surrenders himself to the approaching darkness.

●●●●

Cross

Arnulf Rainer (1929)

1980–86. Oil on wood, 171 x 121 cm. Private collection.

.

.

.

The shape in the painting seems to hesitate between being a rectangle and a cross. Colours pour out of the black paint. A small figure of Christ, trapped in the paint, seems lost in this painting which is far too big for him. He cowers on the wooden crucifix, his body unrecognisable, as though the Passion had left nothing behind but this shrunken object. Just something to wave whilst muttering prayers to chase away demons, a string of phrases, a passing sign of the cross, performed rapidly, in a hurry.

The black paint spreads over him like tar, preventing him from breathing. The paint asphyxiates him as much as the torture on that day. It is all starting again. Rainer has allowed him only this miserable space, a renegade area; but he is in the centre, like an unmissable target. The darkness may stifle him but it does not wipe him out. This night is his.

All around this almost invisible core, the rest of the painting seems to retract and expand. It seems to have some life of its own, it spreads onto the sides, unable to find its intended proportions. It appears to have become stuck between the shape of a gallows and that of a cross, overflowing at the top like a wall that stops too soon. It is hardly a palisade, more an execution post.

The whole picture seems to be dying, drowning in liquid darkness. Christ has no face. Colours break away from one another, abandoning objects, people, landscape, flowing away from everywhere. Before this blackness came, this ink and the story it tells, there had been a multicoloured succession of beautiful and violent moments. All this is carried away by the paint. It has no time to dry, the wounds do not heal in this image of suffering.

The huge black curve stretches out like a wing. On the right of Christ, morning breaks with the first shaft of light; a world that is so new that it is still unimaginable. On the left, a mass of white confronts the black, which mingles with the colours without being able to mask them. The image will cry out right until the end.

The colours from the past are still here, but they have no function any more: the blue of Mary's robe, the red for John and Mary Magdalen, green for nature – they have all disappeared. Christ is now alone on his enormous cross. The picture only retains the memory of him, and the paint flows down like tears and blood.

The cross as a cosmic symbol
●

The cross, the most important symbol of the Christian religion, had already appeared as a motif before Christ. During antiquity it held important cosmic significance, which was later absorbed into the history of Christianity. Well before it became connected with the Crucifixion, it encapsulated the idea of creation in many civilizations: it was thought to indicate the four cardinal points, the meeting of which represented the meeting of opposites. The intersection of the four branches at one point is a metaphor for coming together as much as for dispersal. The notion is both centripetal and centrifugal. Physically the cross is a manifestation of the importance of signposting and orientation, as well as being a basic geometric rule in the division of space. In the spiritual sense it signals the link between top and bottom, between earth and infinity. Thus it has become a universal symbol of reconciliation as well one of balance and order in the universe.

The suffering on the cross
●

The torture of crucifixion, practiced by the Romans, was always considered to be the most horrible of deaths, reserved for robbers, slaves and those who rebelled against the state. It originated in the East, and was intended not just to humiliate its victims through suffering but also to keep them from any contact with the earth, which would have been perceived as sullying it. Christianity reversed this notion by emphasizing the nourishing value of the blood of Christ, shed by his sacrifice. Flowing down the wood, it fertilized the earth and the bones of Adam, whose skull is often depicted at the foot of the cross. It is in a way the image of a baptism with blood, through which humanity can be reborn, and achieve salvation. The artists' insistence on depicting all the details of the flow of blood springing from the wounds of Christ, sometimes caught in a chalice by an angel, is not fortuitous: it is a way of superimposing the message of the sacrament of the Eucharist on the description of the event itself, to connect the ritual with what had engendered it.

Returning to the symbolism of the origins of life, one recognizes the tree of life in the story, restored to man by the blood of Jesus, since, according to the legend, the cross was cut from that very tree.

The legend of Saint Eustace
●

The *Golden Legend* tells the story of the conversion of Placidus, one the Emperor Trajan's generals. Although he was a pagan, this hunter was a charitable man who was rewarded for his good deeds. One day, when he was out hunting, he noticed a stag who was 'more beautiful than the others' and he pursued him, ' . . . as he considered the stag with great attention, he saw between his antlers the figure of the Holy Cross, more splendid than the rays of the sun, and the image of Jesus Christ, who spoke to him through the mouth of the stag, as Balaam's donkey had spoken in the past: "Placidus, why do you persecute me? It is out of love for you that I appear to you upon this animal. I am Christ, whom you honour without knowing it: your charitable giving has appeared to me and that is why I have come. It is to hunt you myself in the form of this stag which you were hunting."' Other writers claim that it was the image between the stag's antlers that spoke to him. Hearing this Placidus, greatly astonished, fell from his horse. After his conversion he took the name of Eustace. The story borrows a great deal, notably the words of Christ, from that of the conversion of Saint Paul, in the Acts of the Apostles. It uses the same theme of the fall on the road to Damascus, when he was travelling there in order to persecute Christians, when he is blinded by divine light. In the fifteenth century the legend was adapted to Saint Hubert, whose cult eclipsed that of Saint Eustace.

The stag and the cross
●

In antiquity the stag was the animal of the sun, in contrast with the snake whom he forces to come out of the ground to fight him. The vitality of this animal also endowed him with an aura of sexuality which endured into the Middle Ages. However the Christian tradition ignored this aspect of the stag, and mainly emphasized the noble image celebrated in the Psalms: 'As a doe longs for running streams, so longs my soul for you, my God.' (Psalm, 42). According to different interpretations, the cry of the deer is either the sound of the soul of the just man who seeks to quench his thirst at the source of life, or the sound of Christ calling a soul to come to him. Nature itself favours the connection with Christian symbolism: the antlers which re-grow periodically make the deer into an emblem of cyclical renewal, and therefore of the Resurrection. He is the image of the Creator who is capable of renewing himself into infinity. This is why, in the early centuries of the Christian Church, stags were represented on baptismal fonts, where they were held to be as pure as lambs or unicorns, the other symbols of the Christ figure. In the Middle Ages, parallels would be drawn between the ritual putting to death of the stag during the hunt and the Passion of Christ.

The cross and the letter T
●

The T shape which appears in Vuillard's nineteenth century interior seems to float in the air like a fleeting trace of history descending from the Old Testament. *Thav* (X), the last letter of the Hebrew alphabet, represents the signature of God, without actually using his name, since, according the Old Testament it is unknowable and unsayable. In Hebrew culture, it is the sign which distinguishes and protects the elect. The cross as a concrete object, that of Jesus Christ, would on the other hand be marked with the abomination associated with all crucifixions.

This hostility would be lessened by the time the Bible was translated into Greek: the pronunciation of the letter *Thav* resembles that of the Greek *To*, the initial of the word *Torah*, which designates the five books of the Hebrew Bible, or Pentateuch. Also the shape of the capital *To* (T) could very well suggest the shape of a gibbet. The noble symbolism of the *Thav*, which long preceded that of the crucifixion and resurrection of Christ, thus contributed to that of the *To*, changing it from a sign of disgrace to one of both spiritual illumination and divine glory. This no doubt partly explains the adoption of the sign of the cross by Christians in the eighth century, notably during the ceremony of baptism.

Painted crosses
●

The art of painting on wooden panels was developed in Italy during the first half of the twelfth century. One of the most common forms of this art at the time was the painted cross, usually of a monumental size, which would be hung in the triumphal arch of the church, in such a way as to be visible to all the worshippers. To make it more solid, it became the custom to make the vertical bar wider, and to paint ornamental motifs on either side of the body of Christ, as well as figures connected to the Passion (the Virgin Mary, Saint John) on a smaller scale. This extension of the shape of the cross continued until it attained the rectangular shape that we are familiar with, gradually incorporating more and more figures and subjects. And in a certain way if one refers to this, the origin of the conventional painting, one can see the cruciform shape as the backbone of every image, reminding us of it at every moment.

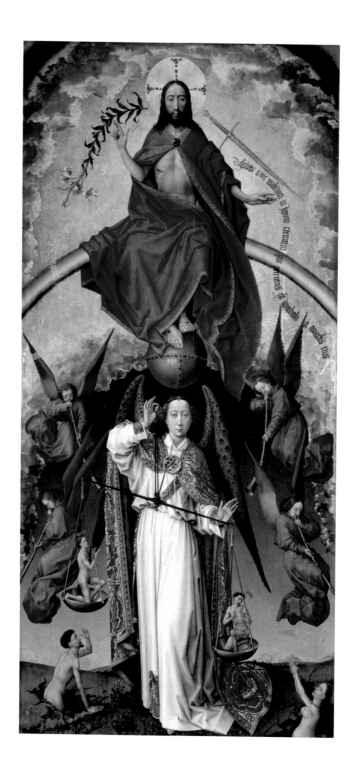

The scales

.
.
.
.
.
.
.

●

The Last Judgement

Roger van der Weyden (1399/1400-64)
1446-50. Centre panel of polyptych. Oil on wood, complete 215 x 560 cm. Hotel-Dieu, Beaune.

.
.

The world has been sliced in two. The skies are in flames around the figure of Christ sitting in judgement, whilst in his name, an archangel weighs good and evil on a large pair of scales.

The angels in Heaven are blowing forcefully. At the sound of their long and fine trumpets, the elected awake from their long sleep, astounded, whilst the condemned tumble down to an eternity of terror. Death has given way. The man who has been forgiven by God heaves himself to the surface of the cracked earth. The woman he has punished pleads in vain. One man and one woman perform the role of the whole human race, their fate sums up the division. An abyss awaits the sinner, who represents all women since Eve gave way to temptation. The earth cracks and crumbles, it gives birth and it swallows up. This is the day of judgement.

The serene archangel, like a pillar of light at the centre of the panel, has placed his thumb in the ring which holds the divine scale. His fingers are delicately raised to demonstrate that he will in no way influence the result of the weighing. And yet he holds his other hand out, as though to hold back the brutal sinking of the heavier bowl. However this almost too human gesture does not go any further. He will not touch it: Saint Michael has no thoughts or emotions, and wants nothing done in his own name. His very presence represents truth, and the fact that everything has been decided already. Mankind has tried to create a story which is about to end. The verdict is about to be delivered.

Addition and subtraction remain accurate, but division no longer exists. The instrument of perfect accuracy can measure the slightest malign thought, the most random of kind actions, or secret cruelties, weak efforts, failed resolutions. On the bowls of these scales which do not wobble, there are two figures, neither male nor female this time, representing virtue and vice. Virtue prays on its knees, with eyes raised towards the judge. It does not ask for anything, and is simply raised up by its own gratitude. Vice cowers in fear as it realizes that it is defeated, nerves quivering because of its bad conscience.

Each one heads for their own form of eternity at their own pace. Van der Weyden has not needed to assemble any devils: there are no demons with forked feet here, none of the slimy monsters or torturers armed with hooks and claws that one sees tormenting the damned in so many paintings. These just condemn themselves. Their suffering comes from within themselves, like a kind of spirit or a thought. There is no need for little hands to complete the work. The artist's conclusion is that vice does a perfectly good job in punishing itself, and that virtue needs no help from anybody, and that there is consequently no need for picturesque props. The old images from nightmares are no longer enough, they are inadequate at describing what is happening within the minds of men, and what has brought them to this place, either cornered by despair or lifted to the gates of Heaven.

Saint Michael feels the approach of each one's fate. His body tilts a little, as though he too might tip over. Sin weighs heavily, even in the hands of an archangel. He stands firmly on the ground, with his left leg planted a little in front of him. Above him Jesus has his right foot forward on the globe. The two figures, placed on the same axis, respond to and balance one another. Each one's gesture springs from that of the other, each movement of God inspires one in the angel.

And so the movement of the Christ figure reflects that of the scale, and his body corresponds to the judgement itself. His face frozen for all time, like that of the angel who is also outside time, he raises his hand to bless mankind. The long stalk of a lily curves down beside the wound from which baptismal water and the blood of the Eucharist has flowed, towards those who have been changed by them. It brings its light and its purity, and perhaps a reminder of the chastity of the Virgin Mary who interceded for them. His left hand is lowered, and points to those who are forever banished from Paradise. The sword will go straight to its target and will show no mercy.

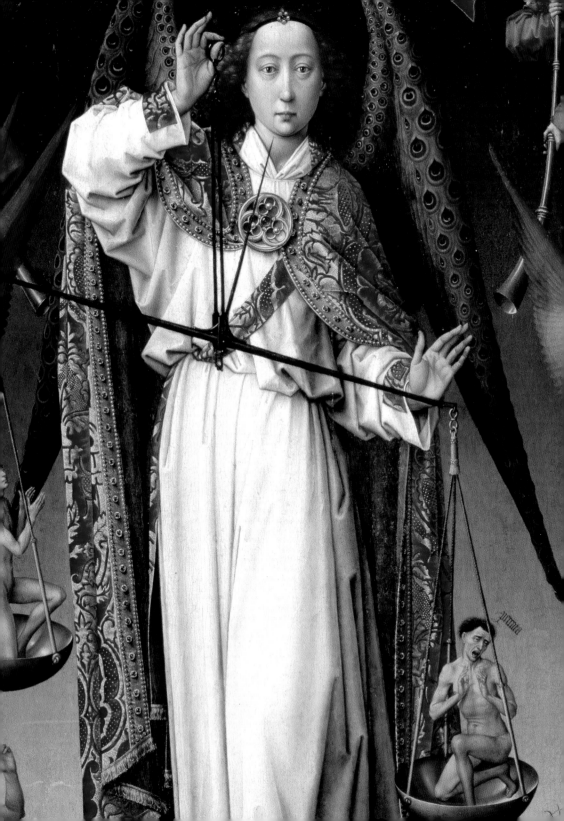

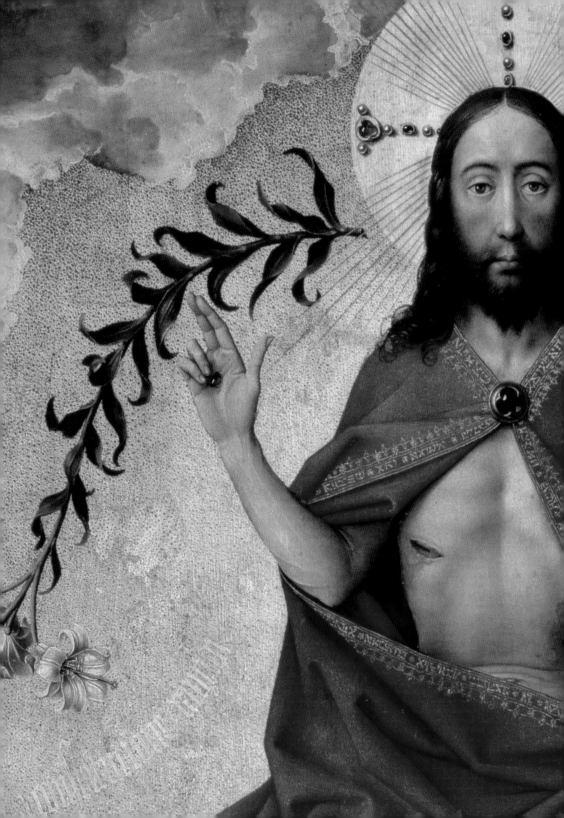

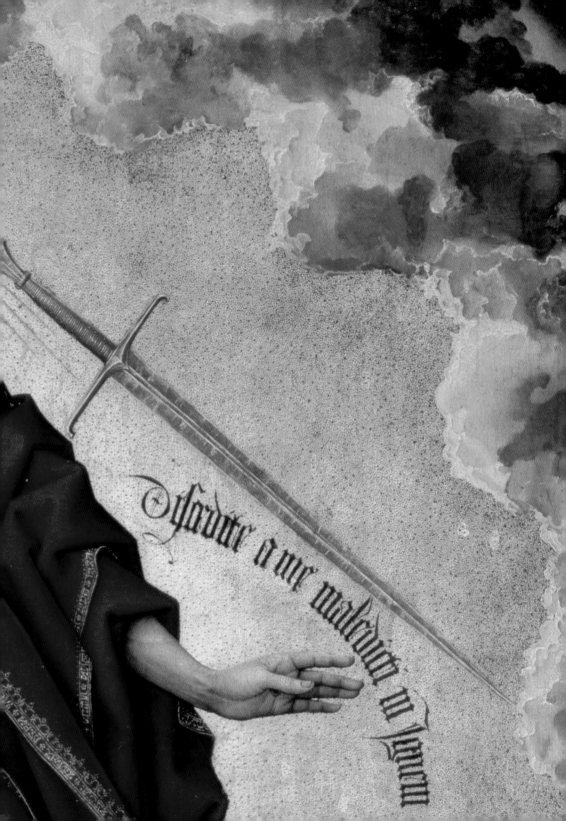

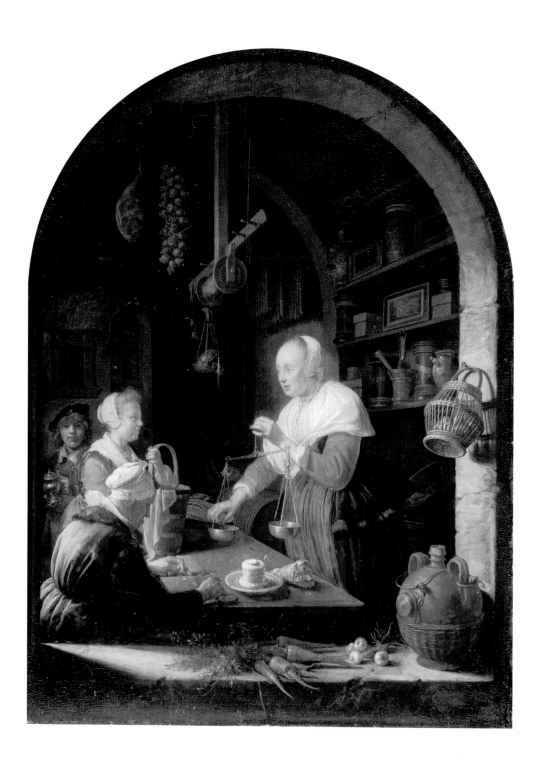

●●
The Village Shop
with the painter's portrait in the background

Gerard Dou (1613-75)
1647. Oil on wood, 38 x 29 cm. Louvre, Paris.

.

.

.

You need a light hand to weigh spices, and this set of scales seems to tip a little: one is so quickly distracted by the slightest conversation. The shopkeeper chats with the little servant girl who has come to do her shopping as usual, just a few words to keep up good relations with the customers. The light flooding in to the shop illuminates her face.

The old woman, absorbed by her book, sits at the counter, as she does every morning. From time to time she makes a remark – nobody takes any notice. Everything is here in this shop, which is as familiar as one's own house: the cooked ham, the sugar, the candles and the vegetables. Carrots lie alongside cloves of garlic on the window sill: the artist has arranged them in the shape of a fan to create an effect of depth. The spectator feels they could lean on this sill as they go by, and greet the figures in the painting. They can gaze freely and easily into the picture, whose tiny details are as attractive as the sweetmeats themselves.

Gerard Dou, at the back of the picture, has stopped too. He has a tankard in his hand and casts an eye on the everyday scene unfolding before us, observing every detail. He has described every single thing piled up there, without omitting the smallest shadow, the very slightest roughness of the stone. And by virtue of this close observation, he seems able to hear what is going on: he knows more than we do about what is happening. He presses a little harder than necessary with the tip of his light paintbrush on the set of scales, and perhaps over emphasizes the rays of sun on the shopkeeper's forehead. It is as though he is a little troubled, perhaps worried by some unaccustomed sensation.

The shopkeeper is bothered by this bright light which makes her blink. She is not the sort of woman who is usually disturbed by anything: she is big and strong and is in the habit of ruling her little world and running her business as she sees fit. She has just realized that the supplies above her are running low. She'll have to do something about it, a few tugs on the pulley are all that's needed – she had never noticed its odd shape, almost like a cross. And by the way the scales seem a bit strange too, as though they are calling her to order. Although she has no reason to reproach herself – they were tested and checked quite recently. As for her accounts, nobody has ever complained, although life isn't easy for anyone nowadays, you know. In any case the little customer will be happy, she always is. Next to her the old woman mutters over her old sermons. It's just a day like any other.

●●●
The Scales

Graham Sutherland (1903-80)
1959. Oil on canvas, 127 x 101.5 cm. Musée de Picardie, Amiens.

A robust weighing machine, from a household or general shop, sits on a wide strip of red stone, an everyday object painted with a few rough brush-strokes. This painting borrows from the tradition of still lifes, and like them, takes a slice of ordinary life and transforms it into an exemplary image.

One of the plates is distorted and tips sideways. Is this because of what is weighing it down, or has it changed its shape over time with repeated use. The repeated blows, everything that has been thrown onto it, day after day, could have got the better of the hardest of metals. It would have started with a scraping sound, as the iron began to grate harder against itself. Until then it had hardly been noticeable, and was more or less negligible, like a minor pain that one has decided to ignore. But the slight dislocation had become with use, as they had had to weigh this and that (one does not know what or why), trying to find the right balance, trying to attain total accuracy. In the end the machine remains lopsided.

The world around the scales reflects its problems. This lopsided plate throws that half of the painting into confusion. Strange shapes appear at the back of the picture, jostling for position. If the machine could just do its job, weighing without prejudice the profits and losses of this battle that has been drawn on the flat wall. Disparate and contradictory shapes appear, meaningless fragments, a quarrelling set of lines and tracks, as absurd and meaningless as a game whose rules we do not know. The other plate hangs lightly, unburdened by any anxiety. The colour behind it remains static.

In the middle of the canvas, the shrunken shadow resembles the hand of justice. It surmounts the arm of the weighing machine, reminding us of the dignity and the mythical role of the scales. An unimaginable presence is hinted at, with its fingers splayed out, as stiff as those of a dummy. Lost in a sea of shadows, the eternal gesture of the judge freezes indecisively, somewhere between a blessing and a threat.

The weighing of souls in ancient Egypt

●

The ancient Egyptians had imagined the stages and procedures of life after death down to the last detail. One of the most important moments was when each person's actions were judged. According to the *Book of the Dead*, the gods determined the fate of the dead by weighing their hearts. Illustrations of this scene, which can be found on papyruses and funerary paintings, show the two sides of a set of scales, with, on one side a little vase containing the heart and on the other a tiny crouching female figure, the goddess Maat. She is infinitely light, with a long feather adorning her head. If the heart of the dead person is heavier than her it will be devoured by a monster. If it is as light, the dead person will be able to go and cultivate the fields of Osiris, in other words enjoy eternal happiness. The two gods Thoth, with the head of an ibis, and Anubis, with the head of a black dog, are in charge of this ceremony, which takes place in the presence of Osiris, the god of the dead.

The money changer's scales and the ransom for lives

●

During the Exodus, God said to Moses that each male adult should pay a sum of money towards the sanctuary: 'When you take a census and make a register of the sons of Israel, each is to pay the Lord a ransom for his life . . . a half-shekel shall be set aside for the Lord. You will devote this ransom money given to you by the sons of Israel to the service of the Tent of Meeting. It will remind the Lord of the sons of Israel and will be the ransom for your lives.' (Exodus, 30, 12-16). In order to pay this tax according to the rules, those of the faithful who did not have the right coin could change their money with a money changer who had a pair of scales. The use of this item, henceforth connected with the 'ransom' that had to be paid to God, led to it becoming a symbol of divine judgement, and consequently, of the Redemption. It is in this role that it appears in certain Biblical illuminations of the Renaissance.

Zeus's golden scales and destiny

●

Apart from their function as measuring instruments, scales can simply represent a sudden and unpredictable movement. In modern language, when people use the idea of a particular situation, or even life itself, suddenly 'tipping', they are not using just a simple image, they are also implying that balancing scales are one of the attributes of fate. Thus Homer places them in the hands of Zeus at the end of the fatal battle between Achilles and Hector during the siege of Troy: 'The at last, as they were nearing the fountains for the fourth time, the father of all balanced his golden scales and placed a doom in each of them, one for Achilles and the other for Hector. As he held the scales by the middle, the doom of Hector fell down deep into the house of Hades.'(*Iliad* 22, 208-213). The use of gold emphasizes the purity and essential incorruptibility that characterize the holy instrument.

The archangel Michael's scales

●

The theme of the weighing of souls, with the consequent notion of a just reward or punishment for man's actions on earth, crops up several times in the Old Testament. Job, the just man who endured all the sufferings that God inflicted on him to test his faith, calls to divine justice in these words: 'If he weighs me on honest scales, being God he cannot fail to see my innocence.' (Job, 31, 6). This symbol, first found in the Egypt of the pharaohs, is also present in Greek and Roman mythology and then passes into Christian iconography, where one sees once again the scales which distinguish between good and evil in representations of the Last Judgement. The archangel Michael, who holds them, takes up the role of the Egyptian god Anubis, as well as that of the god Mercury in classical antiquity, guarding the balanced plates. Contrary to the original tradition and the version painted by Roger Van der Weyden, the soul of the righteous man is generally the one which weighs heaviest on the scales. In the Middle Ages, they were sometimes painted being held directly by the hand of God which reaches down from the sky. And sometimes there is a demon in the shape of a small naked figure, creeping up close by, who tries to influence the scales in order to take a soul.

Scales as the attribute of Justice

●

In Roman times, Justice was represented by a woman holding a sword in one hand, as emblem of her power to punish, and a pair of scales in the other, to show that she is impartial and favours nobody – for the same reason she is sometimes blindfolded. This figure is descended from the Greek goddess Themis, goddess of law, who taught the gods of Olympus about rituals and oracles. She is the daughter of Uranus (the sky) and Gaia (the earth), and, proceeding as she does from two opposites she is the incarnation of the just medium. For this reason she fulfils the role of counsellor to Zeus, the king of the gods. The image of the shopkeeper who presses on his scales is the secular counterpart to that of the devils who try to seize souls for themselves at the Last Judgement. It symbolizes both the corruption of justice and the most commonplace dishonesty amongst unscrupulous merchants. We must also remember that, in Christian culture, Justice is the chief among the cardinal virtues, the others being Prudence, Strength and Temperance.

Melancholy, Wisdom and Time

●

Melancholy supports all the weight of human existence, whilst also glimpsing divine perfection; she is governed by Saturn, god of geometry. Her attributes are a pair of scales as well as other measuring instruments such as a compass, a set square, a magic square and an hourglass: these suggest the need for rigorous knowledge and an ideal to aim for – equilibrium in the face of all the inherent contradictions of the human spirit. Scales, a concrete work tool for builders, can also signify the wisdom of the man who is able to build his own thoughts without allowing himself to be torn apart or carried away by extremes. The sign of the Zodiac which corresponds to the scales, during the autumn equinox, marks the moment when night and day are temporarily equally balanced. In a way scales also suggest a search for total immobility, which would mean a return to a primordial unity before history began, and when Time – which itself weighs day and night, past and present, life and death – had not yet appeared.

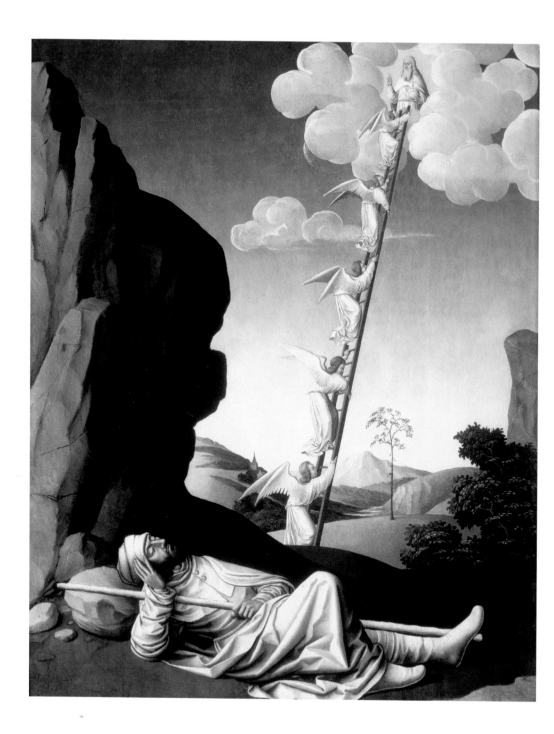

The ladder

Jacob's Dream

Nicolas Dipre (or d'Ypres) (1495-1531)
c. 1500. Oil on wood, 129 x 103 cm. Musée du Petit Palais, Avignon.

Jacob has fallen asleep. The road stretches before him as though it will never end. The stone is hard beneath his exhausted head. He is dreaming. And in this dream which he will never forget, it is broad daylight.

Jacob knows very well that angels have wings and that they fly like birds. It is easier for them to cross the entire sky than it has been for him to cross this single valley. Jacob is tired. In his dream he seems to imagine that the angels might need a little help to get themselves up to the sky. A great staircase would do, or perhaps a ladder would be easier to handle. The angels are such great travellers – they would know where to place it secretly, somewhere over there behind the rocks, where the earth is nice and flat. It doesn't really matter, they are so light that the ladder is in no danger of slipping. It leans against the clouds, leading straight up to the celestial light of God.

Jacob looks at them with his eyes closed, without letting go of his walking stick. He holds on to it in his sleep just as the angels hold on to their ladder. If only this piece of wood could take him that far. Where he is lying, with his head resting on one hand, he is so close that he could almost touch them. He is not at all surprised to see God himself patiently welcoming these glorious creatures who climb the ladder cautiously, as punctual as children returning home from school.

Jacob is far from home, and so he shares their longing to return. These angels are exiles too, he has something in common with them. He hasn't got their wings of course, although his coat and hat have become completely white. So there he is, more or less dressed like them, immaculate down to the soles of his feet.

He has not become an angel, but this marvellous vision has transformed his world and his consciousness of his own self. Nature itself, all around him, has become gentler: a soft light washes the dust from the path, smoothes the surface of the rocks and outlines Jacob's silhouette, ennobling his body as though it was already lying on a stone slab. Would his name ever be so famous that he would merit such a memorial?

When he wakes from this sleep, the path will seem less uncertain, less strewn with stones and obstacles. His melancholy lifts and in his dream he advances forward, his legs stronger than ever. His story stretches out before him, step by step, rung by rung, year by year, generation after generation. And the angels continue to climb up the narrow ladder.

He thought that he had just given way to the exhaustion of the moment. The dream has only just begun, and the angels have not yet begun to descend. But Jacob feels that God has leaned down towards him. The heavens had something to show him, and the moment was propitious. Eternity had dropped an anchor, and he was holding on to it.

Nicolas Dipre has never seen the Holy Land, and so he has invented a simple landscape sufficient for his needs, which leaves plenty of room for the sky. The pale horizon that edges the hills provides Jacob with a peaceful background against which to rest. The patriarch lives in a time when angels circulate freely, and when God speaks even to those who will not listen, clearly expressing his wishes and his promises. There is nothing astonishing about his presence, and that is what this picture is telling the faithful. It calmly shows the Revelation, without any undue insistence: what is happening is perfectly normal, just one more proof of a truth that is never in doubt.

The artist has removed the ochres and all the other warm colours: no violent reds or fiery shades of orange must interfere with the precious vision. The trees are only just green against the soft grey of the rock. The landscape becomes almost disembodied in a cool harmony. For the duration of the dream blood does not flow on this earth.

●●
The Spinners

Diego Velásquez (1599-1660)
1644-48. Oil on canvas, 222.5 x 293 cm. Prado, Madrid.
.
.
.

The wheel turns so fast that it has become blurred. In the buzzing workroom, Velasquez's brush catches the dust which flies around and falls to the ground like manna. He separates the rays of light like spiders' webs which stretch between agile fingers. Here the faces are not as important to him as the gestures of the women, and the concentrated power of their bodies in motion. He has planted his easel right in the centre of this group of women of all ages, all working so hard. They spin, card and cut, never stopping, like modern versions of the Fates who could, with one stroke of a blade, wipe out the life of a mortal. The artist watches their work carefully. He has read the legends and the touches with which he brushes the canvas are lighter than the threads of the Virgin Mary.

In the background some elegant ladies are visiting the workshop. One of them looks in our direction – she is either bored, or just curious. It is a mere passing interest in all this fevered labour. The raised room where they are standing is there, close by, but it is separated by a little staircase which forms a barrier between their world and that of the workers. To come down those two steep steps would no doubt be nothing more than an incursion into a picturesque scene. To go up them on the other hand would be to break out of the barriers of the women's station in life – to recklessly try to elevate oneself. The ladder, placed between ground and ceiling, acts as a reminder of the prosaic duties of everyday life. It simply waits there for the moment when one of the women will need to climb up, her arms stiff with exhaustion, to suspend, detach or adjust one of the hangings.

And in fact the enormous well-lit tapestry in the background, hung in the middle of the picture, tells one of those terrible tales of misplaced ambition: that of the nymph Arachne, who was changed into a spider for having claimed that her spinning was as beautiful as that of the goddess Athena. This would now never be forgotten – a mortal cannot defy a god, and the most accomplished of skills cannot compete with the divine creators themselves. The spinners, who know nothing of weaving or drawing, have nothing to fear from the jealous gods. Why would they need to fill their minds up with these old stories and their wise moral lessons, which, these people in palaces claim, elevate the spirit so splendidly? All they know is sorting, untying and untangling the threads which others will skilfully pull together. And there is so much to do by the end of the day.

The artist has almost finished his work. He has gathered together in a single image the idea of sweat and knowledge, of ideals, ambition and dirty hands, and he has produced a worthwhile painting. With paint still stuck under his fingernails, he dusts down his smock. He is in a bit of hurry as they are expecting him.

Harlequin's Carnival

Joan Miró (1893–1983)

1924-25. Oil on canvas, 66 x 93 cm. Albright-Knox Art Gallery, Buffalo.

.

.

.

The room is quivering with strange creatures which crawl and swarm in every direction. The artist seems to be dizzy with it. At the bottom of the painting, a cockerel stretched like a bow has sung so long and hard that he has lost all his feathers; it must be dawn. A star shoots through the blue sky, but it is impossible to see whether the others have disappeared. The ladder has lost its lower steps. You cannot be too much of a dreamer.

Someone has blown into a huge white pipe which seems to wriggle with pleasure. Or was it the body of a distorted guitarist which ends in a fish skeleton? The musical notes align themselves obediently on the wall behind. A curious butterfly emerges from a carton like a jack-in-the-box and plays with a ball next to a cello in boots, which has little arms shaped like handles, and a round red and blue head: a real cymbal of a head, with a little rake-like beard, a long smoking pipe and a flamboyant waxed moustache.

The cats, in striped jumpers, play with a piece of string pretending to be a ball of wool. They're not hungry so the fish flopping around on the blue table has nothing to fear. He's probably a very cerebral, thoughtful kind of fish, and for him the colour is enough to make him think he's swimming. Perhaps the sea has flattened out, over there, on the other side of the window. It really is a beautiful day. Yes, that must be it – it has become as flat as a painting. And the sphere, too, seems unable to concentrate, and doesn't quite know whether it is earthly or celestial, or why it should have to decide anyway – these choices are always troublesome. The apple beside it isn't about to disagree, it knows a thing or two about earth and Heaven and so on. Oh, don't start on that again, it was just a little mouthful, it didn't matter. The pages of a book turn over by themselves, looking for the passage in question. School is closed today and the set square has gone off to have fun with the ink stains.

The harlequin's costume has blown to pieces somewhere, the colours float about like bubbles. The world has succumbed to a delightful madness. The ladder that leads up to the sky won't let it down. It looks quite certain that somebody has removed the lower rungs just so that no one will try and climb up. The imaginary world begins higher up, much higher up, up where the sirens fly. The sky seems a bit distracted and has allowed a little red star to fall to the ground. Miro has kept it, and one day he will take it back to its home and watch it dance amongst all the other constellations.

The ladder of faith and the ladder of knowledge
●

In ancient Egypt the ladder belonging to Ra, the god of the sun, was a symbol of the relationship between earth and sky, forming a path which the souls of men could ascend to the hereafter. It was held by the goddess Hathor or the god Horus, and it led up to the dwelling place of the gods. Small models of ladders were placed in the tombs of the dead in order to facilitate this journey. The shapes of the pyramids with steps and Mesopotamian ziggurats shared the same symbolic significance. This idea of a path up to infinity also prevailed in the Middle Ages amongst Christian writers who would number the steps – in different quantities – that were needed for continuous spiritual ascension. This progression, from the material world towards spiritual heights, also defines the philosophical movement personified by the image of a woman holding a ladder against her. The top and bottom rungs represent theory and practice. The relation between the vertical uprights of the ladder and its succession of horizontal rungs can also reflect the tension between mystical aspirations and the hard graft of knowledge. This would explain the presence of a ladder in works illustrating the theme of Melancholy, as he ponders the limits of his own thought, and sees that the topmost rungs, reaching into the celestial clouds, are forever inaccessible to him.

Jacob's dream
●

All the fundamental symbolism of the ladder springs from the Biblical story of the dream of Jacob, the son of Isaac, on the road to Haran (Genesis, 28, 11-17): 'When he had reached a certain place he passed the night there, since the sun had set. Taking one of the stones to be found at that place, he made it his pillow and lay down where he was. He had a dream: a ladder was there, standing on the ground with its top reaching to Heaven; and there were angels of God going up it and coming down. And the Lord was there, standing over him, saying "I am the Lord, the God of Abraham your father, and the God of Isaac. I will give to you and your descendants the land on which you are lying . . . Be sure that I am with you; I will keep you safe wherever you go, and bring you back to this land, for I will not desert you before I have done all that I have promised you." Then Jacob awoke from his sleep and said, "Truly, the Lord is in this place and I never knew it!" He was afraid and said, "How awe-inspiring this place is! This is nothing less than a house of God; this is the gate of Heaven!"' In this story the ladder signifies the exact moment when Heaven and earth meet: it is a real entrance to the world beyond, a door which Jacob marks by naming it *Bethel* (the house of God). Artists have sometimes represented it as a monumental staircase rather than the traditional ladder, which corresponds better to the Hebrew text.

Climbing the ladder as a form of penance
●

Saint Benedict, when he was writing his monastic Rule for the use of the monks around 540, used the ladder as a symbol: 'Hence, brethren, if we wish to reach the very highest point of humility? – and to arrive speedily at that heavenly exaltation to which ascent is made through the humility of this present life, we must by our ascending actions erect the ladder Jacob saw in his dream,? – on which Angels appeared to him descending and ascending. By that descent and ascent? – we must surely understand nothing else than this, that we descend by self-exaltation and ascend by humility. And the ladder thus set up is our life in the world, which the Lord raises up to Heaven if our heart is humbled. For we call our body and soul the sides of the ladder . . .' (Rule VII). As a result of this imagery, several monasteries, Cistercian or Carthusian, were named 'Scala Dei' (stair or ladder of God). They were places of retreat from the world, whose purpose was to lead the monks up the rungs of the ladder to achieve divine perfection, through their choice of voluntary penance.

The dangerous climb to Heaven

●

The sacred symbolism of the ladder was fully expressed in the writings of the monk John, who wrote in the seventh century and later became the abbot of the monastery of Mount Sinai. He was known as John Climaces (from the Greek *climax* or 'ladder'), from the title of his book *The Ladder* also known as *The Celestial Ladder* or *The Ladder of Heaven*, which had a great effect in the East. In it he describes a rising path in thirty chapters, or thirty steps, corresponding to the thirty years of Christ's early life. The spiritual progress of the soul is achieved at the price of a supreme effort to find perfection, attaining first virtue, solitude, prayer and tranquillity before finally reaching the supreme goals of faith, hope and charity.

In Byzantine art, illustrations of this theme – sometimes connected to paintings of the Last Judgement – depict the hordes of vices which assail the souls and make them lose their grasp by riddling them with arrows. Only a few of the elect, supported by angels, are able to grip the rungs and reach the summit. The others are for the most part cast down into Hell.

A privileged means of communication

●

The image of the ladder, defining physical, moral, spiritual and intellectual elevation, was immediately attached to other symbolic motifs which had the same message. It became associated with the rainbow, the bridge thrown to men by God himself, and the cross, of which it is a kind of preliminary version. The instrument of Christ's suffering does in fact imitate the structure of a ladder by its simple structure of two intersecting bars. It would appear from then onwards as the exemplary motif of the link, restored by sacrifice, between God and man. The shape of a double ladder, on the other hand, can be compared to that of a pair of scales, clearly divided between ascent and descent, and therefore holding a moral significance. As well as such simple objects, the Biblical figures themselves, who represent the passage between earth and Heaven, would be symbolically regarded as 'ladders of Heaven': the Virgin Mary, through whom Christ 'descends' from Heaven; Jesus himself, the son of God on earth; as well as numerous prophets and saints, distinguished by their rise to Heaven.

The ladder to be avoided

●

According to popular superstition there are a great many actions and gestures that bring bad luck, and walking beneath a ladder is one of them. As well as the simple risk of some random object falling on one's head, there is also the fact that one is passing beneath a triangle formed by the earth, the wall or other support, and the ladder itself. That is to say that one is breaking into a geometrical formation that sends us back to the symbol of the Trinity (Father, Son and Holy Ghost). Such a transgression, which in some sense shatters the divine plan, also carries a reminder of other sinister connotations: although ladders have perfectly innocent uses (as do nails and pincers), they also remind us of those in Crucifixion scenes in the Middle Ages and in the images of Arma Christi. The mystery plays in the Middle Ages always emphasized the most everyday details with the greatest precision in order to resonate with the spectators. In the famous *Mystery of the Passion* written by Arnoul Greban in the fifteenth century, he describes the descent from the cross. Joseph of Aramathea comes to remove the body of Christ from the cross, and speaks to his companion: 'We'd better get to work, Nicodemus, I've got the pliers and a hammer and the ladder is there.' The other man replies: 'Yes we'll need that, because the arms of the cross are very high up.'

The lamp
and the candle

- - - - - -

●

Saint Joseph the Carpenter

Georges de La Tour (1593–1652)
c. 1640. Oil on canvas, 137 x 102 cm. Louvre, Paris.

The flame is smoking a bit. The old man looks up without stopping his work. Just seeing the child reassures him. Even if the candle blows out, they would not be buried in the darkness: this child carries in him all the light of the world. He can feel the gentle warmth of the flame on his wrinkled brown forehead. He is more and more worn by age. The child, with his clear profile, holds up his hand to protect the candle. It is a gesture of prayer, and the red light shines through his fingers.

And yet something is disturbing the flame: a draught, some word that has been spoken, some murmur he failed to notice. Joseph waits for calm to return.

Night fell a long while ago, but there is a backlog of jobs to do in the workshop. They are staying up later and later, life seems to be closing in around them. The candle wax slowly burns down, but it seems to pass quickly all the same. You only notice it at the end, and then it's almost too late. A last glimmer, a slight trembling, and then it's gone. It will soon be time to go in. The old man lets the child decide.

Joseph doesn't know much. He makes whatever he's asked to make. He works the wood, and the customers are pleased with his work. He is a brave worker and a good man. But this child, who has arrived like an angel, this child is different. He seems to know everything without having learned anything. He is not worried

by the shadows. He is docile but does not obey anyone. Still, he will have to learn some sort of trade one day, like everybody else. And so the boy sits there as though he had come to help his father, whose gestures he has observed a thousand times before. He will probably become a carpenter as well. He will be able to work the wood too, and produce unexpected beauty from a shapeless lump. He will make useful objects in any case, things that will be helpful in everyday life. Yes he will certainly make something.

The brightness of the candle brings warmth to Joseph's spirit. He is astonished by it every time, and again this evening. He is a man in whom everything is crumpled and clumsy, with his sleeves roughly pulled up, his dusty sandals, his shaggy beard and calloused palms. He has come to resemble the material he deals with every day, pieces of wood that are too knotty to work with, bark that is too dry, planks that have been badly sawn. Joseph planes, cuts, carves and starts all over again. Sawdust flies around him. He works in silence; the candle lights just what it needs to.

Thanks to the candle, Joseph can see how vibrant reality must stand up to the surrounding darkness, and have the strength to tear itself away. That is the only way it can achieve its true status, its own power and peace. All around the world remains shrouded in darkness. One was less aware of it before this, before the child took hold of his heart, coming here night after night to hold the light over his tools, amongst the sawdust that gets everywhere. It sticks to the soles of the sandals, gets in your hair and your eyes, and up your nose. The only place it does not stick to is the child himself. His robe, which does not belong to any particular time or place, remains pristine, untouched by any stain – dust does not affect him.

In Joseph's youth candles were enough – they gave the impression of producing real light. Now their function is to announce a greater light to come. The child holds the candle with care. In this world the slightest flame is precious. The little flame is as fragile as the faith of honest men – the slightest draught makes it flicker.

Joseph bends down towards the child. On the ground he assembles two heavy crossbars, like simple beams. There is an empty space at the back of the picture. The carpenter is struggling; it may just be tiredness which makes him look up for a moment at his son, trying to catch his eye.

It is a cross that is being made down by his feet.

●●
The Origin of Painting

David Allan (1744-96)
1775. Oil on wood, 38.1 x 30.5 cm. National Gallery of Scotland, Edinburgh.

She will go on drawing for as long as the wick in the oil lamp lasts. She hopes she will have time to finish this formless shape which seems to slide on the surface of the wall. She is hesitant and uncertain and can only draw the silhouette with difficulty. Her model remains quite still, but his shadow quivers in the light of the flame. The young girl knows that he is real, there before her eyes, but she can only half see where he begins and ends. And so in her state of ongoing doubt, each line she draws becomes a major decision. The line is all-important as it is the only thing capable of pinning down this body which is about to escape.

She no longer looks at the departing man; she is preparing for his absence. Rather than embracing him once more, she concentrates on what will remain here: just a projection on the stone, without volume and without flesh, without smell, warmth or breath, merely an image. She works harder: she is not trying to observe and reproduce his face, or the shape of his eyes or his smile – all she is trying to do is fix onto the wall the profile of the man who is about to leave her. She does not know exactly what she is doing, only that the gesture is all-important.

The man she loves is bathed in the lamp-light, in a kind of amber glow. But what she wants to see in him goes beyond the immediate physical reality. The shadow, still linked to the body that is casting it, is at the moment no more than a poor semblance, a kind of secondary image. But when he is gone and the link is broken, he will have been trapped in the drawing, and it will be a precious and irreplaceable reminder of what he was. It will be a memorial, but also a place of hope since the darkened image will in turn create its own illusion. Looking at it, it will be possible to start hoping, even believing in the presence of this person, hidden there, somewhere unreachable, somewhere between the lamp and the wall. If the image exists, surely the model does too.

The young man cannot see what the lamp is showing him: his beautiful girl is here in his arms, preventing him from moving. He has his arm around her, enjoying this moment, not at all ready to leave yet. The light glows around them, enveloping them and isolating them from the rest of the world. His companion is not to be distracted and continues to caress the silhouette on the wall. She must finish this work which represents the inauguration of her approaching solitude. And so she repeats the movement over and over again, until the lamp dies out, eliminating the very last shadow.

●●●
The Meditation

René Magritte (1898-1967)
1936. Oil on canvas, 50 x 65 cm. Private collection.

The candles are tired of waiting. At this rate, there will be nothing left of them when the meditation — yet another one — will only just have begun. How many candles, tapers, wicks have been used up, consumed for all these thoughts that have led nowhere? All those lost nights, drawn out by insomnia, a waste of good candles. Those gloomy reflections, most of the time, were such poor company for an honest taper. There was at least a point to it when they were used to light enjoyable readings or family meals or to drive away the fear of the dark which grips the human heart.

This painting has had enough of penitence, of smoky, hazy flames. These candles will no longer agree to share the space in all those images of magnificent or emaciated saints, all on their way to eternal glory. They will never get that far, they know that all too well. So why wait for the inevitable end, the wax melting in soft puddles on fingers, the empty chandelier. They know that once again they will have been burned up in vain.

The candles have escaped. They don't want to melt for no reason — they would rather drown straight away. That would be quite a fine reversal of destiny. However it is a beautiful clear night, and their energy is beginning to return. They feel themselves wriggling in an unusual way. They can even contemplate travelling horizontally for the first time. That perpetual effort to rise to the heights was always so exhausting, you were permanently on guard. How wonderful to abandon the weight of one's own symbolic significance, a job they had always carried out with the utmost scrupulousness. Perhaps they may even start talking themselves. They have listened to so many murmurs and tears, so many recriminations and moans from the people who stood there paralysed and dissatisfied, gazing around them as the wick in their candle burned down sadly, finally relaxing, causing that soft melting collapse that was almost like a sensual pleasure.

But these candles have only just reached the stage of finding bodies for themselves. They drag themselves along the beach, sliding on the sand, snaking along. They are not fish, or mermaids – little eels perhaps. Fire going towards water – some bold folly, perhaps. They cannot escape from the divine curse. They thought they had been crafty but their escape had been predicted, written even. Their story is already well known, even though they are mere beginners, wriggling around a bit too much to be convincing. These escaping candles have unleashed little serpents of temptation, spurred on by their own deviousness. And, enjoying every moment of their escapade, they are re-living the fatal moment of sin and temptation.

The candle, between dream and contemplation
●

Quite apart from the subject of the painting, the image of the candle often arouses a sort of fascination in the spectator that is not entirely explained by the technical prowess of the artist. Gaston Bachelard explains that the flame 'accentuates the pleasure of seeing beyond what is already apparent. It forces us to look.' He continues: 'The philosopher can well imagine, looking at his candle, that he is witnessing a world on fire. For him the flame is a world reaching towards the future. The dreamer can see in it his own self and his own development. Within a flame space seems to move, and time does not stand still. When the light quivers everything else quivers. Is not the development of fire the most dramatic and vital of movements? The world moves fast when one imagines it in flames. And thus the philosopher can dream of anything - violent or peaceful - when he dreams of the world in front of a candle's flame.' (Gaston Bachelard, *La Flamme d'une chandelle*, Paris, 1961)

The flame and the wax
●

In traditional societies of the past, light was normally provided by resin torches, oil lamps or tallow candles. But the light they gave could not compare with that of wax candles, which was of much purer quality and almost smoke free. That was why they were used by the rich as well as by the Church which specified their use in the liturgy and other ceremonies. There was a practical as well as symbolic aspect to this, which still applies to this day: from the time of the early Christian Church, Christian writers saw in the light of the candle the Word of God spreading through the darkness of the world. From the twelfth century onwards, one can read their praise of the bee, whose virginity they celebrated. After this it was not just the flame itself, but the wax too which became an allegory of the body of Jesus, himself born of a virgin. Thus one can understand the particular resonance of the motif in the paintings of the seventeenth century, where it recurs in many 'candlelit' works.

The tears of Christ and the origin of bees
●

A legend from the Morbihan tells of how 'bees were born of the tears that Jesus spilled on the cross, none of which fell to the ground, but flew away to bring more sweetness to mankind. And so they were venerated, and given golden palaces, and those who dared to touch them were stung by them and died. God, seeing that they had become proud and wicked, punished them by making them live beneath little thatched roofs, and now, when they sting men, it is they who die.' (*Revue des Traditions populaires*, 1902). If one pursues the logic of this fabulous story, one can imagine that wax from the bees, with which candles and tapers are made, also has some role to play in the divine story. And so one can recognize, in the image of a lighted candle, an allusion, a memory even, of a sublime tear that still shines.

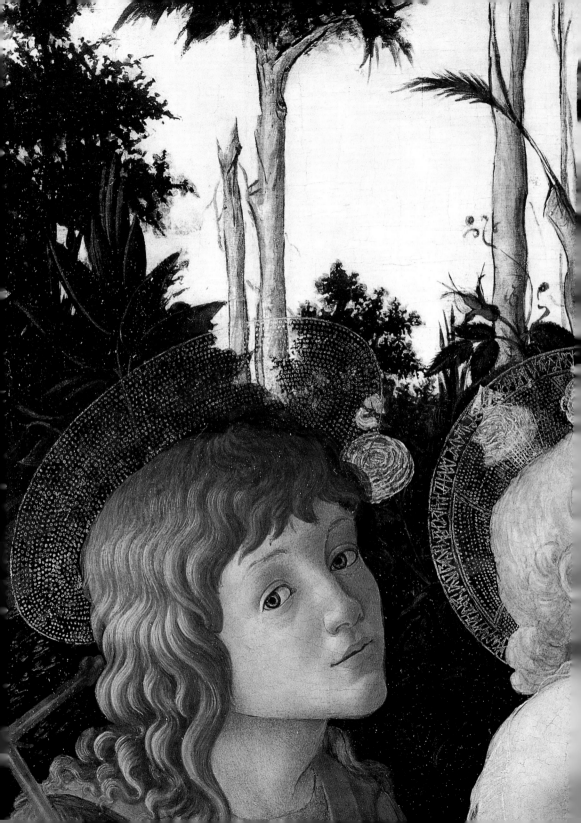

● ● ●

The Veil of Saint Veronica

Francisco de Zurbarán (1598-1664)

c. 1635. Oil on canvas, 70 x 51 cm. National Museum, Stockholm.

A hazy image on a piece of cloth – all that remains of the story. It came to an end, crushed beneath the weight of His cross. For a moment he looked around Him at those who were there, and were watching him pass. A veil, that seemed to come from nowhere, was placed over His face, a face that had seemed to pity those onlookers; a woman was crying. The man continued on His way. The abandoned cloth retained what it could, the imprint of His features. And they are what remains here.

The image of the relic stands out against the black background. The bare simplicity of the painting gives it the power to affirm the unsettling truth of this object, to the point of creating the illusion of a possible contact with the face of Jesus. When he was resurrected, Christ allowed doubting Thomas to touch his bleeding wounds. The rigorous Catholicism of the seventeenth century foresaw the weakness of sinners, and absolved them in advance by offering necessary proofs. Faith might weaken, sometimes you forget to pray for salvation or to obey the holy commandments, but how could one not believe, with every fibre of one's body, in the reality of this cloth, here, within one's reach? One would have to doubt one's own existence. The eternal image of Christ imposes itself on the spirit by overwhelming the senses.

The cloth, which used to be pure white, is fixed to the wall by wax or lead seals. Two folds have left vertical marks in the heavy material; one of them cuts through the face of Christ, like a tear filled with dust. It is such an ancient image. It will be carefully folded up again, and placed back in the darkness which protects its secret. Just for the moment, the face is protected from the danger of light by the edges of the veil which fall on either side. He leans towards the light, without needing to actually face it. It awaits him, he will not linger here. This portrait has no roots – it is perpetually on the verge of disappearing, almost dead with exhaustion.

The person who once wore this veil is long gone. She only exists in the picture through her name, Veronica. It is the true image, no other one will ever be necessary. There is no need to re-tell the story or fill in the details about the place. No other presence is possible, beyond this one, which is about to disappear.

The thin cloth just retains the image of the face which is fading – already no more than a little bit of rubbed earth.

●●●●
Spatial Concept 'Waiting'

Lucio Fontana (1889-1968)

1958. Vinyl on canvas, 125 x 100.5 cm. Pompidou Centre, Paris.

.

.

.

A piece of unbleached linen, slit down the middle. Two cuts, one beneath the other on the central axis of the picture. Either a picture, or the absence of a picture.

It is an emptiness with no mourning, a true void. Nothing has been wiped out or destroyed. The nakedness we see here is not the result of any process of elimination: it is a space upon which no limits have yet been imposed, a brand new form of emptiness. The slits themselves are not the result of wear and tear, but are resplendently clear-cut, the result of blows struck without the slightest hesitation. The irreversible gesture had nothing to do with chance or disorder, and its violent nature, if there was such a thing, is not the result of a sudden impulse: the controlled cleanness of the lines reveal a cold decisiveness.

The gaps, which open towards the spectator, seem to indicate that the power of the impact came originally from the inside. There are two outward thrusts, like those produced by a goldsmith's blade when sculpting shapes in a sheet of precious metal, and then placing them on a wooden base. Fontana is, in his way, describing the central spirit of the picture, by suggesting that it is inside the painting, in that invisible space beyond. It is an unfathomable area, out of which something has tried to break free, lacerating the canvas, desperate to find its way to the outside world, to us.

This work, which represents nothing, does contain an echo of the veil of Saint Veronica. It does not tell a story, but opens up a reflexion on the possible foundation of all painting. The canvas, stretched onto the four corners of a frame, is from the outset performing the same function as that of the cloth in the legend. And it is perhaps doing more than that – it is possibly an exact repetition of the story. The miraculous portrait of Christ, created by the close contact between the cloth and his face, appeared beneath and not on the veil of the holy woman who was showing her pity for him.

In this sense, the authenticity of a painting would not simply stem from the talent of the artist, like any object whose colour, form and appearance one judges. On the contrary it would spring from that ambiguous and unknown space, the place within, to which no human can have access.

The ancients would interrogate the fates by studying the stomachs of sacrificed animals, searching their entrails to discover the future paths of destiny. Fontana just slices into his canvas, and then lays down his arms, and waits, like a fortune-teller, before this gate that he has just opened.

The veil of the Temple
●

The most frequent reference to the veil, one which recurs and is echoed in all subsequent representations, is in the Biblical description of the Temple in Jerusalem. Two veils are mentioned: one separating the Temple from the courtyard; and the other, more important symbolically, Moses has to use to protect the Ark of the Covenant which held the Tablets of the Law from prying eyes. 'You are to make a veil of purple stuffs, violet shade and red, of crimson stuffs, and of fine twined linen; you are to have it finely embroidered with cherubs. You are to hang it on four posts of acacia wood plated with gold and furnished with golden hooks and set in four silver sockets. You must hang the veil from the clasps and there behind the veil you must place the ark of the Testimony, and the veil will serve you to separate the Holy Place from the Holy of Holies.' (Exodus, 26, 31-33) This veil, which forms a barrier between the sacred and the profane worlds, became associated with the image of the sky which, similarly, forms a screen between man and the heavenly vault. Even outside this exact context, the motif of the veil nearly always retains this significance.

The veil and the body of Christ
●

The Synoptic Gospels describe an event that took place at the moment of Christ's death: 'It was now about the sixth hour and, with the sun eclipsed, a darkness came over the whole land until the ninth hour. The veil of the Temple was torn right down the middle; and when Jesus had cried out in a loud voice, he said, "Father into your hands I commit my spirit". With these words he breathed his last.' (Luke, 23, 44-46). Following from this, an analogy grew up in the Christian tradition between the veil of the Temple and the body of Christ: his earthly existence places him between timeless space and the natural world, and he appears as the Word of God 'clothed' as it were in his humanity. The sacrifice on the cross and the rending of the veil are thus linked by a common message of redemption, and the bringing of the Holy of Holies to all mankind.

The veil, swaddling clothes and the shroud
●

In representations of the Nativity or the Virgin and Child, the image of the veil which half covers the child, or is held just above him, holds more than a simple domestic function. It is a reference not only to the veil of the Temple, which reveals the Word of God, but also to the linen shroud in which the body of Christ would be wrapped. It tells us that the presence of this piece of cloth in connection with Jesus is part of a symbolic chain which will lead us all the way to the Redemption. The Virgin who looks after the Child as his mother is also showing him to us as the divine representative of the Church: Jesus asleep or waking up prefigures Christ dead and then resurrected. It is sometimes the custom too to regard the *perizonium* (the material that covers the loins of Christ on the cross) as the veil that the Virgin has removed from her hair to cover the nudity of her son. This symbolic significance recurs in the use of the corporal cloth, the white cloth draped over the altar, in an image of the tomb, which is an integral part of the Eucharist. With the host, or body of Christ, laid upon it it also represents the shroud.

The veil of Saint Veronica

●

The legend goes back to the thirteenth century: a holy woman, on the path of the Passion, wiped the face of Christ with her veil, and it was miraculously imprinted on it. This *Vera Icona* (true image) gave her the name Veronica. It was a way of explaining the origin of a piece of cloth that had been venerated in Rome since around 1200, which had taken the place of a more ancient relic, this time from the East, which had been lost during the raid of Constantinople in 1204, where it had been kept. The cult of Mandylion of Edessa, an image not made by the hand of man, which had been known since the sixth century, was soon superceded by her western rival. In both cases, one of the essential points was to show possession of something concrete that would prove the existence of Christ in the flesh, and also thereby confirm his wish to be represented in this way. For the Church this would justify all the paintings that would follow. The Veronica veil itself disappeared during the raid on Rome in 1527, and was then mysteriously rediscovered in the seventeenth century, and since then has been preserved at Saint Peter's in Rome. The story gave rise to several variations, with differing amounts of emphasis on the figure of Saint Veronica herself, displaying the veil and inciting the faithful to devotion. The face of Christ, represented in full face with set features in the fifteenth century, later became an archetypal image of pain and suffering. Since the fourteenth century, Veronica's veil features as one of the Arma Christi, or Instruments of the Passion.

The Virgin and needlework

●

According to tradition, the veil of the Jerusalem Temple had to be woven by young virgins. One of the apocryphal gospels tells of how the Virgin Mary herself was once charged with this sacred duty. The priests had decided: "'Let us make a veil or tapestry for the temple of the Lord." And the chief priest said: "Bring me virgins who are without stain from the house of David." And they found seven of these virgins. The chief priest saw before him Mary who was of that house and who was without stain before God. And he said: "Draw lots as to who will spin the gold thread and fine linen and purple and scarlet silk." And Mary drew by lot the true purple and scarlet and having received them, went back to her house.' (Apocrypha of James, 10). The association between Mary and the veil goes back to the theme of the Incarnation: by working at weaving the material that marks the uncrossable divide between the sacred and the profane, she is symbolically preparing for the virgin birth of Christ, both son of God and son of man. In many scenes of both the Nativity and the Annunciation, there is a work basket to be seen beside the figure of the Virgin, suggesting simple pieces of needlework such as artists observed from their own everyday life. The original theme is thus transposed, making the image more familiar, without diminishing its significance.

Wearing a veil

●

During antiquity, the wearing of the veil was associated with initiation into a mystery, and symbolized the accession to a state of heightened consciousness. One finds the same significance in that worn by nuns, who were given this mark of distinction by the Church by the twelfth century, in reference to the words of Saint Paul when he said 'Ask yourselves if it is fitting for a woman to pray to God without a veil' (1 Corinthians, 11, 13). To 'take the veil' thus means that one is entering another life, a spiritual area that is separate from the world. The original connection with the Temple and the symbolism of the celestial vault gives the image of the veil laid over a woman's hair an enhanced significance. It is both the image of the heavens protecting the wearer and a sign of her purity. This is why, in the Middle Ages, chastity could be personified by a woman wearing a veil.

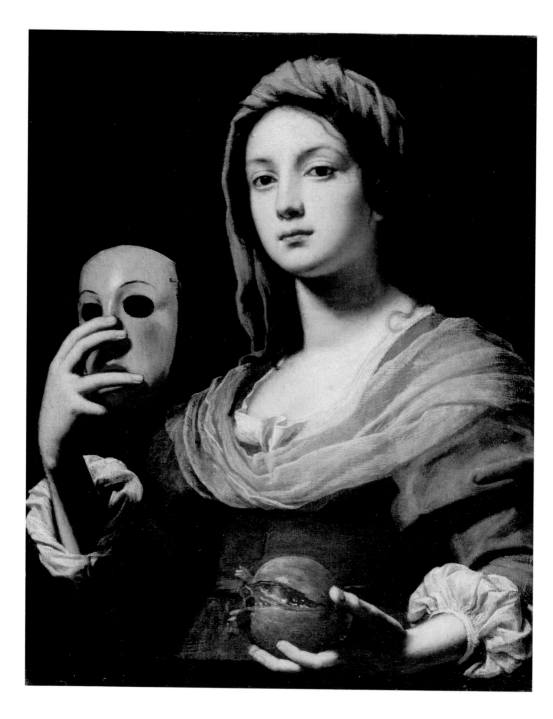

The mask

·
·
·
·
·
·

Allegory of Simulation:
woman holding a mask and a pomegranate

Lorenzo Lippi (1606-65)
c. 1650. Oil on canvas, 71 x 57.5 cm. Musée des Beaux-Arts, Angers.

·
·

With her hand right at the edge of the painting, she holds out towards us a half-opened pomegranate. With the magic of this simple gesture distances are eliminated and the spectator is drawn inside the picture. What seemed like a simple image becomes an almost tangible reality. The young beauty is here and now, waiting for us to accept the fruit that she is offering us.

One is, from the very first glance, trapped and seduced by this young woman with the impassive expression. We have no idea whether the stillness of her features is a sign of inner calm or simply indifference, whether that smooth forehead hides some faint emotion or just a complete coldness. Her pose does not allow us to ponder this question for too long; she is watching us from above, and so, whether we like it or not, we are at her feet. She is the mistress of this game.

Do we deduce from her gesture that she has just taken off her mask, or that she about to put it over her face? Is she waiting for us to turn away before continuing, or is she watching us approaching? Will she eventually take on some new guise suggested by the mask, and embark on a new role? But what could this role be, and in what kind of theatre? At this point in the story, one might well question everything since one knows nothing, and suspect this beautiful woman of every kind of falsehood. Perhaps that fleshy pomegranate is something other than a mere enticement – perhaps a poisoned gift? A large overripe, perhaps rather bland, fruit which we would taste unsuspectingly, emboldened by seeing it so close up.

Pomegranates are well known for disappointing the greedy, drawn by their bright colour just to be repelled by their rotting smell. Is she adding deliberate deception and fakery to the act of simple concealment? Surely just one distraction would have been enough to unsettle us? But in order for the painting to succeed it needs to divide our attention, so that we are lost within its frightening simplicity, fooled by this woman who is tougher than the devil himself.

Faced with these contradictory impressions, the spectator is still none the wiser. The images we see do not help us to understand the subtleties of this mystery, indeed they only serve to emphasize our inability to see where the story is leading, because the subject of the painting does not appear to envisage any development. It is like banging one's head against a wall, a fact emphasized by the solid black background against which the artist has quite intentionally placed his model. This brings us face to face with his dishonesty.

The beautiful woman's smooth face shows no hint of past smiles, or even the faintest movement of the eyebrows. The mask, on the other hand, has its mouth open, as though about to speak; the woman firmly places her finger over its cardboard lips, forcing them to remain closed, like hers. Who is teaching who, which one is the best liar?

The woman's face seems impenetrable at first, but perhaps it is just supremely neutral, nothing more than the personification of an abstract idea, the perfect image of a part of the mind. What about her body, her flesh and blood? There is no substance to her apart from her self-confessed dissimulation, and she only exists in terms of the mystification she causes. Time has no hold on her, her dress is too blue to give her any warmth. This allegory is made of marble.

The strangest part of this story is that the mask in her hand seems to breathe. It has all the life-like colouring that is lacking in the woman, splendid though she is. Perhaps this is because this simple theatrical prop is her only chance of experiencing emotion, drama, love, fear, laughter, death and desire. Everything that could have made this image come to life, that could have shown us some recognizable reality, that we could have understood, can only ever reach us by way of a mask.

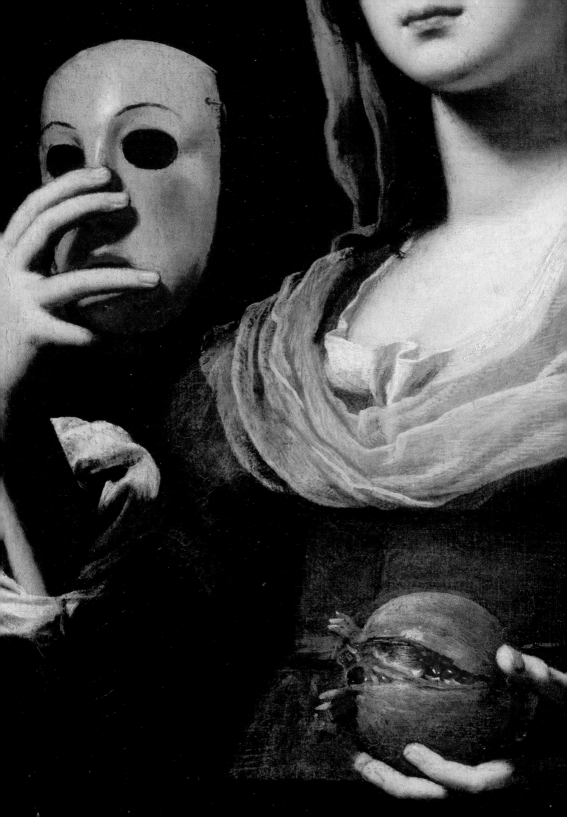

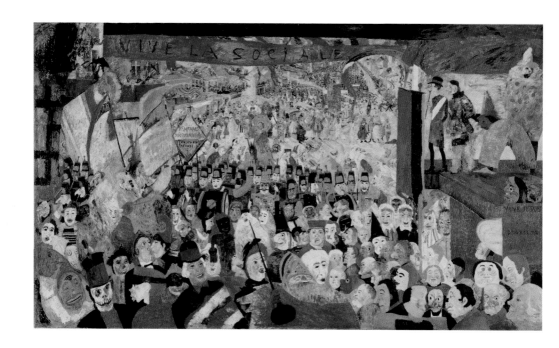

Christ Entering Brussels

James Ensor (1860-1949)
1888. Oil on canvas, 252.5 x 430.5 cm. Getty Museum, Los Angeles.

They arrive head on, into the picture. All of them – the gloomy faces, the clowns, the lead soldiers and the dignitaries in their hats, the elderly coquettes, the ugly dowagers, maybe even some pretty girls, who knows. The shy ones have come along too, as well as the permanently miserable ones, the commonplace madmen and the deaf and dumb who pretend to shout along with the crowd, and the happy ones bursting with laughter. And death is here as well.

The whole town is feeling ill, it has eaten and drunk too much. It swallows all these indigestible faces that crowd its streets and its memory. But still, it's carnival time, and everybody is having fun. Forward march! Beat the drums! There are masks in front, and masks behind, and the police don't know where to look. There are thieves and liars everywhere, and honest citizens too. There are no more children and the young ladies have put on their lace headdresses – the craftiest one is not the one you think.

They have taken all the remaining masks, and there isn't a single one for Christ in this great crowd. Too bad. Anyway, apparently He doesn't like that sort of thing, all because of some old story, embroidered in every sort of colour, especially red. The town can't get over it: there He is showing himself, with His face uncovered. How do they put it – with the face God gave him, the only one. What a character. The whole town is laughing.

He might set a bad example – supposing everyone started copying Him? Some of those in the corners are already considering it, starting with the artist himself who is ready to cause trouble. They look a bit alike anyway, so He hides in the crowd. He thinks He's at the centre of things, but who's going to see Him, poor fellow, with His halo of dented cardboard? If He gets any closer He'll be impaled on the sword of that fat red-nosed soldier who stands waiting right in the middle of the avenue. A terrified Pierrot is already rubbing up against Him, his cheek scratched by the blade: he is too white, too fragile and too clean for these streets. One kind soul approaches and tries to console Him. Who said the carnival was a cruel thing?

● ● ●

Portrait of Mademoiselle Yvonne Landsberg

Henri Matisse (1869-1954)

1914. Oil on canvas, 147.3 x 97.8 cm. Louise and Walter Arenberg Collection, Philadelphia.

The painting gently explodes into grey splashed with blue. Mademoiselle Landsberg, who has a mask with empty eyes instead of a face, blossoms into the shape of a heart. It is definitely her, from the parting of her hair to end of her long fingers. It is all there, unrecognizable and yet understandable, in the most classical of settings: a young woman shown in three quarter length, sitting on an armchair. The bright turquoise of the arm-rest stands out clearly against the dark grey of the background, the colour of the sky after thunder. The slightly low-necked dress, a faint shade of mauve, covers an ethereal body. She just sits there, her hands crossed over her knees.

Matisse does not in any way affront the modesty of his sitter by implying any back story or suggesting any revealing detail. In fact he leaves her with such a margin of privacy that it would be very hard for anybody to recognize her from this portrait, were they to bump into her. But it does not matter: the painter cannot be indifferent, and will never be satisfied with a superficial image. This timid person will have to come to some arrangement with the painting, she will have to be pushed around a little by the brushstrokes which underline, cut away and re-shape everything, unleashing energy in everything they touch. Just describing a face does not always show us its true essence: by replacing that of Mademoiselle Landsberg with an African mask, the painting demonstrates to us that truth must not be confused with accuracy of appearance.

In this search, which takes on the aspect of a transfiguration that is both pagan and savage, the use of a mask creates a visual shock. Matisse removes the portrait from its natural environment, and the spectator too, by reminding us that all painting is by its nature exotic. The real world is somehow effectively projected into an interior world, which is another, more distant, aspect of itself, and which has no common ground with the visible world to which we were accustomed.

The imperious expression on the face of the mask lends the sitter the authority and nobility of a mythical figure. But it also allows a play of lines and tracks which curve freely through the air, like sound waves. The stylized face, which is unknown even though it has a name, provides the template from which the body of the young woman becomes the blazing centre. Matisse has freed her, opened up a breathing space: her shoulders relax, her hips become rounder. She has never been so alive.

The mask as enemy of the truth
●

The mask is the most obvious accessory for deception. It changes the face's appearance, hides or covers up the truth to the point where it almost disappears. Artists have made use of it in a great many mythological compositions, where it serves as an indicator of the lie, placed more or less prominently in a composition, sometimes beside the protagonists in a story, sometimes between them. It acts as an extremely simple way of alerting the attention of the onlooker, and of arousing their suspicions as to the hidden intentions of the characters. It must be added that there is a very wide range of meaning within this definition, and the mask is connected to a great variety of figures. Thus Venus, goddess of beauty, is sometimes shown with a mask, in a reference to Hesiodes according to whom 'pernicious night engenders fraudulence and the pleasures of love' (*Theogony* 223). The object itself, acting as an obstacle to sight, can, equally, symbolize the night and everything it arouses and allows, from the confusion of the senses and emotions in amorous intrigues to the worst machinations of criminality.

The mask as an attribute of Painting
●

Iconographic tradition regards the mask as one of the attributes of Painting, since it can be an image for imitation and reproduction of the appearances of nature. In this context, the use of the mask as a code conveys an understanding of art and the quality of a skill, whilst not assigning it any particular moral value. Thus, following the example of Cesare Ripa, Francisco Pacheco, in the middle of the seventeenth century, writes that the art of painting is personified by 'a splendid woman with curling loose black hair, with arched eyebrows, the sign of deep and fantastic thoughts; her mouth is covered by a band of cloth tied behind her head, a pure gold chain hangs around her neck with, hanging from it, a pretty mask with written on its forehead the word Imitation . . . She has the mask of a beautiful woman, held tight by a chain, to show that imitation is inseparably linked to painting, that it copies things as they are in nature, and that it is the human face which does this.'

Theatre and the mask
●

The use of masks in the theatre in ancient times represents a return to its holy origins. During the ninth and eighth centuries BC, the dramatic performances and the festivals of Dionysus that took place in Athens were official religious ceremonies. The city celebrated the cult of this 'masked god', the symbol of renewal, with his many different faces. By the fifth century, the theatre had moved towards the profane, both in comedy and tragedy: this resulted in a huge variety of masks which, by amplifying the voices and the features of the players, differentiated their physical features and their characters. In painting, quite naturally, this long history is remembered , and the mask is used as an attribute of Melpomene, the muse of tragedy, and Erato, the muse of lyrical poetry. Ropa reminds us that it is important to distinguish between them, which is exactly what the mask does: Tragedy holds the mask in his hands to demonstrate that dramatic art imitates life, whereas lyrical poetry throws it under his feet to show his sincerity and his scorn for fiction which claims to draw inspiration from real life.

The carnival mask
●

The carnival evolved in the Middle Ages, around the tenth century, as a period of revelry which would henceforth precede Lent, the forty days leading up to Easter. In anticipation of the coming time of austerity and penitence, of fasting and abstinence – all restrictions imposed by the Church – carnival became a time of transgression, culminating on the final day, Shrove Tuesday. All moral and social conventions would be overturned in happy carousing. As this feast became rooted in local traditions, it took on different forms, and sometimes went far outside its original religious framework: by the eighteenth century, the Venice carnival, which had become famous throughout Europe, carried on for six months.

James Ensor was familiar with this tradition from his childhood. It was deeply embedded in the life of his birthplace, Ostend, which held the largest carnival procession in Belgium: people would wear masks and fancy costumes, and his mother ran a joke shop where she also sold souvenirs, chinoiserie, shells and carnival masks. The artist loved these papier mache objects and, from 1883 onwards, would often include them in his paintings. He described them as 'made with love, spiced with prettiness, purple, sky blue, mother of pearl, like mussels, oysters, sting-rays, turbots, brill, haddock, sole, made with such imagination and joyful exuberance'.

Christ riding into Jerusalem
●

The four Gospels describe Jesus entering Jerusalem riding on a donkey on Palm Sunday. This marks the beginning of Holy Week, which culminates in the Resurrection. 'The crowds who went in front of him and those who followed were all shouting: "Hosanna to the Son of David! Blessings on him who comes in the name of the Lord! Hosanna in the highest heavens!"' (Matthew, 21, 9). Symbolic importance prevails in this account which echoes the prophecy of Zechariah: 'Rejoice heart and soul, daughter of Zion! / Shout with gladness, daughter of Jerusalem! / See now, your king comes to you; / he is victorious, he is triumphant, / humble and riding on a donkey, / on a colt, the foal of a donkey.' (Zechariah, 9, 9). Some doubt has been cast on the likely historical truth of this event: such expressions of joy would surely have triggered an immediate reaction from the Jewish and Roman authorities. The transposition of this image by James Ensor evokes, more directly than in the Biblical text, the processions of the Middle Ages which commemorated this journey. An image of Christ was carried from one church to another, either on a live donkey, or on a painted wooden one mounted on wheels. The faithful who dragged it along would hope to obtain forgiveness of their sins as a result. Hosanna is a Latin word that comes from the Greek, going back to the Hebrew supplication Hoshanna: 'Please save us' or 'Please give us prosperity' (Psalms, 118, 25). It then became a prayer used by Christians.

The discovery of African masks
●

In about 1906, when Andre Derain, and then Picasso and Matisse discovered African masks, they found themselves confronted with objects whose provenance, history and purpose were completely unknown by the western world. They were struck by their aesthetic perfection, and by a system that seemed to place higher importance on a symbolic relationship with nature than on mere imitation, and this encouraged them to continue to pursue their own lines of research. The African mask, which was free of the western dependency on images in relation to the written word, showed the archetypal image of a face devoid of conventional expression. So-called 'primitive' indifference to naturalism, which goes against all the traditions of classical art, became a catalyst for these artists, whose intention was always to portray the irrational and the instinctive in their art.

The mirror

.
.
.
.
.
.
.

Virgin and Child
(for Martin Van Nieuwenhoven)

Hans Memling (1430/40-1494)
1487. Diptych. Oil on wood, each panel 44 x 33 cm. Memling Museum, Hospital Saint-Jean, Bruges.

.
.
.

The painting lies open like a book. Two panels for two worlds. Two spaces for two realities, but finally one image gathering them together in perfect unity. The Virgin with Child and the man who commissioned the painting, praying. Behind Mary there is a small mirror, half hidden in the shadows. The shutter is open showing a garden in all its natural glory.

There are precious stones decorating Mary's dress and stars made of pearls on her headband; a stained glass window depicting the story of Saint Martin, the patron of the donor, dividing his coat in two to give half of it to a beggar, and another showing the family coat of arms; the interlaced design of the oriental carpet, the gilt-edged pages of the prayer book, the fine hair of the child, the distant landscape – Memling never ceases to pay homage to the sensual beauty of the world around him. Against this background of prosperous bourgeois life, every detail can be easily deciphered, nothing is hidden: weights and measures, light, colours and textures, everything is there. All the familiar objects, like trustworthy witnesses whom one could consult at any time, surround the figures, creating harmony with their measured gestures and peaceful meditation. The meticulous precision with which they are depicted is a moral statement in itself.

The Virgin presents a fruit to the Child, who holds out his hand. His central position in the painting would alone indicate his all-important role. The faithful are being offered an intimation of the face of God. The naturalness of his pose

does not in any way lessen the holiness of the representation: it is a way of reconciling the message of eternal life with the reality of life on this earth. On the other panel, the portrait of Martin Van Nieuwenhoven, is a partial three-quarter view, intended as a clear denunciation of the transitory and imperfect nature of all human existence. The infant Jesus, embarking on the great story that is about to be re-written, shares with him this shifting relationship with space. He mimes the gesture of Adam taking the fruit of the tree of knowledge, as he prepares to deliver humanity from sin.

This precise depiction of gestures and positions indicates the particular relationship each element has with the world and the symbolic territory it inhabits. It falls to the mirror, despite its unnoticeable position in the background, to seal their significance. Memling makes all possible use of this little object shaped like an eye, in which the world is doubly reflected, both visually and intellectually. It does not immediately catch the eye of the spectator, but it is the medium through which they can, with careful study, can draw conclusions about the profound nature of reality.

This is because this mirror will only show us the essence of things; it does not show us the scene with the three figures which is what we see at first. In its determination to make it intelligible to us, it shows both less and more, depriving the world of its colour and carnal beauty, to finally display to us its true nature.

The Virgin, in the reflection, is no more than a triangular silhouette, an abstract shape rather than a woman. The Child, hidden by his mother, has disappeared from the picture, as Christ, in his human shape, was to disappear from this world. And so the maternal figure disappears and is replaced by the symbolic Virgin, the incarnation of the Church. The chair on which she sits is in the shape of a triple arch, probably an allusion to the Trinity, also echoed in the three high windows. Beside her, the large open book transmits the Word of God.

The donor appears in the mirror clearly kneeling, in an attitude of total devotion. The reflection succeeds in removing him from the instability of nature by showing him in profile, like a figure engraved on an ancient coin. His face, with the features erased by the distance of time, is now inscribed forever as a traditional part of history: he has overcome the limits of his terrestrial life.

Narcissus

Caravaggio (Michelangelo Merise, known as Il Caravaggio) (1570/71–1610)
1594-96. Oil on canvas, 110 x 92 cm. National Gallery of Ancient Art, Rome.

The young man is plunged into darkness, but it does not worry him. He is drawn and held by his reflected image. He is abandoning his own life for that of this other, whom he sees but who does not speak to him.

He sits beside the still water and leans his two hands down on the earth, as he gazes at his reflection. Perhaps he is leaning forward a little more than necessary, but for the moment nothing seems to threaten him. The drama has only been hinted at so far. Yet the picture causes us to lose our footing: without a solid foreground, the spectator cannot attain the perspective that Narcissus has in the face of his image. If we were trying to find some reality to hang on to, we would only pick on a few improbable details: a few strokes of brightness attached to his face, his reddish hair, his arms and his knee – all of which are doomed to drown. It is madness to believe in the presence of this figure, wild with love for something that does not even exist – madness to believe in a painted image.

The madness of Narcissus makes him believe that his reflection is a separate being, equal to him and as fully human. And the painting itself gives equal importance to the real boy and the reflection. It presents itself as a double portrait, divided in two by the line which separates the water from the earth. But reality is allowed less space than the phantasm, and Narcissus, in love with his own face, is only half-shown.

For him, worshipping an illusion, no real thing could ever be more desirable. The image transforms reality to such an extent that it leaves the world impoverished. It seems to contain a kind of beauty which he will never understand. His features fade like his consciousness. But the body of Narcissus, surrounded by that heavy darkness, acquires an unnatural prominence – the young man seems more vigorous than ever. The shirt, down in the depths, gleams like the smoothest satin. The water captures the moon's rays and turns them into a kind of skin. His fingers are grasped by their liquid reflection. There can never be a true caress, and the truth, which he no longer accepts, could never offer him anything comparable to this bliss which is already drawing him to his death.

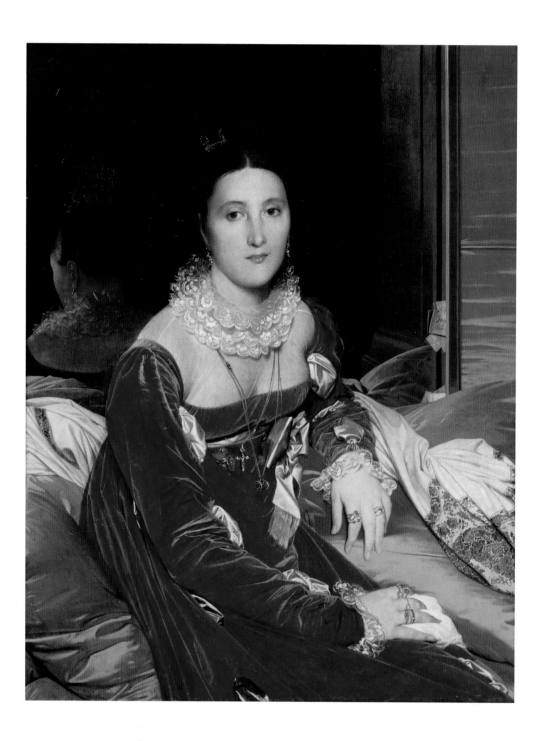

●●●

Madame de Senonnes

Jean Auguste Dominique Ingres (1780-1867)
1814. Oil on canvas, 106 x 84 cm. Musée des Beaux-Arts, Nantes.
.
.
.

Madame de Senonnes, dressed entirely in red, sits on the golden yellow sofa, and coolly meets the gaze of Monsieur Ingres. He, from time to time, looks away from her, to concentrate on the reflection of the nape of her neck in the great mirror that takes up the wall behind.

The painter is close enough to the young woman to smell her scent, and she leans slightly forward, politely attentive, nothing more. A distance remains between the artist and his model, and of the two people present, only one is reflected in the mirror. The spectator may search in vain for the image of the artist at work – he should be there, standing before his easel with at least a paintbrush in his hand, but there is nothing. As though by some magic trick, the portrait has managed to exclude an unnecessary presence and the familiar intimacy such a presence might have suggested. And so Monsieur Ingres has tactfully removed himself; the mirror is silent, and, in the eyes of posterity, Madame de Senonnes is alone in her drawing-room.

The mirror, which could have extended the scope of the painting, in fact appears to restrict it, like a solid screen. The artist knows the customs of this world, which are based on an uneasy equilibrium between what must remain hidden and what one can pretend to expose to polite society. Always a useful tool, the reflected image can reflect and conceal simultaneously, without the worry of any inherent contradiction. The risk of unlikeliness does not matter, the essential thing is that the visible reality should remain beyond reproach. The paintbrush glides over importunate details and tiresome imperfections, leaving out anything that could detract from the serenity and elegance of the subject, or even just draw attention away from her. It is no use insisting – there is nothing to see within the lying depths of the mirror.

In these privileged surroundings, Madame de Senonnes is exposed to the gaze like a precious stone in the safety of its setting. The casual déécolletéé is tempered by a piece of diaphanous gauze and several rows of lace. A jewel, reflected in her hair, has been chosen to brighten up the simplicity of her neck, but it is not particularly striking. It offers just a semblance of intimacy, a piece of artful trickery. There are a few visiting cards tucked in a relaxed and disorderly way into the gold frame: the time for society visits is approaching, and the first guests will soon be here. Madame de Senonnes' gaze gives nothing away, any more than the mirror does – she knows the importance of appearances.

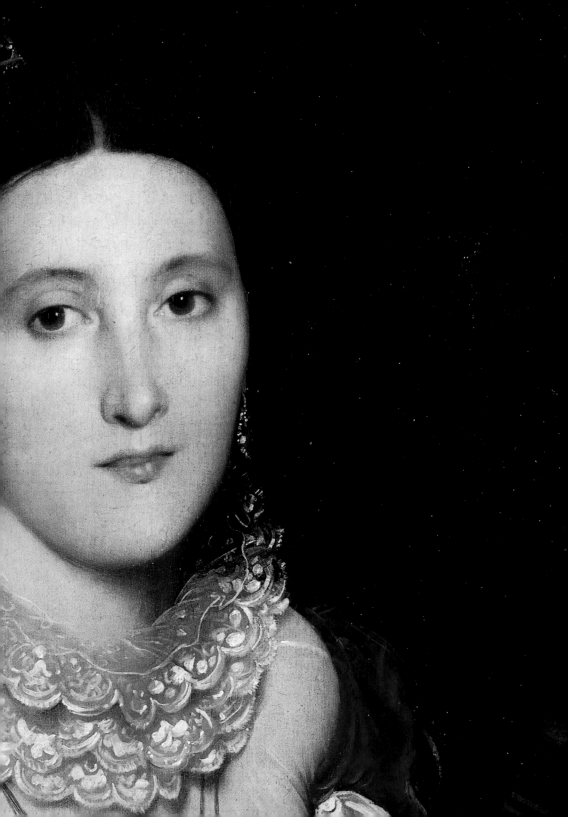

●●●●

Interior with Mirror (self-portrait)

Lucian Freud (1922)

1967. Oil on canvas, 25.5 x 17.8 cm. Private collection.

One could hold this painting in one's hand – it is a small rectangle the size of a child's schoolbook, or one of those little plastic-framed mirrors which one can prop up almost anywhere, as one moves around. An object redolent of poverty and solitude, that lies around on bathroom shelves.

But this mirror is something else, an odd sort of monocle, perched crookedly in the picture. Not odd exactly, more displaced or lost. It has a sort of elegance, but there is nothing here to respond to it. Perhaps it has known better days, been in environments more suited to its character. But now, it seems, it cannot hope for anything better than what little is here.

It clings on to the only tiny reflection it is capable of capturing, a much reduced version of brooding reality. The artist appears in miniature, just his head, without shoulders. A proper bust might possibly have been able to suggest the nobility of the sculptures of antiquity, the fine straight heads of emperors or philosophers. But Freud has given himself long pointed ears. He sees himself as a faun; malice in miniature.

The artist has introduced enormous emptiness into a tiny picture. The mirror has been planted in this desert and has absorbed it. And yet there is a sense of airlessness. Life has been locked up and is suffocating, the flesh has become sad and limp. The cold blue around the precious little mirror completes its isolation from the rest of the world, which cannot appreciate the softness of its curves. It is precious, yes, because it is all there is. The indifferent lines around it cross at right angles against a joyless morning background. There is no good weather to be expected outside this window.

The artist's blurred features follow the angle of the slanted mirror. He has skilfully captured his miniaturized reflection, and has wedged this illusion of himself right into the centre, with geometrical precision. He himself has no illusions, of course. But the painting has saved him – it didn't take much: the mirror was about to fall and his ravaged face with it. He seems to swing like a pendulum. Life passes and sleeps in a rhythm. The mirror is his metronome.

The myth of Narcissus

Ovid tells us the sad story of Narcissus who fell in love with his own image when he saw it reflected in the water. He discovered to his cost the power of illusion in this natural mirror, and died despairing of his own stupidity: 'Thirsty for water, he started to drink, but soon grew thirsty for something else. His being was suddenly overwhelmed by a vision of beauty. He fell in love with an empty hope, a shadow mistaken for substance . . . All that his lovers adored he worshipped in self-adoration. Blindly rapt with desire for himself, he was votary and idol, suitor and sweetheart, taper and fire – at one and the same time . . . I know you now and I know myself. Yes, I am the cause of the fire inside me, the fuel that burns and the flame that lights it . . . Better indeed if the one I love could have lived for longer, but now, two soulmates in one, we shall face our ending together . . . He rested his weary head in the fresh green grass, till Death's hand gently closed his eyes still rapt with their master's beauty. Even then, as he crossed the Styx to ghostly Hades, he gazed at himself in the river.' (*Metamorphoses* III). This myth immediately demonstrates the paradox of the mirror which tells the truth since it cannot invent anything, but which lies because it presents an inverted image which has no substance. Narcissus, who has committed the sin of mistaking a simple reflection for reality is condemned to eternity in Dante's Purgatory, to suffer alongside forgers.

Convex and flat mirrors

Until the sixteenth century mirrors were small precious objects, about the size of a saucer, which were mainly used to look at one's face. They had a convex shape as a result of being made from blown glass, which formed spheres which were then cut in half. Lead was then poured in, melted in Roman times, cold by the fourteenth century; mercury was introduced in the following century. Artisans in Lorraine became known for their skill in this technique, but the Venetians in Murano soon surpassed all their competitors. Venice, at that time, was exporting its glass work all over Europe and the East, although, since it remained very expensive, it never entirely replaced the mirrors made from polished metal which had been used since the days of antiquity. By the middle of the seventeenth century, there was such a craze for mirrors that no prosperous family could be without one. A further development arose with a new technique using melted glass, by which one could achieve larger and flatter mirrored surfaces: the greatest culmination of this method was the building of the Hall of Mirrors in the palace of Versailles in 1682. From then on mirror-making continued to improve and develop until almost every middle class household possessed one, using it to create an illusion of grandeur and space in apartments of diminishing size. And so the private individual image reflected in the small curved mirrors was replaced by a full-size reflection of everyday life on drawing room walls.

The reflection creates the image

The theory of art, from antiquity until the Renaissance, has always been founded on the concept of imitation. The mirror is therefore a symbol of art itself, creating a permanent reflection of the world. Alberti (1404-72), an architect and theorist of art, recognized in the middle of the fifteenth century that Narcissus was the first painter of all, capable of inventing a reflected image of himself from a flat surface. The story of Genesis, too, which describes man as created 'in the image and resemblance' of God enjoins us to perceive humanity as the reflected image of its creator. And so, by his use of the mirror as a motif, the artist is reminding us all over again of his original purpose, which is to condense an image of nature, in either a spiritual or a naturalistic manner.

The mirror and knowledge
●

Truth knows what is, and Prudence looks beyond her own self and is able to foresee events; they are the two virtues most often traditionally shown holding a mirror. In both cases the symbol is connected with knowledge, a theme under constant discussion by the classical and Christian writers and thinkers. The Latin word *speculum* (mirror) quite naturally became the root for speculation in an intellectual sense, particularly as, in the Middle Ages, sight was the sense most readily connected with knowledge, and, obviously, with the exaltation of divine creation. Thus both the perception of the physical world and spiritual reflection and introspection can be perfectly combined in the image of the mirror: it becomes the model for the metamorphosis of solid matter into disembodied form. Socrates had already enjoined his young followers to look into a mirror, either to render themselves worthy of the beauty they saw in their reflection, or to attempt, through education, to compensate for the faults they found and deplored in it. The very instrument of imitation could in this sense lead to inner transformation. The idea that a reflection could show some hitherto invisible truth, and could therefore contain superior knowledge, reappears in the popular custom of covering mirrors after a death: the soul of the dead person would then be unable to see in advance what fate awaited them in the afterlife.

The quality of the reflection
●

The reflection in a mirror can be altered in several ways, changing its symbolic significance. Convex mirrors, for example, which deform reality in a frightening way, have been called witches' mirrors, although they can also be images of the eye of God, able to embrace the whole of creation in one image. For Saint Paul, a human conception of God could only be described as 'seeing a dim reflection in a mirror', since man has deprived himself of light by disobeying his creator.
By contrast, the term 'untarnished mirror' which appears in the Bible (Wisdom, 7, 26), refers to the holy Word, in which man can discover the absolute truth of God by relieving himself of the weight of the flesh and the world. This motif was thereafter attached to the Virgin Mary, notably in images of the Immaculate Conception: here one can see a small hand mirror floating in the clouds that surround the Virgin, a sign of her eternal exemption from all sin. When it is neither darkened nor perfect, the surface of the unbiased prop enables it to be seen as one of the symbols of the age, something which never changes as it reflects the world passing by never to return. It can sometimes be found in the still lifes of the seventeenth century, placed there in order to underline the vanity of earthly life.

The mirror of pride
●

When Venus gazes at herself in the mirror, she can see nothing but a confirmation of her beauty. There is no particular moral message in the theme of the goddess at her mirror, adorned by the Graces, and accompanied by Love, always eager to serve her. It is quite a different story when it involves a woman who is not a mythological figure gazing at her own image. No matter what the reflection shows – accurate, more beautiful or less, the spectator is able to judge this for himself – the highly Christian purpose of the image is to denounce vanity as the first step towards seduction, and therefore an encouragement to lust. The mirror is therefore an attribute of Pride, the most terrible example of which is Lucifer, 'bearer of light' in Latin. By attempting to deny the fundamental difference between the manifestation and the idea, that is to say the creator and his creation, or even the reflection and its source, he had tried to usurp the place of God.

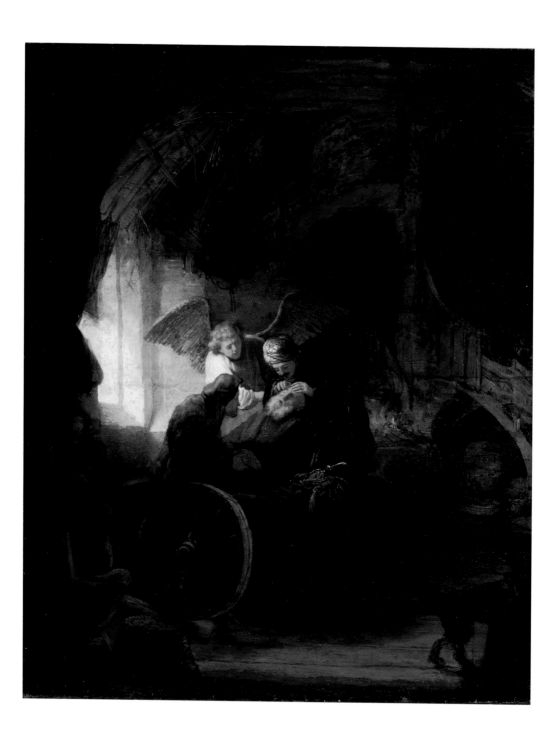

The window

.
.
.
.
.
.
.

Tobias Restoring Sight to his Father

Rembrandt (Rembrandt Harmensz Van Rijn) (1606-69)
1636. Oil, 47.2 x 38.8 cm. Staatsgalerie, Stuttgart.

.
.
.

Tobias leans over his father, holding his head back. He needs light in order to treat the old man's blind eyes; it floods in through the window.

And yet this house is normally shrouded in darkness. A smaller and smaller space was in use, around the few objects that were indispensable to everyday life. In this small room which came to feel too big, the mother's movements had slowed down, and the father's steps had become hesitant, for fear of getting lost. He would wait in the darkness, next to this window, which gave him no light. His home had become as dark as the night is for other people.

Rembrandt is careful not to offer any details as to where the story is taking place, and the spectator, muddled up in the chapters of the Bible, is also feeling their way along. Straw hangs down from the roof beams which seem about to collapse. A bit of staircase rises up above a small cask, going nowhere. Further away a small fire is burning. The people in the picture could be in a courtyard, a cellar, or even the corner of a stable. Some of them have retreated into the shadows, saying nothing. At the bottom of the picture a dog has chosen to leave – there is nothing to keep him here. The distinction between indoors and outdoors no longer makes sense, so why insist on it? Anyway, they have lost their way.

We see a dwelling full of poverty and neglect, suddenly visited by a blinding light; it is a complicated, dilapidated sort of place, and it lends itself to mystery. The periods seem to be mixed up: one is reminded of a Nativity image, with the cradle illuminated, but the story in this scene comes from the Old Testament.

And it is the story of an old man, not of the Child Jesus. Although it is true that the restoration of sight to old Tobit does signal a rebirth. The artist is working with the same material – it is an image of renewal, in advance of its time.

Nothing will be as it was before and the invasive presence of a huge cart wheel is no doubt some kind of metaphor: a metaphor for time passing, rolling along, along all the distances that Tobias has travelled on his journey, and again on his return voyage. One more turn of the wheel and the cycle will be complete. He is back with his parents, after a long tour. He has walked for a long time, through unknown countries, wearing that turban, which in itself is a reminder of foreign lands. When Tobias left he was practically still a child. Now he is almost a stranger and he knows things they have never even suspected; he has brought with him a cure for his father.

Raphael, his guardian angel, who has been his travelling companion, has protected him from all dangers and has taught him how he can restore his father's eyesight, by rubbing his eyes with a bit of fish spleen. He has brought him back to his home and is at this moment helping the young man by guiding his movements. The radiant white of his gown against the earthy shades of the rest of the painting designates him, quite as much as his wings do, as the heavenly messenger.

The blazing light which illuminates the stones stops by the figure of old Tobit and bathes his face; it is destined only for him. One senses that the old man is afraid and has tensed up beneath this caress that is so powerful that it can only come from God. His wife, Anna, holds his hands as though to reassure someone who is not feeling too well. She is afraid too. Who knows what is going to happen? To go from darkness to divine light will surely be another kind of blindness: lack of light or too much of it, in the end the eyes will panic and the burning eyelids will close again. Somewhere between the two, there is the ambiguous condition of mankind, a deceptive and fickle play of light and dark, something one can live with. It is not always possible to endure a miracle. The light continues to flood in through the window, as liquid as honey and as precious as a magic balm.

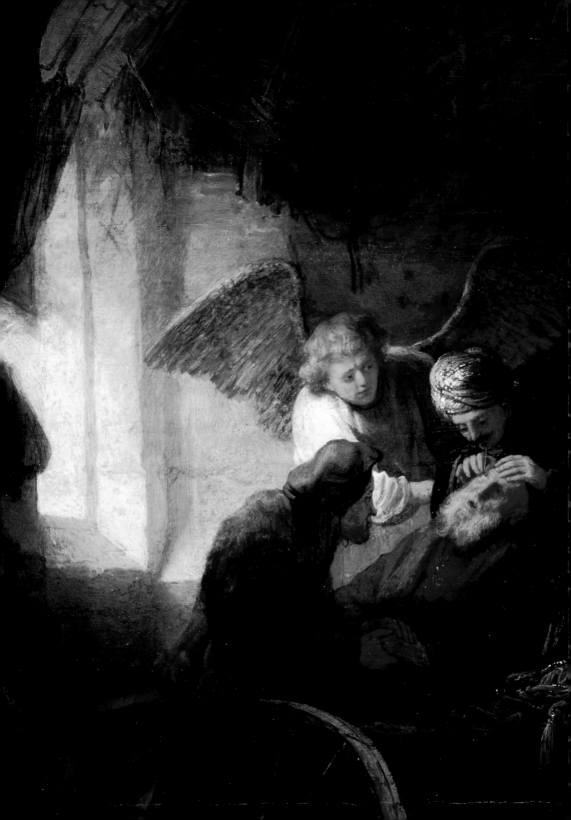

●●

Woman at a Window

Caspar David Friedrich (1774–1840)

1822. Oil on canvas, 44 x 37 cm. Nationalgalerie, Berlin.

.

.

.

A young woman, seen from behind, is leaning against a windowsill, looking out. The calmness of her demeanour tells us that if she is waiting for anyone or anything, she is not impatient.

All around her, the wooden panelling and the lines of the walls and windowpanes measure out the surface of the painting as well as that of the house. Their almost perfect symmetry seems to pull back a little so as not to completely freeze this interior into which daylight penetrates in measured doses, like news of the outside world. The young woman tilts her head slightly and follows the movement of the passing boats. The window, which is set slightly back so that it looks as though it is pushing the wall away, is so high that it would be hard to lean out without a great effort. Even the thought of doing that seems misplaced.

The olive green colour of the room seems to dampen the effervescence of the greenery in the distance, as though suggesting a domesticated version of it, calmer, less intoxicating, easier to live with. The young woman's dress itself seems to melt into this palette of broken colour. No outside tone, no matter how subtle, breaks into the silence of this room. When she turns away from the window her little slippers will slide noiselessly along the wide floorboards.

Only a small part of the window is open to the fresh air outside, allowing a sudden free rein to curiosity, an escape from the habitual restraint. Every time one opens the shutter one is struck by the intensity of the light outside, as though seeing it for the first time. The soft-looking trees on the other side of the river are lit up in the sunshine. Through the large panes of glass small clouds carry with them all the pleasure of a new day.

What is she really looking at, sheltered there from the sharp wind? This window in her parsimonious world makes any vista all-important to her. This geometrical world which carefully subdivides the spaces squeezes the landscape into its centre as in a triptych. On the other side of the high casement the sky stretches to infinity. Soon the ship sailing away with its sails furled will no longer be visible.

.

.

.

● ● ●

The Breakfast Room

Pierre Bonnard (1867-1947)

1931-32. Oil on canvas, 159.6 x 113.8 cm. Museum of Modern Art, New York.

.

.

.

It is like a gentle glow – a radiant summer's day which makes one want throw oneself in amongst the colours and embrace nature. On the table the food is already laid out.

The painting draws one outside and keeps one indoors at the same time. The way is all prepared: the vertical lines of the bay window, the stripes in the damask cloth, the shape of the canvas itself, all draw the gaze outwards into this garden, where one might wander alongside other walkers, those few tiny shapes at the end of the path. But the table, blocking access to the outside, delays this outing, as does the closed window and the heavy stone balcony.

The different orange, yellow and brown tones diffuse a fragrance of ripe fruit against the perfect blue white of the tablecloth. The light is caught in a few threads of gold that enhance the porcelain cups and bowls. The biscuit tin is bright green, as fresh as a mint tea. The image is tipped towards the spectator, as though presenting an offering.

In the undefined depths of foliage, the greens mingle and disappear into the yellow, creating their own complete world, dense but accessible: a painting within a painting, one that gives a glimpse of the intimacy and happiness out there. The sunny room indoors is just as agreeable as the luxuriance outdoors – everything is equally shared. The landscape outside is not one of those lures, those images of a promised land – it is just another dimension of what is here and now. Those people walking by are silently absorbed by the warmth of walls redolent of plums. Knowing that they are there is a kind of relief.

Bonnard's gaze moves ceaselessly to and fro, leaving and returning, from the garden to the house, from the table to the balcony. The colour which pervades his work seduces him like the song of a siren. The edges of the window act as a handrail for him: his paintbrush clings tenderly to them without ever renouncing the call of the distant garden. The real disaster would be to have to choose between the twin realities of the two worlds; it would tear him apart. And so the dazzled window at the centre of the painting confirms the equally shared beauty of the world.

.

.

A Window

Robert Delaunay (1885-1941)

1912–13. Oil on canvas, 111 x 90 cm. Pompidou Centre, Paris.

An invisible window, indecipherable shapes – the work, drenched with colour, does not attach itself to any reality, even though its title assures us of the contrary. All it does is allow itself a closer look at things.

Delaunay has come up so close to the window that it has disappeared, getting mixed up with the painting from which it has overflowed. With one's face glued to the clear glass, one looks, without really seeing properly, at the town down below, at the shadow of a street. A sideways glance at a white facade makes the building tip like a sinking ship. Just as one is becoming dizzy, one recognizes a silhouette, a blueish curve with a few green crossbars standing in the midst of the multicoloured space. It is a lifeboat floating amongst the waves: the Eiffel Tower. The painting recovers its balance, confirming the metallic solidity of its axis. We are in Paris.

The rainbow coloured light which plays on the surface of the glass spreads a green-tinted yellow warmth over the picture. A whitish frost trails in places, giving a false impression of winter, over the ample curves of the painting: these are really just the net curtains drawn to either side to reveal the scene before us. They bring a kind of enchantment to the window, dressing it in a transparent haze. Invaded by the sun, the window regains all its transparency and the colours impregnate it like a stained glass window.

This window matters only to itself and seems to exclude the landscape outside like an old, faded backdrop. The reality of the scene outdoors has been swept away, broken up into fragments as though by a set of mirrors. Light effects have taken over, its a party now – the world is just a kaleidoscope and the picture has been plunged inside it. Delaunay has methodically used the window for his picture, deconstructing the prism of colours whose volatile lines no longer describe anything.

The ambivalence of the window
●

The window motif, present throughout the history of painting, contains within it the most opposed of meanings. In ancient Egypt a window designated the sacred space for a vision of a god, that inaccessible place where the pharaoh, symbol of the rising sun, would appear; in the Near East, the goddess Ishtar leaning from a window was the guarantee of earth's fertility as she revived the link between men and gods. But, to the Greeks, such a gesture was a sign of bold insolence in a woman, seen to be offering herself to all comers; this idea can also be found in Christian imagery. Quite apart from the diversity of the attitudes it arouses, the symbolism of the window varies inasmuch as it is founded on a concrete ambivalence: it is characterized by its double face and so applies to the religious and the profane, the world of indoor domesticity and the outdoor world, it opens to allow things through and at the same time acts as an obstacle. Each of its constituent elements, its openings, the light it allows through or shuts out, its pane or panes, its crossbar, its shutters and lattices, play a part, either together or separately, in the construction of its meaning, as does its actual location. Seen as the instrument of a revelatory vision when seen from the inside, and therefore as a gateway to illumination or memory, it can, when seen from the outside, be the instrument of voyeurism.

The window as a symbol of Christ
●

Although light and doors have been key traditional symbols of Christ, arising from Saint John's gospel, the window is another important element in the repertory of images relating to him. This comes from a passage from the Song of Songs: 'I hear my Beloved / See how he comes / leaping on the mountains, / bounding over the hills. / My beloved is like a gazelle, / like a young stag. / See where he stands / behind our wall. / He looks in at the window, / he peers through the lattice.' (Song of Songs, 2, 8–9). According to the critical interpretation by the Fathers of the Church, the betrothed, the loved one, is none other than Christ himself. His arrival and his look through the window symbolize his heavenly marriage to the Church. The passage about the window represents his incarnation, his arrival in the world of men, the first phase of the marriage which will only be truly consummated with the final coming of Christ. According to Origen (c. 185–254) the wall around the window, its frame, crossbars, lattice and shutters are seen as representing the mortal body of Christ, partly concealing his divine light. And it is clear too that the crossbar of a window, a reminder of the Crucifixion and of Salvation, is also as much a symbol of pain and solitude as of hope and everlasting life.

The window as symbol of the Virgin Mary
●

The symbolic link between the window and the figure of the Virgin is largely based on the glass pane. Glass – which was used in Roman times, and particularly at the time of Christ – represents Mary's virginity, since light shows through it without breaking it, just as she is impregnated by the Holy Ghost without being deflowered. This metaphor was developed by the early Christian writers, and fully embraced in the poetry of the Middle Ages. Rutebeuf repeats this in the thirteenth century: 'If, as in glass / comes and goes / the sun without breaking it / thus you were a complete virgin / when God who is in Heaven / made of you wife and mother.' At the same time, the symbol was embellished by the reflection of stained glass, the humanity of the Virgin 'colouring' the perfect light of God during the incarnation of Jesus. Since virginal motherhood played a decisive role in the absolving of original sin, the window is equally connected with the idea of redemption: the double movement of sky to earth and earth to sky defined in this way connects the Marian symbolism of the window to that of the ladder.

The window reflected
●

With their appetite for detail, painters in the Netherlands favoured a motif which often passed unnoticed. The attention it requires is in itself a lesson as it shows us the limits of the visible world. Sometimes seen on a jewel, more frequently on a globe – the emblem of royalty and eternity held by Christ – a minute reflection of a window can be seen, which is in fact a cross in full light. Mostly unjustifiable in terms of the actual context, a landscape or gold background, the mystical window conveys an image of enlightening grace. This theme disappears towards the middle of the sixteenth century at the same time as that of the insignia of the sovereignty of Christ, but one finds echoes of it in the reflections seen in the eyes of the figures. Dürer (1471–1538) produced many examples of this. They illustrate the idea of the eyes as 'windows of the soul', already a well-worn theme by the time we find it in the notebooks of Leonardo da Vinci (1452–1519), and one which goes right back to the Fathers of the Church: 'Your eye is the window' as wrote Saint Ambrose.

From the seventeenth century onwards, in the still lifes painted in Northern Europe, these reflections, no longer necessarily of church windows, could be found on the curves of glasses, ewers or other shiny surfaces. One can recognize an echo of this on the armchair of Monsieur Bertin, painted by Ingres in 1832.

The window between life and death
●

In the second century, the philosopher Sextus Empiricus was already comparing a man's senses to a window, closed when he is asleep, open when he is awake. Christian thought, distinguishing between the carnal and the spiritual senses, elaborated on this by adding the idea of purity which alone could enable access to God; in other words, the image was of glass whose cleanliness would let light through without distorting its rays. Passage through a clear glass window could therefore stand for well directed intellectual endeavour, capable of comprehending divine wisdom. This would assume, of course, a possible opposite interpretation of a window darkened by dirt and vice, or partly broken, allowing temptations to enter freely. The questions and moral anxieties attached to the window as a symbol were transposed into popular practice. Thus the custom of drawing curtains and darkening rooms after a death was not so much a mark of respect for the dead person as a reminder of this 'night' of the senses. Also, in the same circumstances, opening and shutting a window would allow the soul to escape and not be tempted to return to haunt the living: an echo of faith in the redemption and persistent fear of the devil.

The painting, an open window
●

In the painting of the Renaissance, conceived as an imitation of nature, the illusion of a third dimension in the image created by the use of perspective (from the Latin *perspicere*, 'to see through') played a dominant role. When the architect and theoretician Alberti noted in 1436 in his *Treatise on Painting* that a painting was 'an open window' to the world, he was expressing the view that the medium of the paint must be completely forgotten in favour of the feigned depth of the composition. This definition would remain valid until the end of the nineteenth century when, on the contrary, the surface of things was emphasized and regarded as an integral part of the work. The motif of the window, which soon became a recurrent one in the work of Matisse, Picasso, Bonnard and Delaunay, would therefore underline to what extent the space shown in the picture, rather than projecting itself beyond the canvas, could be a part of it. It ceased to be a symbol and became instead a favoured indication of ideas about the methods and aims of painting itself.

The curtain

Christ Judge and Redeemer

Petrus Christus (active 1444-75/76)
c. 1450. Oil on wood, 11.2 x 8.5 cm. Birmingham Art Gallery, Birmingham.

This curtain is not of this world; it is held open by angels. Christ has stepped forward, stricken and bleeding, to display His wounds to mankind. The angels solemnly hold up the sword and the lilies.

This small painting opens the way to prayer. It is a private object, intended for discreet worship. In this reduced space, the curtain takes the place of all other accessories, more solemn and holy than the most precious of backdrops. It creates a nameless space behind the figures, a thickening darkness that seems without limit. Christ has come out of the shadows, emerging from this tomb whose dark edges one can distinguish at the bottom of the picture. By tearing Himself away from the world of the dead He has returned to the visible world. This gentle and yet violent image stands as a witness to the Crucifixion; it proclaims eternal life and shows us the way. The curtains stand as a place of transition, allowing access to the hereafter.

The praying man, with this tiny painting before him, sees the two panels of material opening up reassuringly before him. Imagine the confusion if they were to close, if the world were to once again become opaque and soundless, like a disused theatre, with a useless stage behind the curtains. But the angels, with the help of the artist, hold the curtains open, to prove that this emptiness no longer exists: somebody is there, death does not triumph.

Christ addresses the weakest amongst men, with an expression of terrible exhaustion, as though He were still on the cross. He presents His tortured body for Christians to worship as though it is a host. The curtain is open for those 'who

know not what they do', so that they too can finally understand: we are not celebrating the joy of the Resurrection here, but everything that led to it, the everlasting torment of the Passion, Christ's suffering to the end, sublimated by the ultimate sacrifice. His crown of thorns has been transformed into a sign of glory, starred with golden flowers. Christ has placed himself between the void and the man who is looking at Him. He has been through everything and stands there now, before the precipice which can now hold no fear.

Only the wounds remain vivid, outside the time of the story: the marks of nails in the palms of his hands, and that of the spear thrust in His side. The cut, from which blood and water flowed on the cross as a sign of the Eucharist and baptism, is now reopened by Christ's own fingers. The man contemplating Jesus will remember Longinus, the blind centurion who dealt the blow and recovered his sight when the blood spurted out over him. He too is in the dark, hoping. Perhaps the image of this wound which he has never seen will have the power to cure him.

The tilt of Christ's head causes the curtain to open a little wider on that side. The panel opens slightly with a suppleness that matches the smooth fragile flowers. The angel of mercy, dressed in soft green, leans forward and the echo of her indulgence fills the sky, making it seem lighter. On the other side, the angel with the fixed expression stands as straight as her sword, forever inflexible. Her pink robe bears the memory of the blood that has been spilled and that cannot be erased. The cloth she holds in her hand does not move.

The two panels of the green curtain flutter like the two sides of a pair of scales, weighing up the different fates of the elected and the punished. In their perfect harmony, the angels serenely divide fate into two equal parts, and under the gold fringed canopy, they await the judgement of God.

●●
Trompe-l'œil

Cornelius Gijsbrechts (active 1659-75)
1672. Oil on canvas, 145.5 x 183 cm. Copenhagen Museum.

.

.

.

Tucked underneath the ribbons, the letter that awaits an answer lies beside others that have been re-read, carefully folded again, or left as they are: news that is no longer new, a small unimportant untidy corner that is normally kept out of sight.

For once the curtain reveals what is missing from the front of the stage: we are shown behind the scenes, given a private performance from everyday domestic life. It is summed up in this accumulation of small objects which have no particular place, things one doesn't necessarily need any more, but that one is reluctant to throw away. They hang there in a dormant state, in a sort of no man's land between their presumed usefulness and complete oblivion. It is a kind of purgatory, this board of objects to jog one's memory. And the moment for a last judgement is endlessly deferred.

They have even started hanging up, as well as they can, those objects which misshape the pockets and create a bad impression: a comb, a pair of scissors, another pocket-watch, a pen or a little work bag that was lying around. The painting lists all the mistakes that have been narrowly avoided. It confirms all the official decisions and last minute changes with the quiet patience of a life-long servant. A well-sharpened razor, sticking out of its pouch, reminds us to be careful. The fine comb is wedged behind the almanac and fleas and every other sort of parasite are there in abundance.

It might finally be time to review all of this, a mixture of the important and the trivial that clutters up the notice board, and do a preliminary sorting through one's thoughts.

 Although it must be said, after all, that this jumble of objects has its own particular harmony, to which the curtain brings a welcome note of elegance. Perhaps it would be a shame to disturb all these memories which sit so well together, and to risk wiping the slate too clean and having to confront the naked truth.

Just one little twitch on the pretty pompom and the false curtain will close over the notice board and on the painting itself. Anyway, what is hidden under there is nobody else's business.

.

.

287

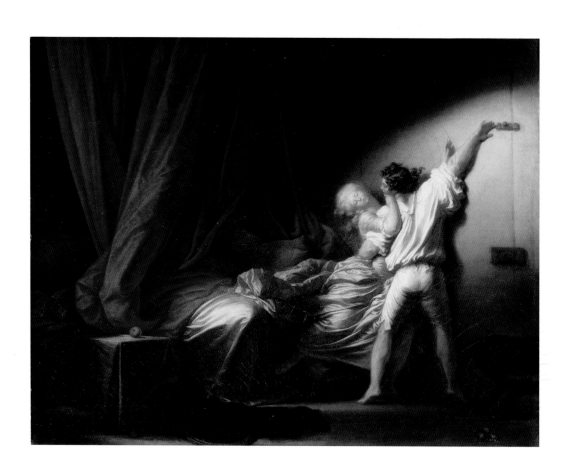

●●●

The Lock

Jean Honoré Fragonard (1732–1806)
c. 1778. Oil on canvas, 73 x 93 cm. Louvre, Paris.

He embraces her, she throws herself against him and pushes him away at the same time. No, it is impossible – if only – we musn't – perhaps – not yet – although . . . The man presses his arm impatiently against the beautiful woman who cannot quite bring herself to give in so quickly. We, too, must not let ourselves be seduced too easily and miss the essentials. The truth is, it was she who came to him, just as he was about to go to sleep, with his clothes dropped untidily on the floor. He is now defenceless, barefoot in his shirt, just as she found him. The woman weakens a little, her eye fixed on the lock. He stretches his hand up to slide it shut, she feebly protests, her virtue already unsteady, collapsing with delight. In the struggle the roses on her dress have become detached. It is all too much – the story is frozen in suspense, and the great curtain awaits the rest.

Fragonard has painted a kind of mist of heat over the whole picture, flaming with yellow and red. The painting is itself caught up in the characters' desire. The impulse which carries them along is embedded in the satin and moiréé, and the light slides around, whirls and disappears, as frivolous and magnificent as their unexpected embrace.

The sumptuous curtain transforms the bed into a theatre of passion, with all its twists and turns. The traditional painting of an interior scene was meant to be very different from this: comfortable beds, grandiose or otherwise, with impeccably aligned drapery and scarlet panels could be displayed to all in paintings of Annunciations, births of the Virgin or Saint John the Baptist, in portraits or genre scenes – all without fail showing exemplary domestic behaviour. Chastity would easily triumph over all temptation, smoothing out any crumpled folds of cloth.

But now we see original sin being replayed in an alcove. Eve as a frail marquise once again loses her head in a cloud of rice powder. A fine fruit on the bedside table will appease her hunger to the point of ecstasy. It will be delightful: from the lock to the apple, the painter lets the curtain drop and draws the line over Paradise.

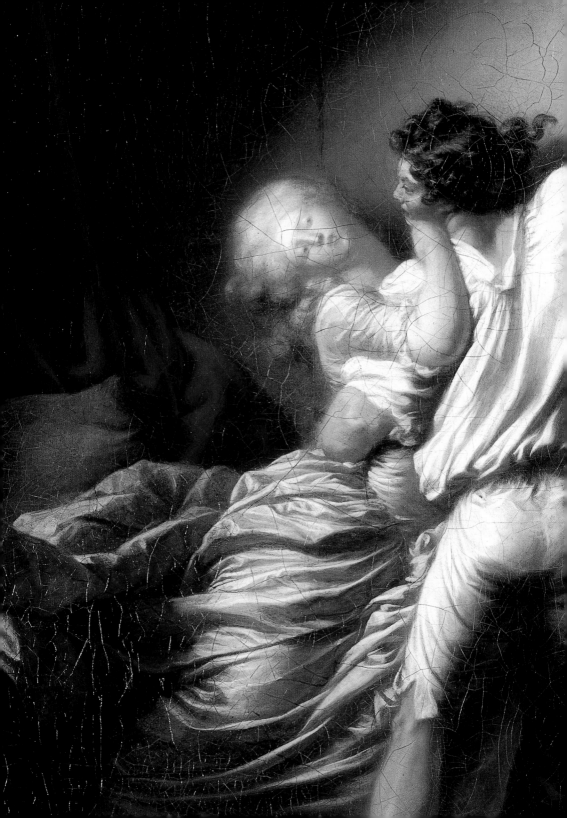

●●●●

The Room with the Balcony

Adolf Friedrich Erdmann von Menzel (1815-1905)
1845. Oil on board, 58 x 47 cm. Nationalgalerie, Berlin.

.

.

.

There is nobody here. The empty space, beneath the high painted ceiling, resonates with memories. For a moment the room is enlivened by a breath of wind. The light curtain quivers in the sunshine.

The objects reflected in the mirror seem almost more real than in life. They were there before and one can see that they now exist as a vague reflection, a more vibrant illusion than the rest of the picture. It is like a sudden loss of balance, the disappearance of such a solid past which has now become insubstantial. The mirror sends back images of what is no longer visible: the fine colours of the material, the elegant stripes, a fragment of a landscape in a gilded frame.

The wall, on the other hand, shows only traces of the successive decor people have lived with: the mark of where a painting has hung, irregular and dirty traces, a rough coat of paint, a bit of new plaster. One could possibly repaint this house, restore some of its original freshness, light up these rooms which seem so unresponsive to the daylight. There would be such a lot to change, one would have to start again from the beginning. Or perhaps it would be simpler to go somewhere else, if such a thing is possible. The curtains in front of the windows sift the daylight, letting nothing through. The room has been deprived of its view of the outside world.

Everything has been said. The story was over before we got here. The furniture has been pushed out of the picture and the two chairs that got left behind turn their backs on each other. From time to time one can hear the rustling of the curtain which is caught on the window frame and might easily tear.

The air blowing into the room lifts up the curtains with what seems like a murmur. The room is able to breathe a little better, like a patient who has been given oxygen. There is the memory here of a light-hearted past. Was it so long ago? Silhouettes used to waltz on waxed floors, as shiny as this one. Children used to slide wildly along a darkened corridor. The artist, who has come back to earth in the corner of the picture, has ponderously painted a date and his initials.

At the end of the room the delicately flowered fabric floats, like a bridal veil.

.

.

.

The curtain as deceiver
●

Pliny the Elder tells us of how two of the most famous painters of antiquity competed with one another to show which of them could imitate nature with the most precision: 'Parrhasios, they say, offered the challenge to Zeuxis. Zeuxis brought along grapes which had been painted with such perfection that birds came to peck at the picture. The other man brought a curtain so accurately painted that Zeuxis, proud of the verdict of the birds, asked that it be drawn back to display his painting. Then, realizing his mistake, he conceded the palm with honesty and modesty, saying that he had only fooled the birds whereas Parrhasios had fooled him, an artist.' (*Natural History* XXXV, 64). This episode was never forgotten and the theme of the curtain, which retains a particular aura from the story, became definitively associated, not just with technical perfection but even more with the deception for which it supplies the means. The trompe-l'oeil, a visual joke whose purpose is to reflect on the limits of man's visual understanding, reached its apotheosis with the curtain: by reproducing the visible world with such skill that it seems real it simultaneously conceals it – there will never be anything visible behind something that cannot be opened. And so the painting itself, insofar as it can be identified with reality, cancels itself out.

The open curtain
●

Curtain panels opening symmetrically behind a central figure represent more than just a simple background in the Christian repertory of images. The motif is a reminder of the event described in the Synoptic Gospels relating the death of Christ: 'At that the veil of the Temple was torn in two from top to bottom.' (Matthew, 27, 51). Only the high priest had the right to draw aside the veil which protected the Holy of Holies, and now the Crucifixion had definitively torn it apart. This violent action is replaced by a harmonious drawing open of the curtain in medieval illuminations depicting the evangelists, and later in the numerous depictions of the Man of Sorrows in the fifteenth century. What had been perceived as a terrible transgression in a Jewish context had become a sign of Christian legitimacy. The Word of God, which had hitherto been separated from man by the impassable barrier of the veil, was now revealed to all through the writings of the Gospel or by the Incarnation of Christ. The open curtain then moved on from a religious context to being a setting for royal portraits, in which it conferred a kind of sacred authority that was rich in connotations.

The curtain of state
●

The curtain of state is a successor to the holy curtain, developing the latter's form and function; it makes use of asymmetry, irregular folds and the contrast between parsimony and profusion. From the Renaissance onward it would provide a backdrop to portraits, biblical scenes, nudes and still lifes, always as the necessary indicator of splendour. The unreality of its proportions, and of the context in which it was often to be seen, either out of doors or in some architectural backdrop, made it the most useful way of separating the figures or objects from the trivia of real life. It would raise them above mere nature, by suggesting the concept of an abstract and unmeasurable space. The material used for the curtain could provide the means for an exploration of light and shade, as it could distribute these contrasts as a kind of image of the world itself, full of heights and abysses, blown about by strange forces. The state curtain is thus more than mere decoration, it is a pictorial vessel for real transfiguration. Generally green in the sixteenth century, as though to mimic the colours of nature, it later became predominantly red, the colour of power, and then in the following century brown, bronze or grey.

With or without folds
●

The French word *rideau* (curtain)
reveals its meaning quite simply: it
means a piece of material in which
rides (wrinkles) have been inserted,
differentiating a curtain from a
simple flat wall-hanging. The
splendid canopies, that were used in
religious festivals to enhance
ceremonies and processions,
stretched up behind the holy or
political figures, would equally be
seen in Renaissance representations
of Virgin and Child, in which they
would temporarily demarcate a
particular space as being sacred.
From the sixteenth century onwards
one can frequently observe a
complementary relationship
between the piece of cloth placed
as a backdrop to the figure, and the
way in which that figure is clothed.
The rigidity of the canopy is
contrasted with the free drapery
around the figure; or, conversely, the
more stiff the clothing and pose of
the figure, the more free the hanging
at the back – the stiff canopy
replaced by the movement of a
baroque free-hanging curtain. A
balance is thus achieved between
man and the world around him. The
curtain, which from the beginning
has designated a holy place,
developed separately from the
window in terms of its symbolism.
Indeed the two were not actually
associated with one another in
depictions of interiors until the
eighteenth century.

Stage curtains
●

In antiquity theatre curtains were
huge painted canvases which were
unrolled and played an important
part in the general effect of the
stage setting, as described by
Ovid: 'Think of a tapestry
frontcloth rolling up in the theatre
at festival time. The embroidered
figures slowly and smoothly
ascend, their faces first and then
the rest of their bodies, till all is
revealed and their feet stand firm
on the base of the curtain.'
(*Metamorphoses* III, 111–114).
This kind of arrangement
continued to be used in theatre
decor for a very long time, until in
the sixteenth century people
began to use draped curtains,
clearly inspired by those that were
used in churches to demarcate
separate areas, and by examples
from painting and sculpture. The
curtain motif, brought to life by its
history of representation in
painting, takes on, in its theatrical
role, a task which is a reminder of
its sacred origins: whether it is
opened, pulled or raised, it
necessarily unveils an alternative
reality, revealing the inner meaning
of myths.

Curtains and windows:
a late pairing
●

It was not thought necessary for a
very long time to cover windows
with curtains. Paintings of interiors
from the Middle Ages onwards, in
both religious and secular settings,
show us that suspended draperies
and hangings were only used over
boxed beds or doors, to darken
rooms or to protect from the cold
and from draughts. Light curtains,
echoing the draperies of antiquity
began to appear in neo-classical
times and later came into general
use. Paradoxically, the classical
desire to escape from the frivolous
vagaries of fashion by an emphasis
on pure nobility gave rise in its turn
to a new fashion which, at the end of
the eighteenth century, completely
took over the plastic arts and daily
life. White net curtains, useful in that
they filtered and diffused the
sunlight and protected the privacy
of those indoors, were used
originally for aesthetic reasons. They
were a kind of parallel to the
clothing of women and young girls,
whose bodies were both covered
and revealed by the cunning
simplicity of light materials. With the
subsequent introduction of heavy
curtains whose thickness
guaranteed their effectiveness, the
net curtain became the equivalent
of the petticoat, a combination of
flirtatious prudery and opulence.
And so this ancient symbol became
a comforting domestic emblem of
good bourgeois habits.

SELECT BIBLIOGRAPHY
AND SUGGESTIONS FOR FURTHER READING

Primary Sources

The Apocrypha
The Bible
Homer, *The Iliad*
Ovid, *Metamorphoses*
Pliny the Elder, *Natural History*
Virgil, *The Aeneid*
Cesare Ripa, *Baroque and Rococo Pictorial Imagery*, trans. Edward A. Maser, Dover Publications, New York, 1991
Saint Francis of Assisi, *Little Flowers of Francis of Assisi*, trans. Robert H. Hopcke and Paul A. Schwartz, New Seeds, London, 2006
Jacobus de Voragine, *The Golden Legend*, trans. Granger Ryan and Helmut Ripperger, Longmans, Green and Co., New York and London, 1948

Reference works

Matilde Battistini, *Symbols and Allegories in Art*, Getty Publishing, Los Angeles, 2005
Herschel B. Chipp, *Theories of Modern Art: A Source Book by Artists and Critics*, University of California Press, Berkeley, 1968
Alain Gheerbrant, Jean Chevalier, John Buchanan-Brown, The Penguin Dictionary of Symbols, Penguin, London, 2005
Pierre Grimal, *The Dictionary of Classical Mythology*, trans. A.R. Maxwell-Hyslop, Blackwell Reference, Oxford, 1987
James Hall, *Hall's Dictionary of Subjects and Symbols in Art*, John Murray, London, 1989
Linda and Peter Murray, *The Penguin Dictionary of Art and Artists*, Penguin, London, 2007
Joshua C. Taylor, *Nineteenth-Century Theories of Art*, University of California Press, Berkeley, 1987

Essays and articles

Hans Belting, *Likeness and presence, A history of the Image before the Era of Art*, Chicago, 1994
Liana de Girolami Cheney, *The Oyster in Dutch Genre Paintings: moral or erotic symbolism*, in *Artibus and Historiae*, No15 (viii), 1987
Carla Gottlieb, *The Window in Art; from the window of God to the Vanity of man; a survey of window symbolism in western painting*, New York, 1981
Anne Hollander, *Seeing through clothes*, University of California Press, 1993
Marina Warner, *Alone of all her Sex: the Cult of the Virgin Mary*, Picador 1985

Exhibition catalogues

L'Abeille, l'homme, le miel et la cire, musée des Arts et Traditions populaires, Paris, 1981.
La Peinture dans la peinture, musée des Beaux-Arts de Dijon, 1982-1983.
Bonnard, Les classiques du XXe siècle, musée national d'Art moderne, Centre Georges-Pompidou, Paris, 1984.
Santiago de Compostela, 1000 ans de pèlerinage européen, Europalia, Gand, 1985.
Arnulf Rainer, Masqué, démasqué, musées royaux des Beaux-Arts de Belgique, Bruxelles, 1987.
Jusepe de Ribera, 1591-1652, Metropolitan Museum of Art, New York, 1992.
Poussin, 1594-1665, Galeries nationales du Grand Palais, Paris, 1994-1995.
Poussin, 1594-1665, Royal Academy of Arts, London, 1995
David Alan Brown, Peter Humphrey, Mauro Lucco, *Lorenzo Lotto, Galeries nationales du Grand Palais*, 1998-1999.
Les Raisins du silence, chefs-d'œuvre de la nature morte européenne du XVIIe et du XVIIIe siècle, musée des Beaux-Arts de Bordeaux, 1999.
Encounters, New art from old, National Gallery, London, 2000.

Olaf Koester, *Painted illusions, The Art of Cornelius Gijsbrechts*, London, 2000.
Le Siècle de Van Eyck, 1430-1530, Le monde méditerranéen et les primitifs flamands, musée Groeninge, Bruges, 2002.

Secondary literature

John Berger, *Ways of Seeing*, BBC / Penguin Books Ltd, London, 1972
Mircea Eliade, *Images and Symbols: Studies in Religious Symbolism*, trans. Philip Mairet, Princeton University Press, Princeton, 1991
Edward Fry, *Cubism*, Thames & Hudson, London, 1966
Ivan Gobry, *Saint Francis of Assisi*, trans. Michael J. Miller, Ignatius Press, San Francisco, 2006
E.H. Gombrich, *The Story of Art*, Phaidon, London, 1995
Rose-Marie and Rainer Hagen, *What Great Paintings Say*, Taschen, Köln, 2000
Sabine Melchior-Bonnet, *The Mirror: A History*, trans. Katharine H. Jewett, Routledge, New York, 2001
Patrick de Rynck, *How to Read a Painting: Decoding, Understanding and Enjoying the Old Masters*, Thames & Hudson, London, 2004
Patrick de Rynck, *Understanding Paintings: Bible Stories and Classical Myths in Art*, Thames & Hudson, London, 2009

Literary works

Charles Baudelaire, *The Flowers of Evil*, trans. James N. McGowan, Oxford University Press, Oxford, 2008
Roy Campbell, *Poems of Baudelaire*, Pantheon Books, New York, 1952
Friedrich Nietzsche, *Thus Spake Zarathustra*

THEMES

PICTURE LIST

PICTURE CREDITS

AUTHOR BIOGRAPHY

AND ACKNOWLEDGEMENTS

Françoise Barbe-Gall

studied art history at the Sorbonne and at the École du Louvre, where she now teaches. She also runs CORETA (Comment Regarder un Tableau), in which capacity she has lectured extensively. She is regularly invited to take part in management seminars in which she is able to draw on her vast experience not only in analysing images but also in marketing and publicity. A collection of her articles was published in Seville in 2000 under the title *La mirada*. She is also the author of several essays devoted to the work of the sculptor Tom Carr. Her book *How to Talk to Children About Art* was published by Frances Lincoln in 2005.

Acknowledgements

This book owes a great deal to other books by highly erudite authors whose works clarified my thoughts and whom I would like to salute with great admiration, beyond the usual bibliographic references. I would also like to thank the readers of *How to look at a Painting*, whose enthusiasm encouraged me to continue with a similar approach to the symbols in paintings.

I must also praise the work of Editions du Chêne, Clara Engel's great patience and Odile Perrard's efficiency and unshakeable courtesy.

Finally I am grateful to my children, who allowed me to spend long hours in the midst of my images, and to my husband, who once again had the difficult task of being the first reader.

Frances Lincoln Limited
www.franceslincoln.com

How to Understand a Painting: Decoding Symbols in Art
Copyright © Frances Lincoln Limited 2010

Translation by Emily Read

Original edition published in French
© Éditions du Chêne - Hachette-Livre, 2007

A catalogue record for this book is available from
the British Library

ISBN: 978-0-7112-3213-6

Printed and bound in China

9 8 7 6 5 4 3 2